The designer and the grid

RotoVision

Published and distributed by
RotoVision SA
Route Suisse 9
CH-1295 Mies
Switzerland

A RotoVision Book
RotoVision SA
Sales & Editorial Office
Sheridan House
112/116A Western Road
Hove
BN3 1DD
UK

Tel: +44 (0)1273 72 72 68
Fax: +44 (0)1273 72 72 69
Email: sales@rotovision.com
Web: www.rotovision.com

Design:
sans+baum
Production and separations:
ProVision Pte Ltd
Singapore
telephone
+65 6334 7720
fax
+65 6334 7721

ISBN 2-88046-814-0

10 9 8 7 6 5 4 3 2 1

The designer and the grid

Introduction
The principle of the grid
Grids are everywhere
The grid in cultural context
The psychology of the grid
Making the grid
Breaking the grid
Bibliography/Contacts/Credits/Index

Lucienne Roberts
Julia Thrift

Contents

The grid	Principle	Everywhere	Cultural	Psychology	Making	Breaking	
	When		Architecture	Wim Crouwel	Control		
	What		Music	Simon Esterson	Precision		
	Why		Furniture design	Linda van Deursen	Measurement		
	How		Fine art	David Carson	Micro/macro		
			Interior design	Peter Gill	Components		
			Screenplays	Krieger	Sztatecsny		
			Digital design	Cartlidge Levene			
			Town planning	Wendelin Hess			
			Conceptual art	Hamish Muir			
				Ellen Lupton			
				John Maeda			

The designer and the grid
Introduction
The principle of the grid
Grids are everywhere
The grid in cultural context
The psychology of the grid
Making the grid
Breaking the grid
Bibliography/Contacts/Credits/Index

1 **2** **3**

12
Introduction

17
The principle of the grid
An examination of the principles of the grid in graphic design that answers some of the basic questions, including a brief historical essay by designer and lecturer Ray Roberts.

31
Grids are everywhere
From gridlock to sonnet structure, electricity to politics, dentistry to hopscotch – a journey down London's Oxford Street to explore the omnipresence of the grid. Photography by Andrew Penketh.

33
The grid in cultural context
The grid is not a typographic device alone. A series of illustrated essays and interviews explores the grid from many perspectives. Although often unnoticed, these structures underpin much of what we see, hear and do.

34
Architecture
An essay that examines the horizontal and vertical in architecture.

42
Music
Essay by John L Walters
An explanation that time-based grids are central to musical structure.

46
Furniture design
Case study
by David Phillips
The work of furniture designer Axel Kufus, with his schematic and humane approach to ordering chaos.

50
Fine art
Essay by Martin Herbert
The use of the grid as a recurring device in painting and the fine arts.

54
Interior design
The design detail of architect John Pawson's family home shows that a desire to explore structure and proportion does not preclude an awareness of more instinctive design.

56
Screenplays
Essay by Damian Wayling
The screenwriter employs time-based grids that simultaneously produce changes in pace and focus to keep the audience's attention until the bitter end.

60
Digital design
Designer Neil Churcher describes the grid as a fundamental part of digital design.

68
Town planning
Professor Bill Hillier, founder of Space Syntax, reveals that there are structures that underpin even the most chaotic-looking towns and cities of the world.

74
Conceptual art
The systems we use to place ourselves in the world include gridded maps and globes; the artist Tacita Dean explains that without them we are potentially disorientated and lost.

77
The psychology of the grid
Analytical psychotherapist Jason Wright introduces this section, and considers obsessive behaviour and the designer's need for control. In the following illustrated case studies, leading designers consider the place of grids in their work.

129
Making the grid
Graphic designers Rupert Bassett, Dave Shaw and Kelvyn Smith outline their working methods and consider the increased potential for precision using contemporary design tools.

145
Breaking the grid
Is an obsession with the grid a twentieth-century phenomenon? In a period of post postmodernism are we witnessing its demise in favour of more organic forms? An illustrated essay drawing upon the work of Frank Gehry, Ushida Findlay, Tomato and Vaughan Oliver explores the future of the grid.

154
Bibliography
Contacts

155
Credits

156
Index

78
Wim Crouwel is an original. He has applied a systematic approach to design thinking from the 1950s to the present day.

84
Despite admitting that he can't work without a grid, **Simon Esterson** describes his pragmatic approach to the complex requirements of editorial design.

90
For **Linda van Deursen**, partner in Mevis & van Deursen, a rigid design dogma seems to miss the point. Grids are useful tools but they should not become restrictive.

94
Having never learnt what a grid was, **David Carson** still finds that he can't start working without eliminating any kind of guideline on his computer.

96
For **Peter Gill**, proportions often determine the grid. For him, this is not about imposing design principles but discovering what's already there.

100
Krieger | Sztatecsny are 'traditional' modernists who apply the principles of the grid with sensitivity and refinement.

104
The design company **Cartlidge Levene** has a reputation for clean, functional graphics. Ian Cartlidge and Paul Winter consider the role of architecture in their recent work.

110
Wendelin Hess is happy to relinquish some control. He describes the work of Müller-Hess-Balland as systematic thinking that will produce random-looking results.

116
Founding partner in 8vo **Hamish Muir** considers the dichotomy between an interest in precision and in work that allows for intuitive decision-making.

122
For **Ellen Lupton**, the grid provides a designer with a set of possibilities that help to diminish the potential for introspection and self-obsession.

124
John Maeda spans the arts/sciences and Western/Japanese culture gaps. He discusses the relevance and irrelevance of the grid from this unusual perspective.

1.8/9 0.8/9 **8/9**

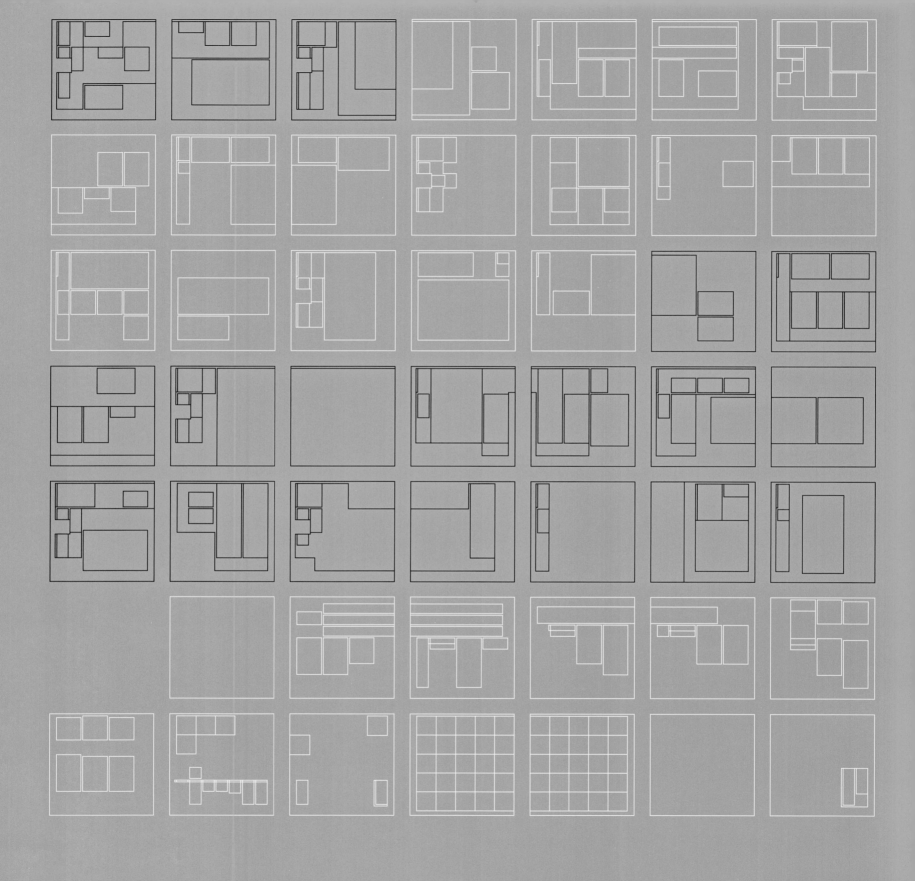

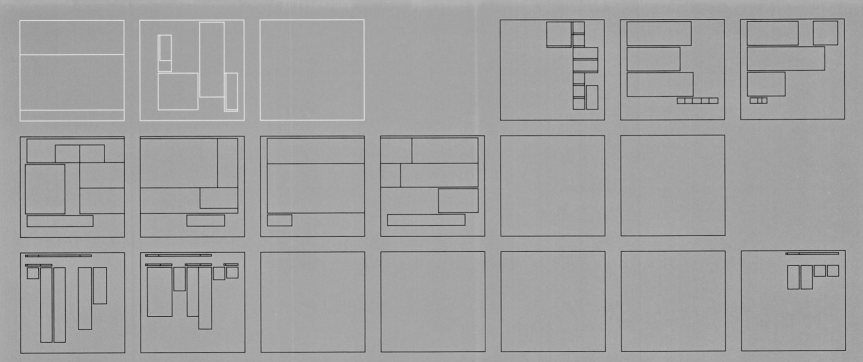

This book uses a seven-column grid. Each column is divided into seven fields. Every page of the book is shown here and on the preceding pages in diagrammatic form, to demonstrate the flexibility of this structure.

The world is a frightening place. Natural disasters are a constant reminder of human frailty, often destroying our attempts to gain control.

problem: a chaotic world in which parameters are always
changing; a need for control without being
controlled; a desire to find beauty and truth;
vast quantities of words and images that need
to be placed on a page...

This book sets out to get beyond and behind the grid. It doesn't merely explain how and why to use typographic grids but also places them in a broader cultural context. It draws references from the visual arts, film, music and architecture to demonstrate that grids are not the preoccupation of a narrow group of austere typographers. It is little wonder that designers are fascinated by systems, modules and grids. Not only do they have practical applications, as a means to resolve complex design problems, but, as analytical psychotherapist Jason Wright explains in his introduction to **The psychology of the grid** on page 77, they also provide a sense of order and temporary respite from the most pressing and basic human fears and dilemmas.

The designers included describe with great passion their interest in these benign-looking structures. But those whose work looks most 'pure' and minimal are aware that perfection is unobtainable and its pursuit can be a dangerous thing. In the section **The principle of the grid**, Ray Roberts describes how, in the late 1930s, the typographer Jan Tschichold began to see parallels between his highly systematised work and the rigidly ordered societies of Fascist governments. In the case study on page 54, the architect John Pawson acknowledges that, while order is desirable and calming in life, an element of disorder is essential too. 'I love the combination of natural things and manmade things,' he says. 'For me, in the end, what's important is what feels right.'

Most of the examples shown demonstrate the prevalence of structures that are imposed by humans upon the world, but many contemporary designers consider that this position isn't tenable. In his book, The City of Tomorrow, published in 1924, the architect Le Corbusier wrote, 'man walks in a straight line because he has a goal and knows where he is going.' In a period of post postmodernism we don't know where we are going, which is perhaps why the grid is simultaneously loved and loathed. It acts as a constant reminder that modernism, which we thought gave permanent answers, was only a temporary solution. In the final section of the book, **Breaking the grid**, the graphic designer/artist Peter Anderson contemplates this shift in approach: 'the more we build, the more we sprawl all over the world, the more we'll feel that somehow we want to get nature back.'

Contemporary designers are keen to embrace the random and intuitive in their work. In the case study of graphic designer Wendelin Hess on page 110, he describes the work of himself and his partners Beat Müller, Ludovic Balland and Jonas Voegeli. 'I think that we are attracted by systems that don't always work. We are happy to let things happen the way we didn't intend.' This is an understandable reaction to the absolutism that is associated with modernism and is a positive embrace of the more organic approach to design that has been facilitated by changes in technology.

Technology has impacted on the way designers think. It is possible to build random responses into a design solution, to make abandonment of control a positive, and not frightening, act. The new connected identity for Sony, designed by Tomato and described on page 148, is interesting in this context. It exists in the abstract on a web server and is unique in its response to any connections made with it. This is conceptually gridless, but the fact that it is produced digitally still ties it to a modular system. As Neil Churcher explains, in the case study about digital design on page 60, the pixel makes 'the grid an absolute... there's no way that you can break it, you can't go off the digital lines, it's impossible.'

Interestingly, while technology has 'freed' design thinking it also makes precision more attainable. In the section **Making the grid**, three contemporary graphic designers describe with enormous passion their joy in controlling the page. A logical approach reinforces the idea that design is quantifiable. Designer Rupert Bassett explains to his clients that their message will be reinforced by a confident design and its content made more accessible if every space, type weight and size means something.

A grid's proportions, and the flexibility with which it is used, should also lead to compositions of beauty. It is relatively easy to apply a step-by-step formula to designing a grid that may function, in that it doesn't impede reading, without producing a beautiful or dynamic page. As the designer Wim Crouwel comments in the case study on page 78, '[A design] should have some tension and some expression in itself. I like to compare it with the lines on a football field. It is a strict grid. In this grid you play a game and these can be nice games or very boring games.'

It is easy to be seduced by the notion of liberation in the design process, but with the questioning of modernism has come a political apathy and resistance to taking design responsibility. Crouwel places the grid clearly in a political context. His formative years were spent during the optimistic post-war period, when the grid first made its formal appearance. Grids were then symptomatic of a thoroughness in design methods and a belief in increased access, rather than a method of control and limitation. 'The big difference, in this postmodernist period,' he comments, 'is that in our period we thought design could help society. We wanted to make things more usable. We all did our job to better society but we didn't succeed.'

The repositioning of the grid is indicative of a rather unhealthy increase in designer self-obsession. For writer, curator and designer Ellen Lupton (see page 122) this is easy to explain. For her, the grid is a design tool that, once applied, brings objectivity. 'The power of the grid is to lift the designer outside of the protective capriciousness of the "self" by providing an existing set of possibilities, a set of rules.' Lupton is driven by a desire to communicate effectively, and dismisses the notion that tools that help in this process are bound to restrict creativity. 'For me a project is a failure if people don't read and understand it. It must be possible to be inventive and creative and still produce material that people can read.'

In his article of 1967, Typography is a Grid, Anthony Froshaug wrote 'to mention both typographic, and, in the same breath/sentence, grids, is strictly tautologous. The word typography means to write/print using standard elements; to use standard elements implies some modular relationship between such elements; since such relationship is two-dimensional, it implies the determination of dimensions which are both horizontal and vertical'. Froshaug was partly describing the modular system of hot-metal typesetting. With the increased use of computers, necessity for grid-based design has been open to question. However, in graphic design, the core parameters remain the same: we read from left to right and top to bottom. It is this that makes the grid still so relevant, and, as shown in **The designer and the grid**, designers continue to lovingly play with and reinvent the form.

Towards the end of the
1930s, the typographer
Jan Tschichold began
to question his advocacy
of systematic design,
seeing parallels with
the rigidity of Fascist
thinking. Interestingly,
in the 1950s and '60s
a systematic approach
to design was allied
to a democratic belief in
greater access for all.

The grid	Principle	Everywhere	Cultural	Psychology	Making	Breaking
	When		Architecture	Wim Crouwel	Control	
	What		Music	Simon Esterson	Precision	
	Why		Furniture design	Linda van Deursen	Measurement	
	How		Fine art	David Carson	Micro/macro	
			Interior design	Peter Gill	Components	
			Screenplays	Krieger \| Sztatecsny		
			Digital design	Cartlidge Levene		
			Town planning	Wendelin Hess		
			Conceptual art	Hamish Muir		
				Ellen Lupton		
				John Maeda		

The designer and the grid
Introduction
The principle of the grid
Grids are everywhere
The grid in cultural context
The psychology of the grid
Making the grid
Breaking the grid
Bibliography/Contacts/Credits/Index

The following section gives an overview of the grid in graphic design by examining the basic principles and asking the questions 'what?', 'why?' and 'how?' The question of 'how' grids are applied is answered theoretically and not prescriptively. Each job requires new consideration. Issues of taste, fashion and appropriateness are raised in discussion with a variety of designers in the section **The psychology of the grid**, which starts on page 77.

As discussed in the **Making the grid** section, there are a variety of theories applied to arrive at a grid. Common to them all is consistency. The approach outlined here makes clear the main considerations. In keeping with the practice of many designers, this model uses the typographic unit of the point to measure the type area vertically, and millimetres to measure margins and column widths.

Also included in **The principle of the grid** section is a very broad look at the question of 'when' the term 'grid' became widely used within graphic design. This essay, by Ray Roberts, sets the arrival of the grid against a backdrop of more than 500 years.

Ray Roberts
Roberts graduated from the UK's Central School of Arts and Crafts in 1947. After working under Oliver Simon at the Curwen Press, he set up his design practice in 1961. He has taught at several British colleges and universities including the Central School of Art and Design, Middlesex University and the University of Reading.

When
Early printing and standardisation
The first symmetrical page
The need for asymmetry
The Arts and Crafts Movement
The early twentieth century
The Bauhaus
Jan Tschichold
Swiss typography

The grid

What
What is a grid?

Why
Why use a grid?

How
How to think about grids
Asymmetry v symmetry
Geometry v maths
Creating a grid

The first decades following the introduction into Europe of printing from movable type, in about 1450, saw printers grappling with the problems of textual interpretation through a new medium using individual metal letters. For a considerable time prior to the advent of printing, the formal manuscript book had been increasingly employed to convey secular material alongside religious texts. Ways and means had been found to increase the output of handwritten books. Simplified scripts, payment by the piece, and dictation by a master scribe to a number of followers all increased production. One effect of such efforts was a growth in the number of literate people who, in turn, became contributors to the store of knowledge, thus encouraging a further growth in manuscript production.

The early printers had the calligraphic book as a model for style and structure, but the wider distribution of printed texts led to a gradual standardisation in such matters as spelling and grammatical usage, as well as the ways in which subdivisions of texts were expressed typographically. In the calligraphic book, variations in the size and style of script were used to introduce new sections of content, or to indicate divisions in the text matter. Colour was employed to emphasise important words or phrases, as well as to highlight key initials.

The relatively rapid dissemination of printed books to a much wider audience, together with the growth of more complex texts, required the printers to develop ways in which to present commentaries, notes and references, and to indicate degrees of emphasis, or textual subdivisions. The management of such material needed careful typographic structuring that could be readily understood by a growing readership from a widening social base.

An early example from the fifteenth century showing printing following the appearance of manuscript books. Commentaries and notes have produced a complex structure around the central main text. Note the use of a second colour.

The basic principle of a grid is extremely simple. A grid is the graphic design equivalent of a building's foundations. As we read from left to right and top to bottom, a grid is generally a series of vertical and horizontal lines. The vertical lines will relate to the column widths, while the horizontal will be determined by the space that a line of type occupies. Occasionally designers will rotate a grid so that these lines are at an angle, but the basic determining factors will still be the same. The size of these smaller units or fields is determined by the nature of the content, together with the components that will make up the whole; for example, the type and images.

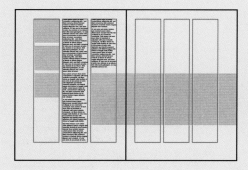
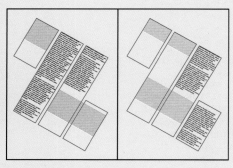

A simple three-column grid, which defines column widths and all margins. Column widths should be determined by the type's point size and the number of words per line to maintain easy legibility.

The same principles can be used for a grid that is at an angle to the page. As with all grids, alignments are sometimes made horizontally with type or image. Elements do not always have to hang from the top of a column.

When
Early printing and standardisation
The first symmetrical page
The need for asymmetry
The Arts and Crafts Movement
The early twentieth century
The Bauhaus
Jan Tschichold
Swiss typography

The grid

What
What is a grid?

Why
Why use a grid?

How
How to think about grids
Asymmetry v symmetry
Geometry v maths
Creating a grid

In the manuscript book, text was presented in single, double or more columns to the page. Double-page spreads were symmetrical, the left hand page mirroring the right. Prior to decoration, a manuscript book usually had wider outside left and right margins than those in the centre of a spread, and a larger margin at the bottom of both pages than at the top. These spaces were often filled with illustrative or decorative material, or used for notes or comments on the text, thus losing much of their value as space.

It is understandable that the first printers should have followed closely the form and appearance of the calligraphic book, as initially they relied on the purchasers of the latter to buy their own new productions. Nevertheless, printed books in general were simpler in visual effect, which emphasised one important difference between the printed and the calligraphic page. Handwritten text has slight variations in line length, thus producing an even edge to the left of the column and an uneven edge to the right, unlike the typographic book, in which the text lines could be, and nearly always were, justified to the same length. This may not seem to be a crucial difference, but in visual terms it turns the text areas into strong rectangles, and makes margins and intercolumn spaces into clearly defined vertical barriers. In essence, the manuscript book was therefore asymmetric, and one of the great changes in modern typography has been a return to asymmetry.

An asymmetric treatment of the text area also changes the way in which space operates. Where text is justified, the marginal space acts as a frame, but is otherwise passive. In an asymmetric setting, with text areas strongly defined at the left but open at the right, the surrounding space becomes a much more active constituent of the design and cannot simply be used as a frame. In modern typography, the handling of space is just as important as the treatment of text and illustrations.

An archetypal classical double-page spread from a book printed in 1755. Many present-day books follow this model.

A three-column grid using horizontal divisions to form 'fields'. Columns are shown used in multiples to form wider text measures or picture spaces demonstrating the flexibility of the system.

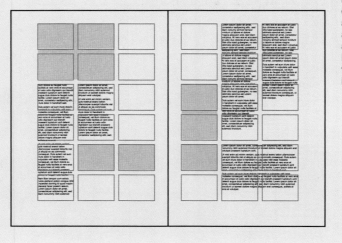

There are several reasons why designers use grids. These epitomise the micro and macro concerns of graphic design.

Grids are practical, particularly for producing multiple-page documents. They make the production process quicker and build a visual consistency into the design that should help the end-user to find their way around the page. Once the margins, column widths and type sizes are determined, a designer can concentrate on the detail of the layout. In using a grid, designers have to engage with the minutiae of the process. The smallest unit of a grid is often half or a quarter of the space occupied by a line of type, and so could be as small as three points.

Grids unite the practical with the aesthetic. They are about the organisation of objects in space and this involves making aesthetic decisions about proportion and scale.

Grids are fundamentally about a way of thinking. They are used to help bring order to a page and to impose structured thinking into the design process. In making these decisions, a designer is generally helping to make content accessible. This engagement with the wider world is a political act. The term 'the grid' came into common use just after the Second World War. At that time, many designers saw their role in socio-political terms and wanted to be instrumental in building a new and better world.

There are, of course, even wider psychological considerations. Grids can be seen as metaphors for the human need to make sense of the world and to position ourselves in control of it. The straight lines of a grid have been criticised as symptomatic of a preoccupation with 'progress' that is actually limiting and one-dimensional. Designers often mistrust this appropriation of this simple design tool, considering it irrelevant and pseudo-intellectual.

When
Early printing and standardisation
The first symmetrical page
The need for asymmetry
The Arts and Crafts Movement
The early twentieth century
The Bauhaus
Jan Tschichold
Swiss typography

To a large extent, the evolution of structures in calligraphic books must have been driven by content, rather than imposed through theoretical ideas concerning proportion or textual relationships. Form grew from the need to communicate meaning. These observations apart, the first 450 years of printing that followed were dominated by symmetrical design, mostly devoted to book production.

By the mid-sixteenth century, the typographic book had developed its own style, and most of the problems related to function had been solved. The title page had been adopted, together with running headlines, page numbering, indexing, paragraphing, and fairly standard treatments of chapter openings and footnotes. Within this typographic scheme there was, of course, room for considerable inventiveness in choice of typeface, type sizes and combinations of these with rules and typographic ornament, but the overall visual structure of the printed book became fixed. Double-page spreads were centred around the gutter, with headings, subheadings and the like centred over the text matter. At best, this produced highly refined work, which was often carefully detailed; at worst, this rule-of-thumb approach allowed the lowliest printer to prepare usable products, no matter how dull and poorly executed they might be.

Through the course of the seventeenth and eighteenth centuries, the quickening interchange of knowledge, made possible by printing, led to even more complex texts. Symmetrical design could not cope with problems such as lists and tables. These were usually set with the longest line centred on the text, but the inherent randomness of a table, for example, meant that it was visually destructive of any balance around a central axis.

The grid

What
What is a grid?

Why
Why use a grid?

How
How to think about grids
Asymmetry v symmetry
Geometry v maths
Creating a grid

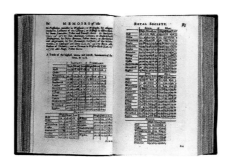

A double-page spread from Memoirs of the Royal Society, 1741. Simple statistical matter is difficult to contain in the classical layout.

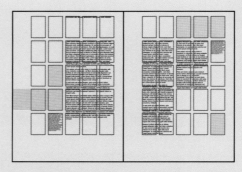

A typical asymmetric grid. Both left-hand margins are larger than the right hand. The top margin is considerably smaller than the bottom. These relative proportions are not absolutes, but it is easier to achieve dynamic layouts if margins have extreme differences in size. The grid is split into five columns with horizontal 'field' divisions also. This gives enormous flexibility for hanging positions and text measures.

Because grids combine issues of aesthetics, practicality and appropriateness, there are large decisions to make as well as small. This requires a certain amount of vision on the part of the designer. The large questions tend to be about design philosophy. The following section explores this.

Given that the notion of 'the grid' was a modernist one, it is important to understand that one of the central tenets of modernism was the use of asymmetry. This was partly a response to an increased demand for a broad range of printed items – posters, leaflets, timetables – none of which suited a classical page layout synonymous with the symmetrical double-page spreads of books. It also grew out of a logical approach to legibility. Since we read from left to right, each word should be separated by an equal word space, and this automatically produces ranged-left typesetting. This is in contrast to 'justified' typesetting, where word spaces are altered in size per line to make the left and right column edges align. The latter was criticised as preoccupied with form over function.

However, no one should be under the misapprehension that modernism was not concerned with aesthetics. Asymmetry lends itself to greater exploration of layout and its visual potential. The freedom to dramatically exploit space and scale has produced pages of great beauty and dynamic tension. The asymmetry can be in the number of columns – three or five, for example – and in their positioning on the page with larger left or right hand margins.

When
Early printing and standardisation
The first symmetrical page
The need for asymmetry
The Arts and Crafts Movement
The early twentieth century
The Bauhaus
Jan Tschichold
Swiss typography

The grid

What
What is a grid?

Why
Why use a grid?

How
How to think about grids
Asymmetry v symmetry
Geometry v maths
Creating a grid

The situation had become worse by the early nineteenth century. Newspapers had existed in rudimentary form for over 200 years, but now became more numerous and complex with increasing use of illustration. Journals and magazines proliferated, covering all areas of human activity and interest, while the range of subject matter, and the quantities of books produced, increased dramatically. The Industrial Revolution led to a new form of print – advertising and promotional material. There was very little precedent for these kinds of printing and the new problems were overcome in an ad hoc manner.

Existing roman types were inadequate. Bolder versions were designed alongside new families of letters with slab serifs or no serifs at all. By the mid-nineteenth century, the range of bold and decorative display fonts was vast, and was supported by rules and ornaments in bewildering variety.

Most advertising was still centred. Type size and style, and the grouping of the content, were the devices used to give emphasis. There was a growing awareness of the suggestive qualities of letter design and that typography could be utilised as a potent means to flavour or enhance a message. The total effect of the piece of printing could establish a product in the public arena. Thus the seeds of modern typography were sown.

In a similar way, by the end of the nineteenth century, publishers had become aware that the design of their books could establish them in the marketplace. With this divorce between design and production, the ground was prepared for the specialist typographer, who would control all the aspects of production that affected the final appearance of the book.

Typical of many nineteenth-century scientific works, these pages show the clash between style and content, where structures fail to work.

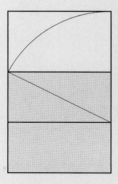

Designers have often been intrigued by the mystical aspects of the golden rectangle and its geometric construction. It is shown here in portrait format. Draw a square, divide it in half and then draw an arc placing the compass point at one end of the division to find the top of the rectangle.

Designers who profess to be interested in grids generally think of them in mathematical, rather than geometrical, terms. This is because they consider one to be more logical and practical than the other. It is important to be aware of these distinctions, particularly when it comes to considering format or the proportion of text/image area to margins.

Geometry is the branch of mathematics that is concerned with the relationship of points, lines, surfaces and solids rather than their measurement. This is an important distinction because it is fundamentally 'irrational', in that it is not preoccupied with whole numbers.

The derivation of 'irrational' is 'ratio'. This term means a quantifiable relationship between two similar magnitudes expressed as the number of times one contains the other either integrally or fractionally. In order to be defined as 'rational', the ratio must be expressible in whole numbers.

Modernism professed to be driven partly by logic. The common understanding of the term 'irrational' is 'illogical'. Design is, however, also concerned with beauty, and proportion is an important consideration in designing a grid. Designers, from the Greeks to Le Corbusier with his Modulor Man, have looked towards nature and the mystical aspects of geometrical construction for inspiration. In particular, the formula of the golden section has been applied in all areas of design.

The grid	What	Why	How
	What is a grid?	Why use a grid?	**How to think about grids**
			Asymmetry v symmetry
			Geometry v maths
			Creating a grid

into infinity...

To find the section

It is possible to draw
a golden rectangle using
a compass and set square.
Draw a right-angle. Place
a compass in the right
hand corner and draw an
arc to find a square. Draw
a vertical line through the
centre of the square. Place
the point of the compass
where this line hits the
baseline and draw a
further arc to find the
left hand vertical of the
golden rectangle.

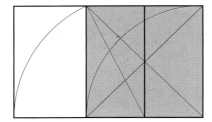

draw a line

subdivide it using the ratio
1(a):1.618(b)
this gives you the golden section

to make a golden rectangle the short edge will be
(b)
and the long edge will be
(a)+(b)

The mystical aspect of this proportion
is that the ratio of a:b is the same as b:(a+b)
and that further subdivisions will repeat
the ratio indefinitely. For example:
A 50mm line (c) subdivided 1:1.618 gives
(a)19.099: (b)30.901

If we add
(b)30.901 to (c)50
to arrive at (d)80.901
the ratio between
(c)50 and (d)80.901
is the same as
(a)19.099 to (b)30.901
In both cases the ratio is 1:1.618

Alternatively
if we subtract
(a)19.099 from (b)30.901
to arrive at (e)11.802
we find that
the ratio between (b):(a) is 1:0.618
and so is the ratio (a):(e)

The golden section

The repetitive nature of the golden section
formula makes it instantly appealing and
intriguing. This fascination is rooted in
a belief that there must be an order to the
chaotic world in which we live and that,
once discovered, humans have a key to
the perfect solution.

Grids are fundamentally about proportions,
and since the first books were printed, the
golden section has been used to arrive at
an ideal relationship between the page and
the type within it. However, its influence in
history is greater than this. In Greece, the
master planner of the Acropolis and the
architect of the Parthenon both employed
this formula. Fra Luca Pacioli made an early
reference to it in 1509 in a book tellingly
titled De Divina Proportione, which contained
drawings by Leonardo da Vinci. It was
probably Leonardo who first called it the
sectio aurea, Latin for the golden section.

While the mysterious nature of this repeating
ratio is fascinating, to any mathematically
orientated designer with a fondness for whole
numbers, it is irrational and dysfunctional.

The proportions of the classical book were
often based on the golden section, but its
requirements were for one or two columns
of type per page. Any attempt to construct
a more contemporary multiple-column layout
using these principles becomes impossible.

When
Early printing and standardisation
The first symmetrical page
The need for asymmetry
The Arts and Crafts Movement
The early twentieth century
The Bauhaus
Jan Tschichold
Swiss typography

The grid

What
What is a grid?

Why
Why use a grid?

How
How to think about grids
Asymmetry v symmetry
Geometry v maths
Creating a grid

1:1·618033988 7
800 700 600 500 400 300 200 100

These developments occurred in the last decades of the nineteenth century against a background of generally poor design. This situation produced a reaction among thinkers and designers, leading to various movements that sought better standards in Britain, the US, Germany, Austria and elsewhere in Northern Europe. The most notable of these in Britain was the Arts and Crafts Movement, with William Morris as the prime activist. Those involved believed that there was an indivisible link between usefulness and beauty. Morris' followers placed a great deal of emphasis on making by hand. However, the idea that form could relate to function without being visually unattractive also impacted on the quality of printed design produced in quantity through new technologies.

Although still centred, there was a move towards simpler and less cluttered layouts. There was also an increased awareness of proportion and space, with greater consideration of the relative sizes of margins, text areas and overall format. The golden section, for example, was much favoured as a basis for achieving good margins. It came to be felt that the design of a book should be transparent, and not intrude between author and reader, while still giving aesthetic pleasure in its own right. All these efforts ran in parallel with the rise of the modern movement, which, despite having different aims, was also interested in notions of simplicity, clarity and usefulness.

above
The golden section ratio to 1,710 decimal places.

The Fibonacci sequence
The golden section still finds great favour with designers who look to the natural world for inspiration and believe that truth and beauty should be derived from it. The number progression at its heart, which involves adding two numbers to arrive at the next in the sequence, is also found in nature, as identified by Fibonacci in his book of 1202, The Book of Calculating. The 1(+1), 2(+1), 3(+2), 5(+3), 8(+5) etc progression is found within many natural forms, from leaf formations to shell structures. Not surprisingly, it is also used to derive the margins of the classical page.

A typical symmetrical spread. Type is justified to the column width. The format is based on the golden section and the margins use the Fibonacci sequence. The relative proportions are: inner margins of three units, top and outer of five and bottom of eight.

When
Early printing and standardisation
The first symmetrical page
The need for asymmetry
The Arts and Crafts Movement
The early twentieth century
The Bauhaus
Jan Tschichold
Swiss typography

Cubism

While the effects of the Arts and Crafts and related movements were still active, a great revolution was brewing in Europe that would fundamentally alter the course of the visual arts and architecture.

At the start of the twentieth century, Picasso and Braque were experimenting with Cubism, exploring the third dimension in new ways on a two-dimensional plane. In the second phase of Cubism, forms became more abstract and painted or montaged lettering started to enter many compositions. Found elements thus became part of a new exploration of the representation of experience. Cubism heralded many experimental forces that became the foundation of the modern movement.

Futurism, Dadaism, Constructivism, Surrealism, Suprematism and Expressionism all contributed to this revolution, united by a desire to break with the past and come to terms with a civilisation based on industrialisation and ever faster communication. Nevertheless, there were differences between them. Some saw the future of art and design as a reflection of the technical developments of the time, others as a means to greater intuitive expression.

These movements all recognised the power of words and the vital role that typography plays in presenting messages effectively. They paid little heed to the craft aspects of printing and pushed compositors to the limit by breaking with the vertical and horizontal nature of type. The effect of the printed image mattered, not how it was produced.

Despite the First World War and the Russian Revolution, artists and designers travelled, spreading these ideas rapidly throughout Russia, Poland, Holland and Germany. Among those who made enduring contributions to modern typography were El Lissitzky and Rodchenko, the former moving in and out of Russia on several occasions.

The grid

What
What is a grid?

Why
Why use a grid?

How
How to think about grids
Asymmetry v symmetry
Geometry v maths
Creating a grid

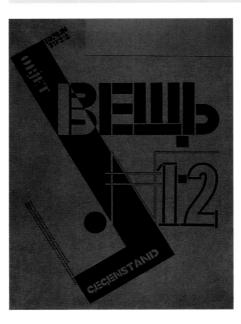

Illustration for El Lissitzky's own book, BEM6, 1922.

Width to height ratios

Designers sometimes refer to using 'root two, three or four' rectangles and the different properties derived from their geometrical construction. A root two rectangle has the same width to height ratio as the two rectangles formed if halved. A root three rectangle has the same width to height ratio as the three rectangles formed if divided into three. A root four rectangle has the same width to height ratio as the four rectangles formed if divided into four, and so on.

Apart from a root four rectangle, which is essentially two squares on top of each other and therefore has a width to height ratio of 1:2, the numbers of all the other rectangles' width to height ratios are uncomfortable. The ratio for a root two rectangle, for example, is 1:1.414 and for root three 1:1.732. These seemingly uncomfortable numbers are unimportant because of the significance placed on their construction.

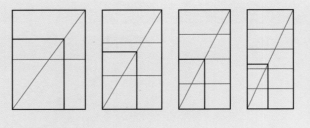

Root two, three, four and five rectangles. All of these rectangles have something in common while having completely different characteristics. If a root two rectangle is folded in half, as shown, the two rectangles formed will have the same proportions as the original rectangle. Similarly, if a root three is divided into three, each new rectangle retains the proportions of the original. This principle is explained in further detail in Peter Gill's case study on page 96.

When
Early printing and standardisation
The first symmetrical page
The need for asymmetry
The Arts and Crafts Movement
The early twentieth century
The Bauhaus
Jan Tschichold
Swiss typography

The grid **What** **Why** **How**
 What is a grid? Why use a grid? **How to think about grids**
 Asymmetry v symmetry
 Geometry v maths
 Creating a grid

Futurism

Marinetti's Manifesto of Futurism first appeared in Le Figaro newspaper, France, in 1910. It outlined a new approach to art and design and welcomed the age of the machine with power and speed at its centre. Abstract painting was seen to have much in common with typographic composition. Futurist typography set words at conflicting angles with violent contrasts in size and weight of type. Space became an active element.

Dadaism

Founded in Zürich in 1914, Dadaism used ridicule and irony as its weapons to oppose what its members believed was a corrupt society full of absurdity and hypocrisy. Their typography reflected these ideas, both in content and display. Like the Futurists, strong contrasts and abrupt changes in direction of type were key elements in their design. Kurt Schwitters initially supported the movement in the periodical Merz, which he edited and designed. He became a major influence through his work using the technique of collage.

De Stijl

In 1917, Theo van Doesburg founded De Stijl in Holland, a movement that included the painter Mondrian among its number. Influenced by Constructivism, it was characterised by strong geometry built upon the rectangle, with colours limited to black, white and the primaries. Most early modern typography had been limited in application to the propaganda of a movement, but De Stijl's influence was broader. Designers like Piet Zwart and Paul Schuitema used these principles to produce commercial advertising and publicity, introducing photography as the main method of illustration.

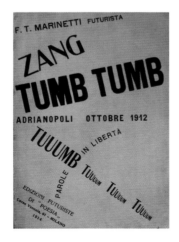

Cover from Zang Tumb Tumb, 1912, by FT Marinetti and published by Futurist publisher in 1914.

The 'A' paper sizes use root two rectangles. An A0 sheet is shown below subdivided to A7.

It is possible to use 'A' sizes to form differently proportioned pages while still being economic. Below right, an A2 sheet is subdivided into six. This gives a page size of 210 x 198mm.

An 'A' size can also be subdivided to form more unusual page proportions. On the far right, an A2 sheet is subdivided into 12 pages, each measuring 210 x 99mm.

Standardised formats

The shape of the publication is determined by a combination of use, economics and commonly available paper sizes. For the true modernist, believing in standardisation and ease of mass production, working with European 'A' paper sizes is extremely logical. Designers who want to usurp the system, but remain economic, will often subdivide them to achieve more unusual shapes and sizes.

The 'A' paper sizes are all root two rectangles, and this is undeniably an extremely clever system. A0 if folded in half becomes A1, A1 becomes A2 and so on, while all maintaining the same width to height ratio. This means that there is little waste and that a unity of proportion can be maintained across a variety of different sized publications.

The negative side of this system is that the actual measurements do not appear to relate to anything other than themselves and so may result in some peculiar measurements for margins.

When
Early printing and standardisation
The first symmetrical page
The need for asymmetry
The Arts and Crafts Movement
The early twentieth century
The Bauhaus
Jan Tschichold
Swiss typography

In 1919, Walter Gropius, an architectural modernist, was appointed director of a new school of art and design in Weimar, Germany. He called it the Staatliches Bauhaus and it was to become the most important school of design in Europe during the following decade.

De Stijl was a strong influence, although Gropius believed in individual creativity rather than one imposed style. Central to his philosophy was a belief that architecture, painting, sculpture, graphic art, industrial design, typography and photography should be interdependent parts of a whole. He also believed that a basic education in the visual arts should include craft training to impart skills and develop judgement. He appointed Paul Klee, Wassily Kandinsky and Laszlo Moholy-Nagy to give impetus to these intentions.

In 1925, political change led to a move from Weimar to a purpose-built school in Dessau, the architecture of which reflected the school's design philosophy. Gropius appointed Marcel Breuer, Josef Albers and Herbert Bayer, who ran the typography workshop. A desire to see the visual arts linked to industry, in order to improve life in modern society, became a clear objective.

Herbert Bayer gave Bauhaus typography greater consistency than that emanating from other areas of the modern movement. He also paid closer attention to the detail of text matter and its layout on the page. The drama and strength of new typography were thus directed towards answering everyday problems, and were no longer mainly a means to startle and arouse the reader. Asymmetry itself was used to order and clarify verbal content. Bayer also explored notions of minimalism. He believed that it should be possible to communicate effectively using only one font, in a variety of weights, and that capital letters were unnecessary. The simplicity of sans-serif also seemed more appropriate to an industrial age.

In 1938 Bayer left Germany for the US, where he and other refugees began to influence American art and design.

The grid

What
What is a grid?

Why
Why use a grid?

How
How to think about grids
Asymmetry v symmetry
Geometry v maths
Creating a grid

abcxyz abcxyz
abcxyz abcxyz

Advertisement showing inside pages from the magazine Bauhaus Magazine for Design, designed by Herbert Bayer and published by Bauhaus-Printers in 1928.

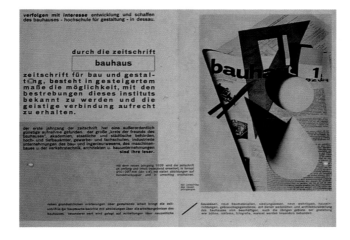

The basic principle of a baseline grid is that the measurement from baseline to baseline is subdivided, usually into three or four. This smaller unit will be used to determine all paragraph spacing, spacing around headings and relative type sizes.

Shown below is the comparative size of text to caption, both using the same baseline grid. The x-height is also identified, in magenta.

The baseline grid

The baseline grid is a series of horizontal lines running across the page. Each line represents a possible baseline of a line of type. The baseline of type is the line on which the bottom of capital letters sit. The space between baselines is determined by the size of type plus the extra space between each line of type, traditionally called the 'leading'.

In order to develop a system that gives maximum flexibility, the unit of the baseline grid is usually smaller than the measurement from baseline to baseline of the text type size. The starting point can be the caption type.

For example, imagine that the captions are in seven-point type and that these have two extra points between each line, giving a baseline to baseline measurement of nine points. In order to develop a system that is easy to use, and gives typographic alignments where possible, the type area is divided into a small unit that relates to nine points but also gives the possibility of a flexible system. A three-point baseline grid would be appropriate. The main text size could be nine point with three extra points between lines giving a twelve-point baseline to baseline, also divisible by three. This baseline unit of three points is then used to develop a hierarchical spacing system; headings may have an extra six points above them and three after them, for example.

In first setting up a baseline grid, it is important to consider where you will be first measuring the type from. Some designers consider the 'x-height', the height of the lower case x, to be the visually strongest point, while others consider the top of the column to be the top of the first capital letter.

When
Early printing and standardisation
The first symmetrical page
The need for asymmetry
The Arts and Crafts Movement
The early twentieth century
The Bauhaus
Jan Tschichold
Swiss typography

The grid

What
What is a grid?

Why
Why use a grid?

How
How to think about grids
Asymmetry v symmetry
Geometry v maths
Creating a grid

The other typographer of immeasurable importance in this period was Jan Tschichold. During the early 1920s, he contributed various articles to German technical publications. In these, he demonstrated the underlying principles of asymmetric design and began to systematise the approach to typographic structuring. His book, Die Neue Typographie, was published in 1928 and was the summation of his thinking to that time.

Although he was not a member of the Bauhaus, he taught for Paul Renner in Munich. He became a powerful advocate of modern typography, and showed in understandable ways how it could be applied to everyday design problems. Tschichold smoothed away the rough edges of modern typography, and much of his own work possessed a convincing sense of inevitability, as well as fastidious concern with the small details. Like Bayer, he considered sans-serif type best suited to the purposes of modern typography, and also designed a single alphabet sans-serif font.

In 1933 Tschichold was accused by the Nazi regime of promoting typography unsuited and damaging to the needs of the new German state. He was dismissed from his teaching post and left Germany to seek shelter in nearby Switzerland. There he became a teacher at the School of Arts and Crafts in Basel, as well as an advisor to the publisher Benno Schwabe. His book, Typographische Gestaltung, was published in Switzerland in 1935, and an exhibition of his work was mounted in London in the same year. He received commissions for work in England, including the design of the 1938 Penrose Annual, and spoke to the Double Crown Club on A New Approach to Typography in 1937.

It is ironic, then, that in the late 1930s Tschichold began to see his highly system-atised work as an unconscious reflection of the rigidly ordered societies under Fascist governments. He gradually turned towards the classicism and symmetry that he had formerly attacked so vehemently.

A spread from Tschichold's influential book, Die Neue Typographie, first published in 1928.

Grids can also be designed to accommodate vertical type, in this case a heading. Emphasis can be given to text by using a wider measure than is generally being used.

The column and the field

Vertically, the page is split into margins and columns. Horizontally, the page is split into a baseline grid with top and bottom margins. In addition, the page can be divided into larger horizontal units to form fields.

The smallest column may contain captions, but two or three of these columns joined together may contain the text. It is important to consider how many words of text occupy one line, as very long lines can be harder to read. It is preferable to make the smallest column of the grid measure in whole or half millimetre units. The combinations of columns will then be easy to add up. The space between columns – the intercolumn space – is generally four or five millimetres for similar ease of use.

Some designers work with two or more different grids placed on top of each other. This gives unusual spaces in which to drop captions, footnotes or other extraneous matter, but can be harder to work with mathematically.

One of the distinguishing features of the Swiss grid system was the use of fields. The depth of a field is usually a multiple of baselines. These horizontal divisions of the page are often used to give hanging heights for images.

The margins

Sometimes, if the grid uses fairly small columns, one or more are left blank to give a consistently large left or right margin; alternatively, large margins can be part of the basic grid structure. Extremes of all kinds make the page more visually dramatic, so a tight margin at the top, or head, of the page may be contrasted with a very large margin at the bottom, or foot.

Left and right margins are generally specified in millimetres, while top and bottom can be specified in either points or millimetres.

When
Early printing and standardisation
The first symmetrical page
The need for asymmetry
The Arts and Crafts Movement
The early twentieth century
The Bauhaus
Jan Tschichold
Swiss typography

The grid

What
What is a grid?

Why
Why use a grid?

How
How to think about grids
Asymmetry v symmetry
Geometry v maths
Creating a grid

By the early 1940s, the revolution in visual art had changed the direction of typography. Classicism was still alive in much book design. However, display typography in advertising and publicity had been liberated by the use of contrast, dynamic movement, balance achieved through asymmetric placing of elements in space, unification of the message and its typographic expression, and the acceptance and powerful use of photography for illustration. In addition, new and more direct ways of delivering statistical and technical information were being explored, often with a strong abstract bias.

During the Second World War, Switzerland was neutral and therefore continued to have contacts with protagonists from both sides. The country became a haven for intellectual refugees, many of whom had suffered oppression under Fascism. A major strength of Swiss graphic design was the blending of influences from the German, French and Italian members of the population. While most European countries were either at war or were occupied, Switzerland was able to continue most peacetime activities, including design for promotional materials, cultural events and packaging.

In many ways, the refined modernism of Tschichold was very suited to the ordered lifestyle of Switzerland, where a relatively large population lived in a small land area, much of which is mountainous. Swiss industries were already highly developed and technically advanced. In the years between 1939 and 1946, the Swiss design schools and many practitioners continued to promote modern typography, building on the work of Tschichold and other refugees. Many Swiss designers, including Max Bill, Hans Erni and Celestino Piatti, also had reputations as fine artists. This combination often resulted in an experimental approach to typographic layout.

The grid

What
What is a grid?

Why
Why use a grid?

How
How to think about grids
Asymmetry v symmetry
Geometry v maths
Creating a grid

Karl Gerstner's 58-unit grid. A complex but extremely clever system whereby different multiples give two, three, four, five and six column structures.

58 units divides as follows:

one intercolumn space of two units, two columns of 28 units

two intercolumn spaces each of two units, three columns of 18 units

three intercolumn spaces each of two units, four columns of 13 units

four intercolumn spaces each of two units, five columns of ten units

five intercolumn spaces each of two units, six columns of eight units

A classic example

While these basic principles are simple and straightforward, ultimately a grid is as interesting and flexible a tool as the designer chooses to make it. If it is not paradoxical, the grid shown by the Swiss designer Karl Gerstner is a classic example. The grid, or 'matrix' as he called it, was designed in 1962 for the periodical Capital. The journal included texts and tabular information illustrated with photographs and illustrations. Gerstner's grid best demonstrates the use of fields and a multicolumn structure that allows for infinite variation.

The smallest unit is ten points, which is the baseline to baseline measurement of the text type. The main area for text and images on a page is a square, with an area above designated for titles, running heads etc. This square area is then subdivided into 58 equal units in both directions. If all intercolumn spaces are two units, a two, three, four, five or six column structure is possible without there being any left-over units.

In diagrammatic form, this may at first seem complicated. However, the mathematics are very simple – and clever. Here is a structure to satisfy and intrigue any designer who is interested in the principle of the grid.

When
Early printing and standardisation
The first symmetrical page
The need for asymmetry
The Arts and Crafts Movement
The early twentieth century
The Bauhaus
Jan Tschichold
Swiss typography

The grid **What** **Why** **How**
What is a grid? Why use a grid? How to think about grids
 Asymmetry v symmetry
 Geometry v maths
 Creating a grid

The use and development of grid structures was one of the important aspects of graphic and typographic design that occupied theorists and practitioners. This seems to have been done in a very thorough way, going beyond the simple desire to make the arranging of type, charts, tables and illustrations into a logical procedure. As a result, once peace returned and contacts were reopened, the whole appearance of much Swiss design came as something of a revelation to students and designers worldwide. This impression was further enhanced when Swiss design journals became available, notably Walter Herdeg's Graphis. The Swiss content was always impressive in its combination of brilliant presentation with functional efficiency.

The idea of using grid structures to contain and unite all elements of a design seemed exciting and inevitably right. The Swiss preference for sans-serif types in much of the work was also attractive to post-war eyes. It seemed appropriately modern and rational.

Many designers contributed to the widespread application of grid structures, but there is little doubt that the publication, in 1961, of Josef Müller-Brockmann's book, The Graphic Artist and his Design Problems, gave a new direction to the teaching of graphic design. He demonstrated that intellectual analysis was very important, even when a solution required intuitive input. He also explored the application of grids to a wide range of problems, simple and complex, in two and three dimensions. After the publication of this book, many young designers felt that grids had almost mysterious qualities. This could be explained in part by the way in which space could be given value and point for its own sake, while being part of the whole scheme of a layout.

The following generation continued to explore grid systems, and with the advent of layered design, made easier by the computer, grid structures became very complex. Today grids are widely employed by most typographers and can sometimes be used with dazzling finesse.

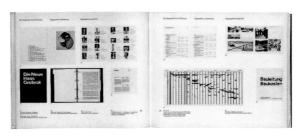

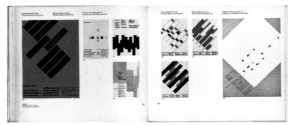

Spreads from Josef Müller-Brockmann's book, The Graphic Artist and his Design Problems, published in 1961, in which he demonstrated the use of a variety of grids. This book became an influential teaching tool within graphic design.

Further reading

Hans Rudolf Bosshard
The Typographic Grid
Verlag Niggli
2000

Arthur A Cohen
**Herbert Bayer:
The Complete Work**
The MIT Press
1984

Karl Gerstner
**Review of 5 x 10 Years
of Graphic Design etc**
Hatje Cantz Verlag
2001

Armin Hofmann
**Graphic Design Manual:
Principles and Practice**
Van Nostrand Reinhold
1965

Richard Hollis
**Graphic Design:
A Concise History**
Thames & Hudson
2001

Gyorgy Kepes
**Structure in
Art and Science**
Studio Vista
1965

Robin Kinross
**Modern Typography:
An Essay in
Critical History**
Hyphen Press
1994

John Lewis
**Typography:
Basic Principles**
Studio Books
1963

Editors Ellen Lupton
and J Abbott Miller
**The Bauhaus and
Design Theory**
Thames & Hudson
1993

Editor Lars Müller
**Josef Müller
Brockmann: Pioneer of
Swiss Graphic Design**
Lars Müller Publications
2000

Josef Müller-Brockmann
**The Graphic Artist and
his Design Problems**
Arthur Niggli
1961

Josef Müller-Brockmann
Grid Systems
Verlag Niggli
1996

Herbert Read
**The Philosophy
of Modern Art**
Faber & Faber
1964

Emil Ruder
**Typography:
A Manual of Design**
Arthur Niggli
1967

Herbert Spencer
**Pioneers of Modern
Typography**
Lund Humphries
1982

Erik Spiekermann
and EM Ginger
Stop Stealing Sheep
Adobe Press
1993

Editor Nikos Stangos
Concepts of Modern Art
Thames & Hudson
1985

Jan Tschichold
Asymmetric Typography
(first publication in English)
Faber & Faber
1967

Jan Tschichold
The New Typography
(first publication in English)
University of
California Press
1999

From gridlock to sonnet structure, electricity to politics, dentistry to hopscotch: a journey down London's Oxford Street to explore the omnipresence of the grid.

photography
Andrew Penketh

f7
Advertising
It is claimed that ads that move are 51 times more likely to be seen than those that don't. All posters have to be the same size in order to make this possible.

a2
Air conditioning
Such is the desire to control the natural environment that humans have devised systems for regulating the humidity, ventilation and temperature in a building or vehicle.

g6
Battenburg cake
Battenburg cake, a grid of pink and yellow sponge wrapped in marzipan, seems to be a very English delicacy, despite being named after a family of German counts. Although there is something endearingly old-fashioned about it, it clearly remains very popular – in 1999 alone, the cake-makers Mr Kipling made 36 million Mini Battenburgs.

c2
Bricks
To the casual observer, one brick looks much like another. There is, however, an enormous range of shapes, sizes and patterns of brick-laying, called 'bonds'. The type of brick used in a building, and the pattern in which it is laid, are often unique to a particular time or place. Generally speaking, the thinner the brick, the older the building.

a5
Carpets
There are two types of carpet, the knotted and the woven. Both are made on a grid of horizontal and vertical lines. The resulting pattern is stepped: just as the square pixel means that you cannot make a true curve in a digital image, the patterns on carpets may appear to be free-form in design but in fact all curves can only be suggested.

g4
Cloth
Even cloth that is printed in spots or swirls is fundamentally a grid. The pattern is printed on top of woven fabric and this has a natural grid structure because of the warp and weft.

f6
Credit card
The credit card is an ambiguous object – a worthless piece of plastic that has been invested with huge value. In many respects it can be seen as the ultimate symbol of modern life: look closely, however, and you'll see that this ubiquitous shape follows an ancient pattern. This is no ordinary rectangle – it has golden section proportions.

e4
Dentistry
London-based dentist Eddy Levin believes the way to create a beautiful smile is to ensure that the relationship between the teeth, when seen from the front, follows golden section proportions. So the central front teeth should be, roughly speaking, golden section rectangles, and the ratio of the width of these teeth to the width of the slightly smaller ones next to them should be the golden section ratio, and so on to the next teeth. Mr Levin believes that a set of teeth that is proportioned this way will result in a smile that is generally thought to be attractive.

f2
Embroidery
The conventional embroidery kit uses a pre-existing grid of canvas. There are holes left by the vertical and horizontal threads of the woven canvas. These determine the positioning of all stitches.

b4
Games
A variety of games was played on some form of grid for centuries – a game similar to draughts was played in 600BC. Perhaps one of the reasons for the enduring attraction of grid-based games is that they are simple enough for children to grasp, yet allow for enormous complexity. It has been calculated, for instance, that there are 255,168 possible outcomes of a game of noughts and crosses.

c6
Globe
A spherical representation of the earth showing its grid of longitudinal and latitudinal lines.

b3
Gridlock
Sam Schwartz, a former New York City chief traffic engineer, claims that he and a colleague, Roy Cottam, were the first to use the term 'gridlock' in 1980 when discussing the implications of closing a street in Manhattan's grid system. Nowadays, while traffic engineers worry about the practicalities of getting the world's 600 million cars from a to b, scientists are increasingly interested in the theory behind gridlock. The maths of getting lots of individual cars around a road network is similar to the maths of getting lots of packets of data around the internet. Oddly, theory indicates that, in some circumstances, adding a new road to the network will increase the chances of gridlock, not alleviate it.

f3
Key-pads
Pocket calculators and push-button phones are relatively recent inventions: someone must have sat down to design the first key-pad and decided that the keys should be laid out in a grid. Given the shape of the human hand, this seems a bit perverse.

d6
Maps
The UK's Ordnance Survey Maps are based on a huge grid system – at the largest scale, the whole of the country is divided into squares of 100 x 100km, identified by two letters. These, in turn, are divided into squares of 10 x 10km, and these are divided into squares of 1km.

e6
Mosaic
The ancient Greeks were the first to use mosaic – made of coloured pebbles – in the third century BC.

g1
National Grid
The 'national grid' is the name given to the high-voltage electricity transmission system in England and Wales. Following privatisation in 1990, this became owned and managed by The National Grid Company plc, which manages 6,985km of overhead electricity cables.

d4
Paving
Whether posh York stone, simple grey slabs, or nostalgic retro-cobbles, our streets are paved with grids.

g7
Poetry
The number of stresses to a line of poetry, coupled with the rhyming scheme, give it both horizontal and vertical structure. The sonnet, a poem of 14 lines, is a perfect example of this. Each line is broken down into five iambic feet. Each foot is an unstressed followed by a stressed syllable. There are a variety of complex rhyming schemes. For example, the Italian sonnet follows the same scheme for the first eight lines and then changes for the last six. This is identified as abba/abba, changing to cde/cde.

f5
Politics
The Grid is a document that acts as a tool for co-ordinating British government announcements across the whole of Whitehall and is given to ministers at Cabinet meetings. It is a restricted document, and so can't be shown here, but it has become mythical in media comment on how British politics attempts to control output to the media across government. The Grid is co-ordinated by the Strategic Communications Unit. Each department negotiates slots for announcements and account is taken of other departments' work, as well as the external media agenda, before agreement is given.

b1
Scaffolding
A temporary structure made of poles and planks erected, usually by builders, on the outside of a building.

b2
Starting grids
Different types of motor-racing use grids in different ways – in Formula One, for instance, the driver's position on the grid is determined by his success in the qualifying round – whoever does best gets pole position on the 'clean' side of the track.

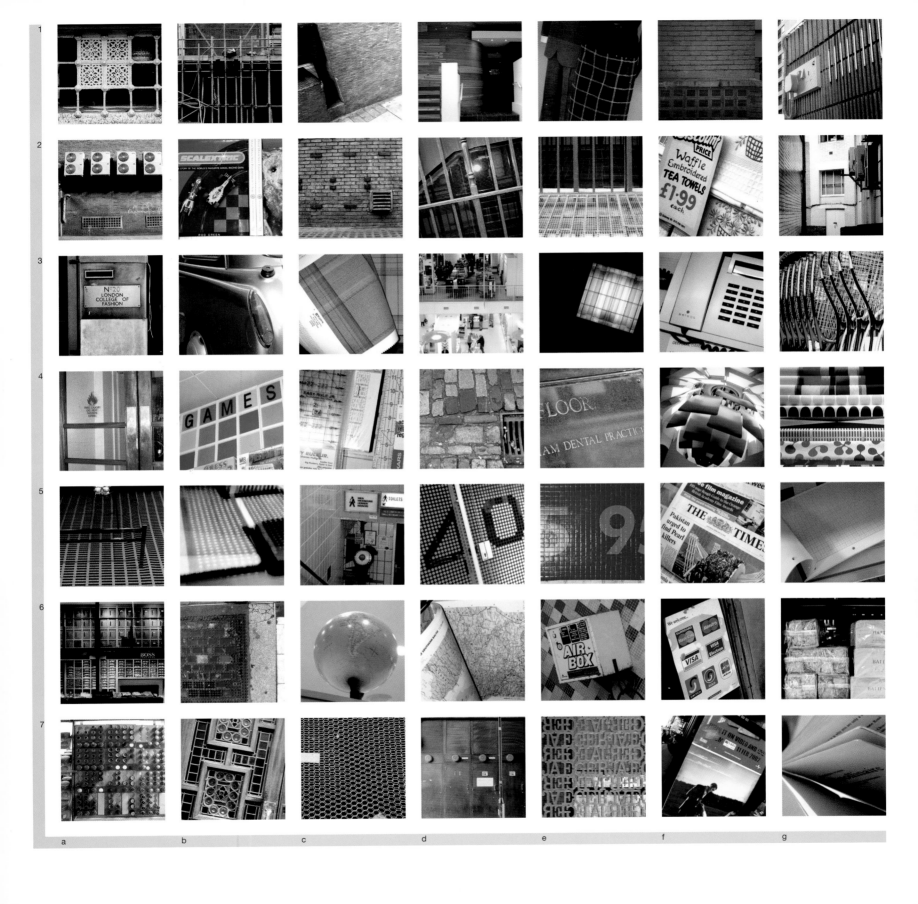

The grid	Principle	Everywhere	Cultural	Psychology	Making	Breaking
	When		Architecture	Wim Crouwel	Control	
	What		Music	Simon Esterson	Precision	
	Why		Furniture design	Linda van Deursen	Measurement	
	How		Fine art	David Carson	Micro/macro	
			Interior design	Peter Gill	Components	
			Screenplays	Krieger \| Sztatecsny		
			Digital design	Cartlidge Levene		
			Town planning	Wendelin Hess		
			Conceptual art	Hamish Muir		
				Ellen Lupton		
				John Maeda		

The designer and the grid
Introduction
The principle of the grid
Grids are everywhere
The grid in cultural context
The psychology of the grid
Making the grid
Breaking the grid
Bibliography/Contacts/Credits/Index

In graphic design, the grid is visible to those who look for it. Often, a layout that to uninformed eyes is a random arrangement of photographs, type and space is seen quite differently once its grid structure has been pointed out. The perceptual shift can be quite dramatic: what had seemed arbitrary suddenly looks immutable.

As the twentieth century progressed, grids became equally prevalent in other areas of culture, although often just as invisible to the uninitiated. As Damian Wayling reveals in his essay on page 56, the structure of film scripts, and the way that the finished film is edited, is more often than not responsive to a time-based grid.

Music, too, is structured according to a grid, to varying degrees. As John L Walters explains on page 42, in traditionally performed music the grid acts as a map or guide, enabling a group of musicians to collaborate, while allowing each freedom of personal expression. With electronic composition, however, the sounds you hear can be precisely aligned to the grid, with each note starting and ending exactly on cue.

Grids have been a feature of town planning for thousands of years – throughout the centuries, people creating new cities from scratch have seen a grid layout as an ideal of civilisation. According to Professor Bill Hillier, however, even the most random-seeming city layout is, to a surprising extent, a grid (see page 68).

Of course, many of the buildings that form a city's layout are themselves often structured by grids. From the modular façades of many tower-blocks, to the three-dimensional Rubik's cube approach to building design, the grid has been an important influence among post-war architects.

However, the most important grid of all is, perhaps, one that is completely invisible, that of latitude and longitude. The artist Tacita Dean, much of whose work has been about the sea, explains what happened to Donald Crowhurst, a sailor who lost his position on this huge, conceptual grid.

As the essays and interviews in this chapter demonstrate, grids are a pervasive influence throughout our culture. We may not always notice them, but their influence on what we see, hear and do is everywhere.

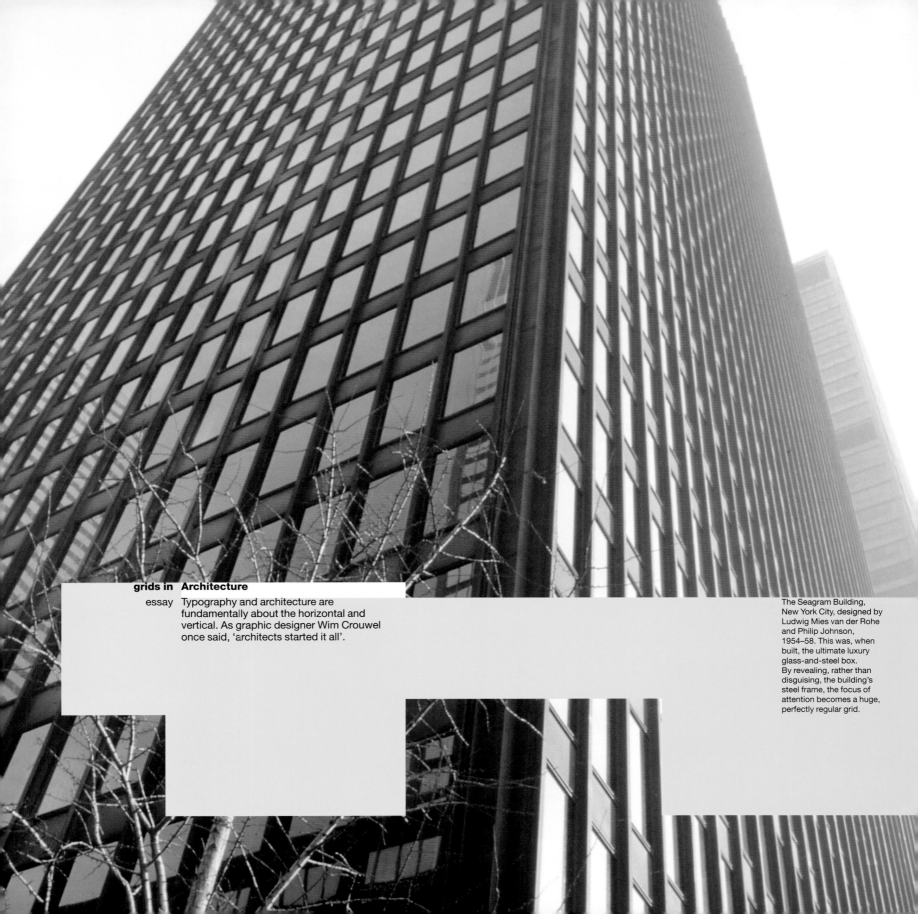

grids in Architecture

essay Typography and architecture are
fundamentally about the horizontal and
vertical. As graphic designer Wim Crouwel
once said, 'architects started it all'.

The Seagram Building,
New York City, designed by
Ludwig Mies van der Rohe
and Philip Johnson,
1954–58. This was, when
built, the ultimate luxury
glass-and-steel box.
By revealing, rather than
disguising, the building's
steel frame, the focus of
attention becomes a huge,
perfectly regular grid.

The practical difficulties of making buildings stand up – and the dire consequences if they fall down – mean that architects have to be extremely sure about what they are doing, however experimental their designs may be.

Calculating the load or stress on a certain part of a structure is complex, and so the design process is made easier if the same element is repeated. Building components are easier and cheaper to design and source if each one is not unique. Consequently, repetition, modularity and symmetry make the process of designing and erecting a building more achievable – they also tend to result in some form of grid.

Some of the earliest and most influential buildings composed of a grid-based design are the Greek Doric temples of around 500BC. The grid was defined by the rows of columns around the structure's edge, which supported the triangular pediments at either end, and the pitched roof that ran between them. The beauty of these buildings lies partly in their proportions, calculated as multiples of the diameter of a single column.

Inspired by Classical architecture, the Renaissance architect Andrea Palladio designed the plan of the Villa Rotonda on a 8 x 8 unit grid. The plan of the building itself, which was symmetrical through two axes, was essentially a 4 x 4 square, but Ionic porticoes and flights of steps built onto each façade added another two units in each direction. Impressive porticoes added visual interest; without them, each façade would have been a simple grid of small windows – far too austere for a sixteenth-century building designed as a display of wealth.

It was not until the twentieth century that a total lack of decoration came to be seen as a virtue in design. As a result of this, the grid, so long a hidden element of architectural structure, began to become more overtly visible. In part, this was driven by social changes, such as a desire for less formal living. It was also partly a reaction against the late nineteenth-century obsession with decoration, which came to be associated with the pomposity and hypocrisy of a divisive and unegalitarian society. Several early modernist designers felt this so strongly that they came to see decoration itself as immoral – in 1908, for instance, the Viennese architect Adolf Loos wrote an article called Ornament and Crime. In part, the emergence of a form of architecture that was unadorned and displayed its structural elements, rather than disguised them, was driven by technology: innovations such as the introduction of steel-frame building techniques and the invention of the lift made possible a totally new approach to architecture.

Many individual designers started to explore the possibilities of the new materials and technologies that were now available to them. However, it took the cataclysm of the First World War – which, in the eyes of many young people totally discredited the previous generation – to make new ideas not only acceptable, but desperately needed. It was in this social and intellectual climate that a radical new school of design, the Bauhaus, opened in Germany in 1919.

During the first few years of its existence, the emphasis at the Bauhaus was on the appreciation of craft skills and ideals. Gradually, however, the focus shifted to an exploration of the potential of industrialised forms of production. Throughout its existence, however, it was the idea that designers should learn through experimentation, rather than through studying and emulating the past, that made it so very different from other design schools. Underpinning this was the egalitarian belief that the new technologies and ideas should be used for the greater good of society and not just the wealthy.

In 1925, when the school moved from Weimar to Dessau, its director, Walter Gropius, designed a new building that to contemporary eyes must have seemed brutally unadorned. Flat-roofed, it had strong horizontal elements formed by a slab of concrete at first floor level and another forming the roof: between these two was nothing but a huge, uninterrupted grid of panes of glass, behind which lay three storeys of the building. Because the building's weight was supported by interior columns, the exterior walls did not need to be strong and so could be made of glass. By exploring new technologies and materials, Gropius had helped create a new form of architecture in which large buildings could be made to look lightweight, transparent, almost as if floating above the ground, rather than solid, dense and massive. Coincidentally, it was also the creation of an architecture that stripped away all decoration to reveal, and celebrate, the structural grid beneath.

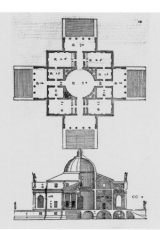

left
Plan of Palladio's Villa Rotonda, Vicenza, 1550–69. The building is designed on a 4 x 4 unit grid; if you include the steps it becomes an 8 x 8 grid. The elevation, without the portico on each side, would be simple grids of windows.

right
North-westerly view of the Bauhaus, Dessau, designed by Walter Gropius, 1926. With its glittering glass curtain wall and clean grid-structure façade, the building is a solid and permanent advertisement for a school that was in a constant state of flux.

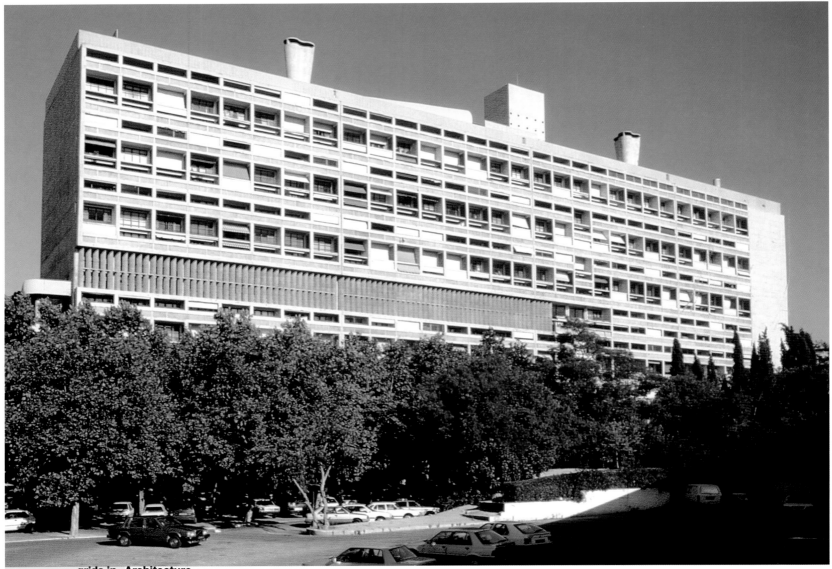

grids in Architecture

Unité d'Habitation, Marseille, designed by Le Corbusier 1947–52. The complex articulation of the three-dimensional façade is the result of a grid based on the Modulor system of measurement, and a desire to balance privacy with communal living.

At the same time that Gropius was designing the new Bauhaus building, another architect was creating an equally radical – but far less public – building in Utrecht. It was a semi-detached family house. It wasn't even built of concrete – an excitingly modern material in 1925 – as Gerrit Rietveld and his client and co-designer Truus Schroder couldn't afford it. Instead, they made do with brick, plastered to look like concrete. Nevertheless, the Schroder house is one of the first truly modern houses, designed as a series of intersecting planes, with ribbon windows and sliding interior walls that allow light, flexible living spaces. Rietveld was fascinated by the idea of standardisation, and although the Schroder house was a one-off, he hoped that in its modularity and flexibility it contained useful ideas that could be applied to mass housing schemes.

During the 1920s, Le Corbusier was also creating innovative houses that were designed for a new, less formal lifestyle. The majority of Le Corbusier's buildings were designed with the help of grids, usually both in plan and section. However, to see his designs as being only generated by grids would be to drastically underestimate the richness of his work. In early buildings, such as the Villa Stein de Monzie of 1926–27, the grid and the golden section can be seen as being superimposed on each other. Looking at the garden façade, we see the verticals of the grid using multiples of a single unit in the sequence 2/1/2/1/2. With regard to the golden section, the giveaway is the slope of the ramp: this, and the diagonal from the top corner of the building on one side, down to the bottom corner on the other side, form the diagonals of golden section triangles.

In later buildings, however, the synthesis of grid and golden section is far more subtle. In 1950, Le Corbusier published a description of what he called the Modulor system. This was a system of measurements and proportions generated from the human form. Inspired by the idea that the most successful manmade objects – the fountain pen, the typewriter, the telephone – had designs that evolved from the dimensions of the human form, he decided to work out a system that would enable buildings to be created in a similar way. By basing his buildings on the Modulor system, he would ensure that they always felt human in scale. The Modulor system, however, was generated by taking the measurements of what he assumed to be the 'standard' human stature of 1.83 metres and then applying the golden section ratio of 1:1.618 in various ways. Golden section proportions are therefore intrinsic to the Modulor system.

The Unité d'Habitation, built in 1947–52, is perhaps Le Corbusier's most notable synthesis of grid and golden section. The Modulor system was used to determine the dimensions of the building from the micro to the macro scale. Looking at the façade, the syncopated rhythm of the grid structure is immediately visible: what is not visible, however, is the fact that the proportions of the grid itself were inspired by a combination of the scale of the human form and the golden section. Consequently, the word 'Unité' can be understood in two ways. Not only does the building unify a variety of different functions – housing, shopping centre, gymnasium and so on – but the building itself is unified because every element is in proportion, and in proportion with the people who use it.

Le Corbusier's contemporary, Ludwig Mies van der Rohe, had been the last director of the Bauhaus before it closed in 1933. In 1937 he moved to the US, taking with him many of the ideas developed at that school – although, it seems, not its egalitarian idealism. By the 1950s, he was refining his ideas about technology, form and function to create increasingly monumental skyscrapers for wealthy corporate clients. His 1958 Seagram headquarters in New York, designed with Philip Johnson, is praised for its exquisite proportion and detailing. By day, it is a glossy slab; by night, illuminated from within, it is a delicate, three-dimensional grid. Impressed by the powerful, modern image that the building gave the Seagram Corporation, many other companies commissioned other architects to create similar – but usually far less sophisticated – blocks for their own headquarters. Within two decades, the world's cities were peppered with dreary, gridded slab blocks, until what began as a radical exploration of form, function and technology became a dull architectural cliché. Modernism, which had started with such strong egalitarian ideals, was now beginning to be seen as little more than a slick style for wealthy, power-hungry corporations. The idea that ornament was morally dubious had long ago been replaced by a feeling that architects, with their insistence on creating unadorned blocks with severe gridded façades, were little more than aesthetic dictators.

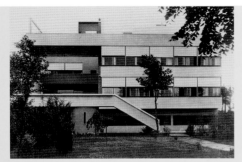

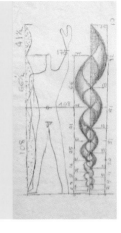

left
Villa Stein de Monzie, 1926–27, south elevation. Le Corbusier had fun with geometric games here: the ramp forms part of a golden section triangle that cuts through the grid formed by the ribbon windows. This diagram of the south elevation shows the complex relationship between the golden section and the grid.

right
Le Modulor, Le Corbusier's system of measurement, was created to ensure that buildings suited human dimensions. Modulor Man, the archetypal man used by Le Corbusier to calculate these dimensions, had a height of 266cm from the top of his outstretched hand to the ground.

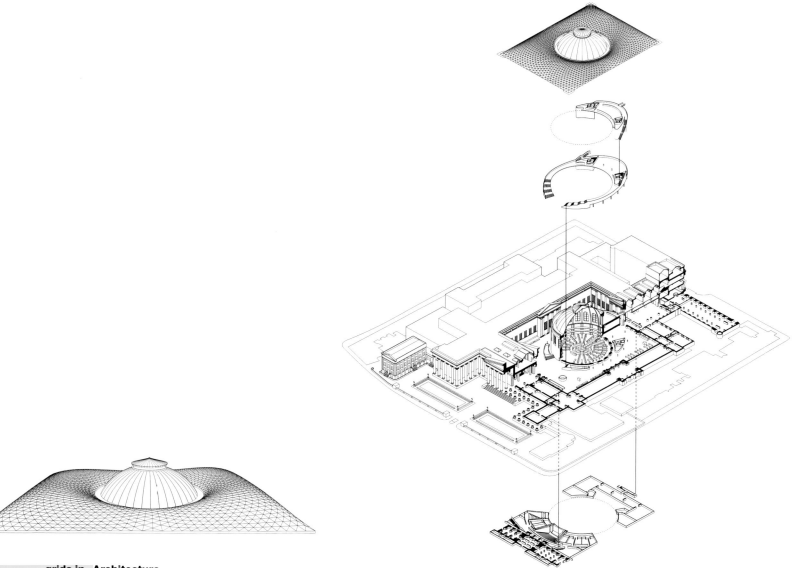

grids in Architecture

above
Wire frame diagram
of the new roof over the
Great Court, British
Museum. The grid of 3,312
triangular glass panes that
forms the roof looks very
regular, but each pane of
glass is a slightly different
shape. Before computer-
aided design, calculating
the shapes of the panes
of glass would not have
been possible.

above
Exploded axonometric
of the Great Court,
British Museum, showing
the integration of old
and new.

right
General interior view
of the Great Court
and Reading Room,
British Museum in
London designed by
Foster & Partners.

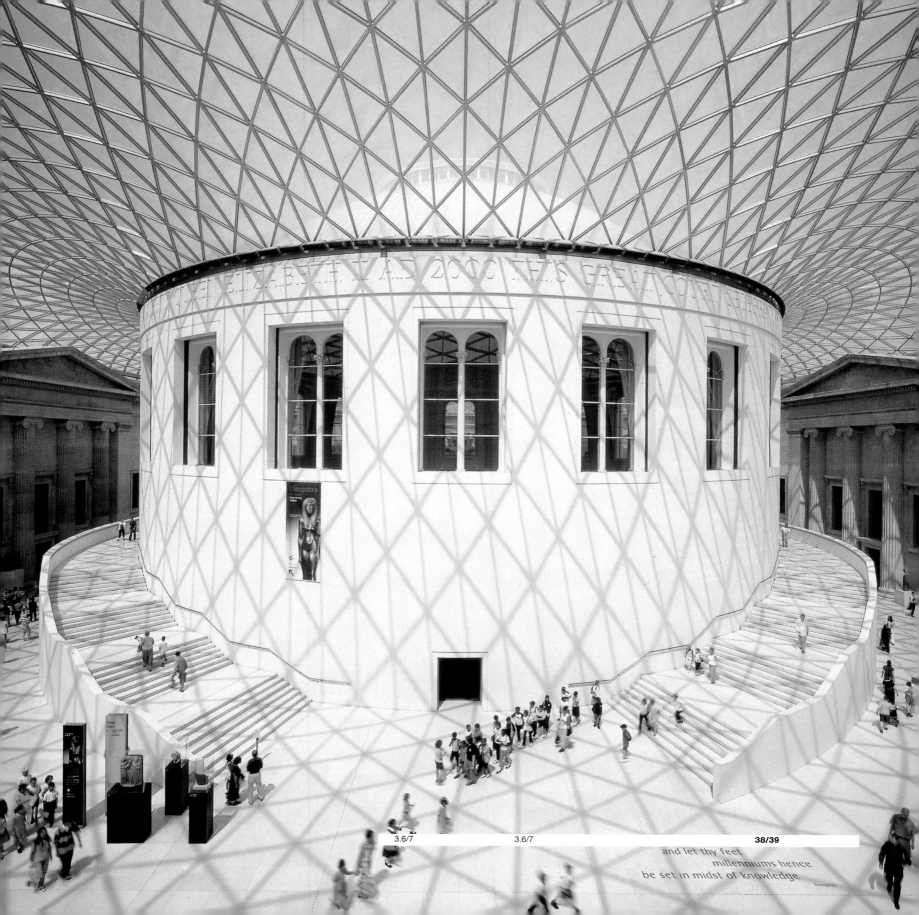

and let thy feet
millenniums hence
be set in midst of knowledge

The strength of feeling against modernism – and against architects in general – can be appreciated from author Tom Wolfe's seminal book, From Bauhaus to Our House, published in 1983. 'Every child goes to school in a building that looks like a duplicating-machine replacement-parts wholesale distribution warehouse,' he wrote. 'Not even the school commissioners, who commissioned it and approved the plans, can figure out how it happened. The main thing is to try to avoid having to explain it to the parents.'

Of course it wasn't just in architecture that the hegemony of modernism was being questioned. Throughout society, long-held beliefs – such as the idea that 'experts' always know best, or that one form of cultural expression (such as opera) is self-evidently 'superior' to another (such as pop music), or the idea that one interpretation of events is 'truer' than another – were being undermined as postmodernism began to seep into the many ways in which we try to understand the world.

Architects responded to this challenge with what at first seemed like a very refreshing dose of humour. It's not that they abandoned the grid: they simply layered some entertaining bits and bobs on top of it. In the case of New York's AT&T building, designed by Philip Johnson and John Burgee and completed in 1982, they quite literally stuck a classical-style pediment on top. The result was an otherwise undistinguished skyscraper office block that was immediately world-famous. For decades architects had, it seemed, been designing buildings that only other architects could understand. Now they were using their buildings to tell visual jokes that anyone could get.

The problem with buildings, however, is that they hang around for years. Jokes, on the other hand, tend to become tedious after a very short time. A few of the very best architects created sophisticated and enduringly interesting postmodern buildings; the many who followed, sticking ill-proportioned pediments here and functionless columns there, created buildings that were little more than a tacky mish-mash of competing styles.

In recent years, there has been a return to an architecture that often looks very much like mid-twentieth-century modernism, yet in many ways is subtly – and sometimes profoundly – different from what went before. One reason for this is that technology has moved on. In particular, powerful computer-aided design programs enable architects to create buildings that simply could not have been done before because the calculations, or manufacture of components, would have been too complex.

The Great Court at the British Museum in London, for example, designed by Foster & Partners and completed in 2000, has been created by putting a curved glass roof between the round, drum-like Reading Room and the buildings that create the rectangular courtyard in which it sits. Because the Reading Room is not precisely at the centre of the courtyard, the curvature of the roof is irregular. Consequently, although the grid of 3,312 triangular glass panes that forms the roof looks very regular, each pane of glass is a slightly different shape. Before computer-aided design, calculating the shapes of the panes of glass, and manufacturing them accurately, would simply not have been practical.

Architectural practices such as Foster & Partners can be seen very much as following on from the modernist tradition, in that they focus on the technical sophistication of the structure itself. Other designers, however, are increasingly interested in the subjective experience of the people who visit their buildings. One approach to this is to create ambiguous spaces that are deliberately left open to interpretation by those who experience them. Another approach is to create a structure that purposefully triggers an emotional response in people.

grids in Architecture

below
The 'Spiral' extension of the Victoria & Albert Museum, London, designed by Daniel Libeskind, not yet built. This unusual structure has been created as a place to display design and craft objects while helping to link the many levels of the existing museum buildings.

right
Jewish Museum, Berlin, Daniel Libeskind, 1999. It was opened to the public before the exhibits were installed and many wanted it to remain empty, arguing that the building alone was powerful enough. The acute angles formed by the zigzagging plan give the building strange juxtapositions, creating a disorientating, sometimes suitably claustrophobic, experience.

Perhaps the most successful example of this is the Jewish Museum in Berlin, designed by Daniel Libeskind and opened in 1999. Libeskind has said that the process he used to design the building cannot be explained entirely rationally. An example of his unusual approach to the design is that the zigzag plan of the structure was created by plotting the addresses of important Jewish people who lived in pre-war Berlin and then joining these dots on the map with lines. The intersections of the criss-crossing lines created the jagged shape of the plan. That Libeskind succeeded in creating a building that triggers powerful emotions in those who visit it was dramatically demonstrated by the fact that many people thought the building should remain empty and not contain the exhibits it was originally designed to house.

It was the idea that 'form' should follow 'function' that led to the creation of buildings that overtly displayed the structural grid that supported them. Inadvertently, it also led to the many millions of buildings that looked, as Tom Wolfe put it, like 'duplicating-machine replacement-parts wholesale distribution warehouses.'

In an era in which, increasingly, architects believe that one of the functions of a building is to create a subjective reaction in the people who experience it, there is very little reason for the structural grid to be the focus of attention. It is unlikely that architects will stop using the grid as a means to help them design – it is, after all, a practical and useful tool. It is likely, however, that the grid will simply function as one element in an increasingly complex and multi-layered design process, and that, as a result, the grid itself will gradually recede from prominence.

grids in Music

essay

As **John L Walters** explains, the notion of the grid is not exclusive to the visual arts. Music uses time-based grids that are as central to its structure as are the grids measured in points, pixels, millimetres or inches.

John L Walters is the editor in chief of Eye magazine and writes about creative music for the UK's The Guardian newspaper. He is the co-founder of the CD journal Unknown Public (www.unknownpublic.com).

One of the 193 pages from Cornelius Cardew's Treatise, 1963–67, which remains one of the most visually engaging examples from the 1950s and '60s avant-garde.

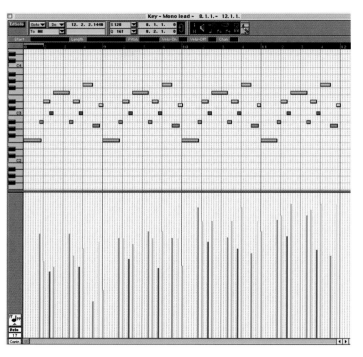

grids in Music

right
The conventional
score uses a two-axis
grid. 'Sequenced'
computer music is similar:
the program Cubase
displays a grid of notes
that start and stop as
the time axis moves from
left to right.

far right
Digital technology permits
new ways of experimenting
with, and breaking, the
grid. Computer programs
such as Logic are able to
incorporate 'unquantised'
sequences of notes and
freely played samples
to create music. Rather
like a map, this is a way
of describing rather than
prescribing what the
music should be.

far right
A page from Michael
Gibbs' score for the
BBC Scotland television
series, Strathblair. It is
a conventional orchestral
score, in which the parts
for each instrument run
parallel to each other.
This grid is still one of
the most efficient means
of organising groups
of musicians.

Music cannot avoid the grid, because it is a time-based art in which repetition plays a large part. The grids of classical notation, graphic scores, computer programs, piano rolls, digital recording, optical movie soundtracks and even the stereo spiral scratch of vinyl have one thing in common: an axis that delineates the passage of time, time that moves relentlessly forward from now into the future until the music stops.

Yet there's a difference between the grids you hear and the ones you see. Conventional music scores are precise within their own rules, but can be interpreted in many ways. For a simple tune, the x-axis is time and the y-axis is pitch. The notes make up a graphic code system that shows the player which notes to play, when to play them and when to remain silent. The player follows the 'dots', reading from left to right: further graphic details prescribe the duration of each note, and hence the rhythm of the piece. Vertical bar lines divide the sequence of notes into handy sections that make navigation easier. The notation must obey the grid imposed by these bar lines – the duration values within the bar will always add up to the amount set by the 'time signature': four crotchets (or quarter notes) for 4/4 time, six quavers (or eighth notes) for 6/8. Time signatures may change within a piece, which may also speed up or down, but the notation remains anchored to a grid.

Despite this precision, any player can invest a written line with additional unwritten elements through the sound of the instrument, and in interpretation: through tiny inflections in dynamics and phrasing – slight changes in the speed of attack and decay, for example – the performer 'personalises' the tune. When several players follow a score, the grid is what keeps them playing together, whether there's a conductor, a drummer or just their own sense of time passing.

The graphic scores of the 1950s and '60s avant-garde relied on these conventions in order to challenge the hegemony of notated music, producing explosions of visual invention that would provoke performers to improvise and play together to produce new and largely unpredictable results. Scores by Roman Haubenstock-Ramati are packed with extravagant mark-making, while John Cage's scores, with his distinctive hand-lettering, can be enjoyed as pure graphic invention. Cornelius Cardew's 193-page Treatise is still one of the most visually captivating and inscrutable examples from this era.

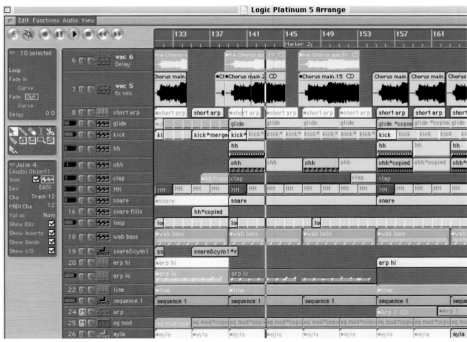

The grid of the orchestral score, in which the parts for each instrument run parallel to each other, still makes conventional orchestration one of the most efficient means of organising groups of musicians. A film composer prepares a score, from which a copyist writes out the individual parts. The conductor, whether supervising a handful of specialists or facing 60 musicians in the recording studio while the clock is ticking, can scan the score horizontally to see what each musician is supposed to be playing. He or she can also view the score vertically to see what chord the massed musicians are playing at any one time.

'Sequenced' computer music uses a similar two-axis score: a program such as Cubase displays a grid of notes that start and stop as the time axis moves from left to right. Of course the program is also the performer – a note shown on the display is a representation of the programmed note you hear every time. Such programs can 'quantise' the notes, 'correcting' their start times to the nearest exact rhythmic measure. There is an analogy with visual culture here: the acoustic score is like a grid that has to be copied by hand, and however accurately this is done, different versions will vary slightly in inflections and emphasis.

Performing such a score with rubato (flexible tempo) passages, is akin to projecting a pristine grid onto a roughly plastered wall, or the curves of a human body. For example, as the tempo slows, a crotchet's (quarter note's) duration will lengthen, as will each quaver (eighth note), though the latter will still be perceived as half the length of the former. When a more ad lib or improvisatory interpretation is made, the musical grid is pushed out of shape even more – for example, in a jazz performance of a 'straight' theme – but the score will still hold the piece's identity.

The electronic score, particularly the kind used for dance and pop music, frequently locks every note to a quantised grid, much in the way that QuarkXPress encourages the user's text and picture boxes to snap to an invisible grid. In some musical genres it is not appropriate to think of breaking such rules – the gridded divisions have become part of the aesthetic. Walk into almost any urban club or bar to hear the gridlocked beats of programmed music. Watch current films, or pop videos: music and visuals are often ruled by the same subdivided grids, linked by a common time code.

Fortunately, digital technology permits entirely new ways of using, or breaking free of, the grid. Computer programs such as Logic are able to incorporate long, 'unquantised' sequences of notes, and long, freely played samples to create music. Here, the grid becomes more like a map (or an itinerary) than a precise score, a way of describing rather than prescribing what the music should be. The creative music program SuperCollider allows the musician to discover the effect of recombining gridded elements in combinations that are not entirely predictable: a system explored by John Eacott in his drum and bass project, Morpheus. (The programmer determines the probability of notes and sounds occurring at certain times.) The most extreme use of this program may be Jem Finer's Longplayer, an asynchronous collage of sounds made with Tibetan bowls, superimposed and recombined in such a way that the piece will continue to play without repetition for 1,000 years, a score that is too gigantic for its creators or listeners to analyse.

grids in Furniture design

case study Modular shelving systems are a three-dimensional equivalent of the typographer's grid. **David Phillips** considers the work of furniture designer **Axel Kufus**, with his schematic and humane approach to ordering chaos.

David Phillips is a UK-based design practitioner involved with many aspects of both graphic and architectural design. Presently he is a senior lecturer in information design at the London College of Printing. He is a graduate of the Royal College of Art in London.

right
The shelving unit designed by Kufus for an ante-room at the Bauhaus University in Weimar. It is intended that visiting lecturers will each contribute one metre of books to add to the collection. This design formed the basis for Kufus' most recent shelving, Egal, which is now in production.

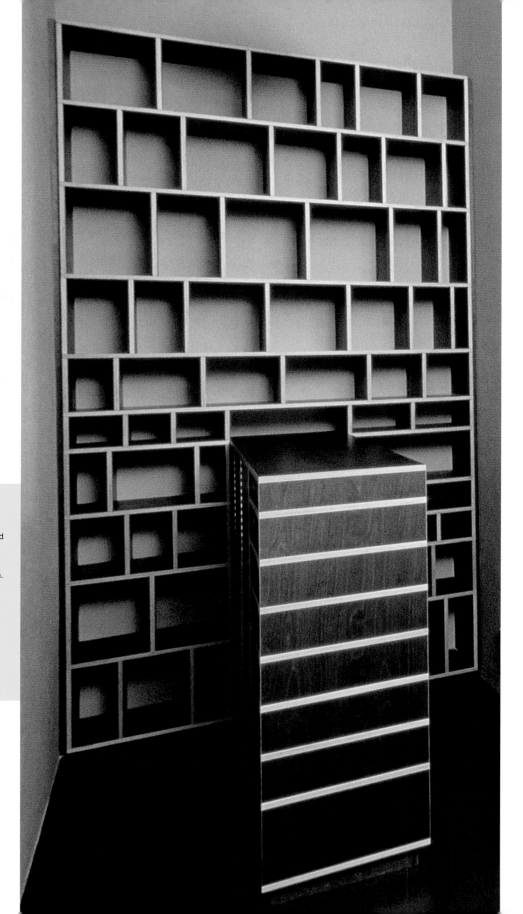

The idea that grids have a role to play in furniture design is most prevalent in the design of system furniture, where a family of components is assembled to form different units that fulfil different functions. The relative success of any system will be determined by the designer's response to constraints; these may be ergonomic or arise from the availability and dimensions of pre-made materials. Axel Kufus' work as a furniture designer is a positive affirmation of the notion that an object's form is dictated and defined by constraints and is determined by a real understanding of the materials with which it is made. His work embraces constraints in many areas; some are self-imposed, others are dictated by the object's function or means of production.

A prevailing theme in his work is economy – both of form and of materials. Often one design springs from the materials left over from making another. For example, a chair is made from the material remaining after making a table. The objects are sparse, lean and perfected; their proportions and qualities magnificently fitted to their purpose. Kufus asks questions of the furniture's components – how basic can they be? Can they just be of the system and not extraneous?

His Lader storage system uses a simple set of parts: drawers and frame elements in four different heights that can be combined to make a multitude of different combinations. Much of his work takes the form of modular shelving or storage systems that can be composed and configured to suit the user. The function of many of Kufus' designs is to order and contain things such as books, documents and objects. As such, they are grids – formalisers and unifiers. Like good typographic grids, Kufus' storage systems are able to absorb objects of diverse size without loss of unity.

Emerging from the strong functionalist aesthetic of post-war German design, Kufus' work continues in the tradition of the Bauhaus and Ulm schools. In 1989, after an apprenticeship as a cabinet-maker and having trained at Berlin Academy of Fine Arts, Kufus joined with Jasper Morrison and Andreas Brandolin to found the influential Utilism International design group. This group – formed as a reaction to the influence post-modernism was having on design in the late 1980s – was concerned that objects above all else should express their use and be useful. Kufus is interested not in appearance, but in what things are.

His approach to design is primarily humanistic; each work contains a simple tectonic dialogue between materials that establishes order and precedence for every decision. Whenever questions are asked by materials or forms, Kufus provides answers that are informed by analysis and systematic thinking. Structure defines each object. However, Kufus is always looking for the harmony, the resonance and the poetry within the structure. There is a reductionist rigour present in the work; an order often arrived at after a difficult journey.

For Kufus, design is an investigation into the qualities and limits that each material allows. He looks for the edges, the strengths, the weaknesses and the places where things will join or bend. He talks about working with strong and weak forces. When a designer knows and understands these places, he becomes instinctively guided. Ultimately, for Kufus, a system is a form of guide; a kind of marker to show the way.

With only three constituent parts (side panels, shelves and aluminium rails) and two materials, (MDF and aluminium) the FNP shelving system is a design classic of refined elegance. It was designed virtually overnight in 1989. Its dimensions are determined by the division of a standard sheet of MDF to gain the maximum use from it. Waste is kept to a minimum. It is two things, structure and the modular measure. Like any good grid, the flexibility of the system allows the user to construct spaces appropriate to many uses. No tools are needed to construct the shelves.

Kufus' recent work returns to the theme of modularity, flexibility and function. He has designed a beautifully elegant office kitchen system. For use in the new office environment, it can be almost endlessly adapted to suit the needs of a particular location. Every detail has been examined and controlled and each part has a function and relationship with the whole. The kitchen can be fully specified online, then delivered flat-packed on a pallet.

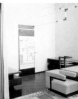

In the early 1920s, Walter Gropius and Hannes Meyer, architects and tutors at the Bauhaus, subdivided a standard atelier room to form a square Director's room – which has recently been restored – and a smaller ante-room. Kufus is professor of product design at the Bauhaus University in Weimar and as part of his work there has designed a shelving system for use in this ante-room. This modular system uses a traditional peg support grid in construction, but turns it on its side. From this simple manoeuvre, a system is constructed that provides for endless variation to a constant rhythm. It is intended that each visiting Bauhaus professor leaves behind one metre of books, which will build up to form a history of influence and ideas. A development of this system, named Egal, is now in commercial production; its flexibility is testament to the simplicity and elegance of the concept.

Guiding principles are as much grids as are lines on paper. In the design of furniture, the first reference is the body – this is the measure. Next, there are materials, each with its own dimensions. Axel Kufus knows better than most the measure of both.

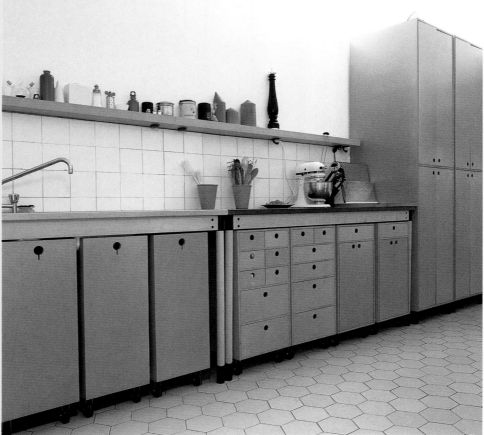

above
A system of kitchen
units designed by Kufus
that are visually simple
and highly flexible.

right
Kufus is famous for
his FNP shelving system,
designed in 1989 and
shown here in his
own studio. As with
the typographic grid,
a successful shelving
system accommodates
diverse objects without
losing its unity.

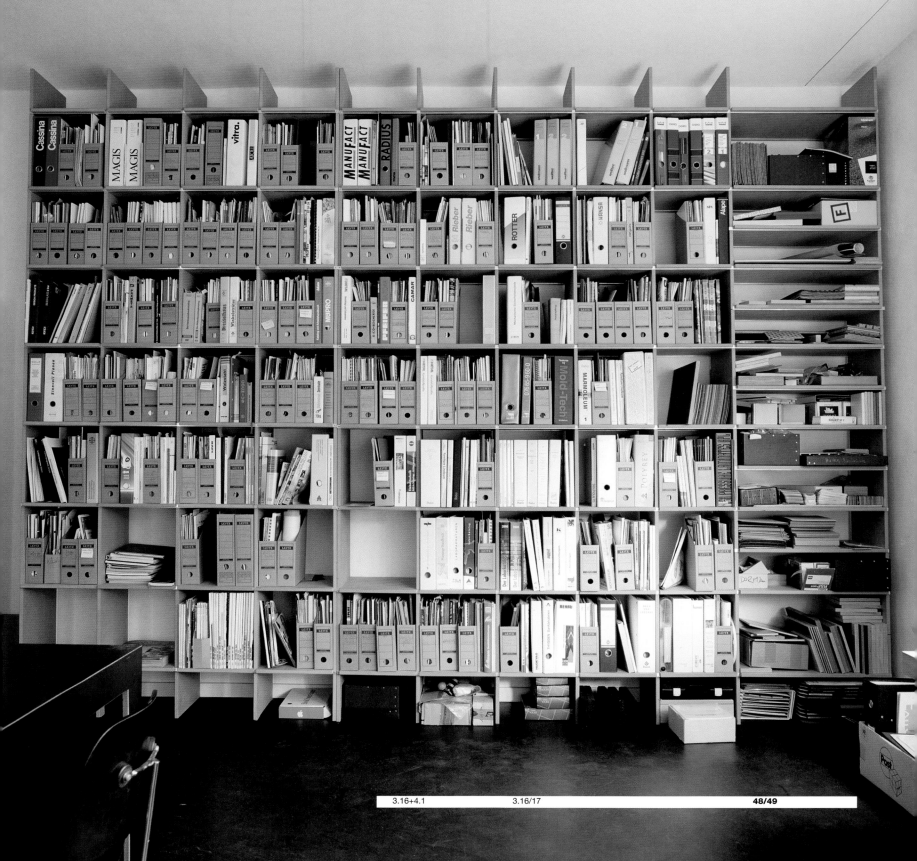

grids in Fine art

essay Grids can simultaneously be mystical and mechanistic, rational and irrational. **Martin Herbert** explores the use of the grid as a recurring device in painting and the fine arts.

The grid is among the oldest formal devices in the history of visual art. After making a successful sketch, the Old Masters would draw a squared grid over their image in order to facilitate scaling it up, square by square, into a painting or a fresco. In the fifteenth and sixteenth centuries, the development of perspective by pioneers such as Paolo Uccello led artists to routinely employ grids in their images to correctly mark out the recession of space. As such, the squared-off picture plane was essential to the development of pictorial illusion. However, it was not until the twentieth century that the grid moved from the background to the foreground in works of art.

below
Argininamine by Damien Hirst, 1994. Painted in gloss household paint on canvas and measuring 26 x 26in with one-inch spots.

right
Midtown – Paine Webber Building (with neons) by Sarah Morris, 1998. Painted in gloss household paint on canvas and measuring 84 x 84in.

far right
20 Brasset by Carl Andre, 2001. Made of 20 brass units and measuring 7.6 x 7cm.

Martin Herbert is a London-based writer and art critic. He writes for various European art and cultural magazines including Flash Art, Modern Painters, Art Review, Contemporary Visual Arts, Tema Celeste, Camera Austria, Time Out, and Dazed & Confused.

When it did so, the reasons were surprisingly mystical, given the rigorously scientific order that grids would seem to represent. The grid, and geometry in general, made its return in various responses to the early twentieth-century art movement Cubism, whose exponents, Pablo Picasso and Georges Braque, had conceived of an aesthetic that fragmented and abstracted reality into angled planes in order to more closely approximate the way we look at things. Inspired by Cubism during a stay in Paris before the First World War, the Dutch artist Piet Mondrian wanted to create an art that was even more 'realistic', though paradoxically the works he came up with – in a style he labelled 'plastic art' – were increasingly abstract.

'True reality,' wrote Mondrian, 'is attained through dynamic movement in equilibrium. Plastic art affirms that equilibrium can only be established through the balance of unequal but equivalent oppositions.' Mondrian described this balance as being 'of great importance to humanity', and set about presenting it using paintings in which a heavy grid of black lines on white created squares that he filled in using primary colours. The effect, something like an ultra-refined stained-glass window, is saved from repetitiveness by Mondrian's highly flexible sense of pictorial balance.

At approximately the same time, in Russia, Kasimir Malevich was also using the grid as the basis for a spiritual quest. His movement, Suprematism, was founded on the idea of a 'non-objective reality' organised around pure colour and form, which would free up the mind of the viewer. Malevich's works, such as Black Cross (1913), employed the cruciform shape – a three-by-three grid in which a central 'cross' was filled in using a different colour. The sparsely idealist effect that resulted was echoed in his writings. 'At the present moment man's path lies across space,' Malevich wrote in 1919. 'Suprematism is the semaphore of light in its infinite abyss.'

This will to reduction, which might also be interpreted as a will to purity in light of the horror of the First World War, was also being felt elsewhere – in the Dutch design and architecture group De Stijl, for instance, whose geometric designs were much influenced by Mondrian. After around 1920, however, those who picked up the purist ball and ran with it – most notably the Russian Constructivists – took abstraction further away from rigidity and towards the inventive organisation of forms on the picture plane. Simultaneously, movements such as Surrealism had little use for geometry. The grid once again went underground.

It resurfaced, in fits and starts, in the 1950s. Pop Art, with its latent analysis of serial industrial production, used the form – think of Andy Warhol's silk-screened soup cans, arranged in an even grid, and Roy Lichtenstein's use in his paintings of 'Ben Day' dots, found on newspaper reproductions of photographs. So did cool-eyed individualists such as Jasper Johns, who in a series of canvases arranged numbers in a painterly lattice, treating the numeric system as a ready-made subject, much as he did the American flag. But these are fleeting examples.

In the 1960s, however, grids made a big comeback. If Pop Art had alluded implicitly to mechanisation and ordering processes, the new movements of Minimalism and Process Art did so explicitly. Works such as sculptor Donald Judd's metal cubes, seemingly untouched by human hand, fitted right into a world whose economies ran on serial production and industry. Meanwhile, the German photographers Bernd and Hilla Becher arranged their monochrome, frontal studies of buildings and industrial structures in close grids, emphasising the subjects' similarity and practical purpose.

American sculptor Carl Andre's floor pieces used the form repeatedly – his works employing a chequerboard pattern of metal tiles laid out on the floor, for example. Yet here, as at the beginning of the century, there were elevated reasons for the grid's prevalence – Andre wanted viewers to get at the essential beauty of the materials he was using, and so laid them out using the grid, a form that seemed almost transparent in its familiarity. Not everyone approved: the Tate Gallery bought his most notorious piece, Equivalent VIII, a floor-based double layer of firebricks, in 1972, sparking a blaze of controversy.

In some ways, this sudden efflorescence of geometric orderliness can be seen as a rebirth of the high-minded ideals of the early twentieth century, and a reaction to the messy, psychology-inspired work of the intervening years, such as Surrealism and Abstract Expressionism. Art in the '60s and '70s was increasingly concerned with thought processes, rather than action, and the epitome of this shift was Conceptual Art. Among this movement's proponents, the grid was often used as a way of suggesting precision and control, and of alluding to time's passing.

In 1971, for example, Dutch artist Jan Dibbets made a grid of photographs showing the movement of shadows across a gallery floor over the course of a day, while the American John Baldessari arranged contradictory photographic images in grids to produce deliberately confusing allegories. This was the era in which British conceptualists Gilbert and George began to make their deliberately shocking photographs of themselves, which they arranged in grids for a practical reason: to make imposingly large, multi-image works.

left
Composition with Grey, Red, Yellow and Blue by Piet Mondrian, circa 1926.

below
A self-portrait by Chuck Close, 1997. Oil on canvas, measuring 102 x 84in.

right
A detail of Donald Judd's 100 untitled works made in mill aluminium, 1982–86.

Probably the most dedicated user of grids in this era was American artist Sol LeWitt, whose entire career has been devoted to the form. His fiercely rational work seems suited to the unitary form of the grid, and he has used it in three-dimensional floor pieces that stack up wooden grid-structures into boxy, diagrammatic forms, and in later paintings in which a single motif is progressively rotated through angles, the stages being presented together in grid form.

This fixation on the grid – which some have termed obsessive – also characterises Canadian painter Agnes Martin's pale, hushed canvases, which are committed to delicate surface effects and seriality, and which create ad hoc grids through compulsive build-ups of horizontal and vertical lines. Like the work of early geometric artists, they aspire to a perfection of form, reflecting a Platonic ideal that exists inside the artist's head.

The latter are surprisingly uncommon examples of the grid being used in sophisticated contemporary painting. It is a form eminently suited to photography, which is where it has mainly appeared. But there are other exceptions: American artist Chuck Close, for example, returned to squaring-off – the artistic roots of the grid – to make his hyperrealist portraits, and since the 1980s has brought the grid itself more and more into play. In later works he has treated each area of the grid as a discrete section, filling it with swirling colours and forms that, close up, seem abstract, but from a distance reveal themselves to be elements of a larger portrait, often of Close's own face.

This is the unitary function of the grid, wherein each section contains something that is given equal weight. In the 1990s, British artist Damien Hirst cleaved to this principle in his 'spot' paintings. Featuring varicoloured circles painted on white backgrounds and arranged in a regular framework, these darkly upbeat works bear the names of chemical compounds and synthesised drugs. They are ambiguous – each of the circles might represent a different chemical – but invariably stimulating, and the feeling of harmonious balance the grid achieves is central to their appeal.

In recent years, the format has continued to exert a pull among younger artists. An example is American painter Sarah Morris, herself influenced by the undervalued, 1960s-era British artist Jeremy Moon, whose canvases Morris's kinetic, angled, colourful grids resemble. She is also inspired, however, by everything from the rhythmic grids of skyscraper windows to illuminated, chequered dancefloors like the one in the film Saturday Night Fever.

That Morris can draw such wide-ranging inspiration from the grid format reminds us of one reason for its staying power. Regular geometry is not only found at the microscopic level, in the underlying structure of all matter, and in the dream structure of human ideals. It is reflected everywhere we look in the world around us, particularly in the manmade environments in which we live. Consequently, whether in the foreground or the background, its permanence as an element of art seems assured.

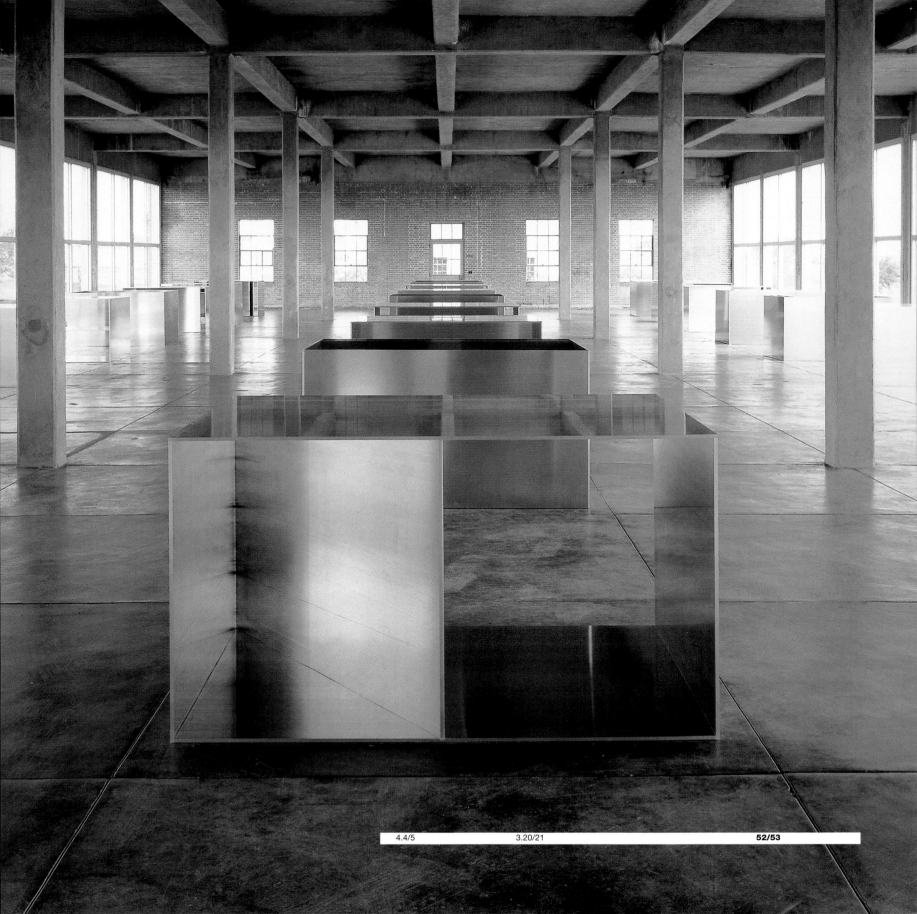

grids in Interior design

case study It is easy to assume that minimal design has to involve a rigid use of grids. In looking at the design detail of the architect **John Pawson**'s family home, it is clear that a desire to explore structure and proportion does not preclude an awareness of more instinctive design.

The interior of the architect John Pawson's family home. Here the traditional boundaries are ciscarded as the interior of the kitchen links with the exterior of the garden. The minimalism of the design makes one even more aware of its structural components, for example kitchen units, floor tiles and trellis.

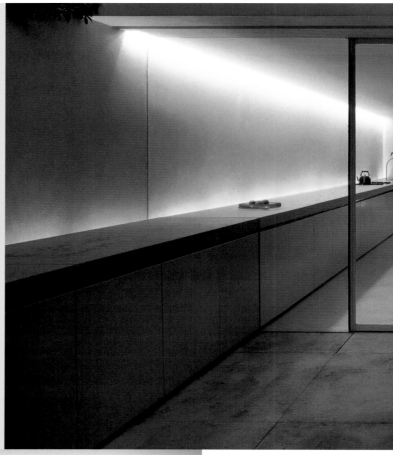

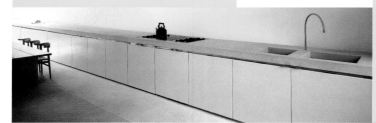

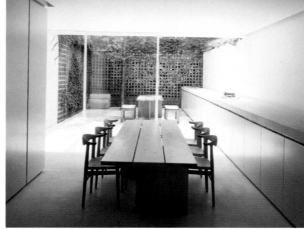

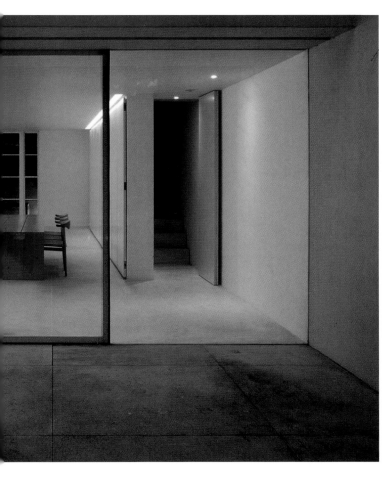

'I certainly never start designing by laying out a grid and saying, this is what I'm going to do,' says John Pawson. 'But I do think about proportion. I do what looks good – and it usually turns out that I've done a golden section, or a double square, or a double cube.'

Pawson is famous for creating stunningly minimal environments – ranging from houses, to art galleries, retail interiors for Calvin Klein, and even an airport lounge in Hong Kong. His work is minimal, but simultaneously very expressive. By designing out all but the most essential elements, he creates sculptural spaces in which details such as the way light diffuses through a room, the natural variations in colouring in a slab or stone, or the way a shadow falls across a wall, are just as much part of the architecture as the structure itself.

Despite his assertion that he does not start his designs with grids, looking around the house that he designed for himself and his family, there are a number of repeating proportions that – whether intentionally or not – form very visible grids. The floors are made of huge square slabs of pale golden coloured stone. Large square kitchen units run the length of the kitchen and continue straight through into the garden, with only a frameless sheet of glass dividing inside from out. At the back of the garden, a handmade trellis forms a strong, yet permeable wall, a rigid grid through which honeysuckle meanders.

With so little to distract the eye, visual elements such as the edges of the stone floor slabs and the grid of the trellis are surprisingly noticeable. As Pawson points out, the more visually simple a design is, the more the eye notices details that would otherwise not be seen. 'Often, if you reduce too far, then other things start happening,' he says. 'I was once trying to take photographs of this house, trying to make it look as simple as possible, but everywhere I looked there were grids and squares. It was like grid city. When the sunlight comes out, you find the trellis repeated on the walls. I was thinking; What have I done? There are all these lines everywhere. It's supposed to be simple.'

Looking closely at the house, however, it is evident that any grids that happened to have been formed are secondary to the design as a whole. The four-foot square stone slabs – chosen because Pawson wanted the largest pieces of stone he could get – may form a subtle grid, but the plan of the house was clearly not designed around them. The strongly horizontal grid formed by the repeating squares of the kitchen unit doors does not line up with the grid formed by the stone slabs. To some designers, this would be an endless source of irritation. For Pawson, however, it is important not to get too het up about lining everything up. 'You can tie yourself in a terrible knot,' he says, 'For one thing, it's not very elegant. For me the stone is the earth and everything gets put on top of it. Everything should be just placed on it. You should put things where you want.'

Often in fact, Pawson works hard to ensure that things don't line up. 'I was very careful to make sure that that door overhangs that joint there,' he says, pointing to a place where the edge of a wall overhangs one of the stone floor slabs. Despite this, when looking at the rear façade of the house, he does wish that more of the elements lined up.

Inherent in Pawson's design philosophy there seems to be a set of parameters that are not clearly defined, but are instinctive to what he does. Up to a certain point, aligning the various elements of a building is an important part of ensuring its visual simplicity. Beyond that point, having things line up, or fit into a grid, is too mechanistic.

It is this, perhaps, that makes Pawson's work so much more satisfying than the work of lesser minimalist architects. Whereas second-rate minimalism can seem sterile and soulless, Pawson's architecture has a humanity and warmth to it, an acceptance that while order is desirable and calming in life, an element of disorder is essential too. 'I love the combination of natural things and manmade things,' he says. 'For me, in the end, what's important is what feels right, what looks good. I know what's comfortable.'

Having trained as a graphic designer, Damian Wayling worked for Assorted iMaGes in London for three years before moving into graphics for television. After working as a documentary development producer and script editor, he now writes for film and television.

right
Diagram representing the key moments as a percentage of the overall length of a number of films.

Film timings taken from the book Myth and the Movies by Stuart Voytilla

following spread
A key moment in the film Jaws. The Fourth of July celebrations are disrupted by the return of the terrifying shark that the town fathers claimed to have killed.

grids in Screenplays

essay Film structure is more complex than the formulaic 'beginning, middle and end'. As **Damian Wayling** explains, the screenwriter employs time-based grids that simultaneously produce changes in pace and focus, keeping the audience's attention until the bitter end.

First Act
At some point in the First Act, usually after the audience has seen a little of the hero's ordinary world, something will happen to disrupt that world and kick the hero's story into action. This is often called the Inciting Incident.

Star Wars
125 minutes

32 minutes
Luke's aunt and uncle are massacred and Luke now goes with Obi-Wan.

The Godfather
175 minutes

35 minutes
Don Corleone refuses to enter the narcotics business and a war of the families begins.

Sleepless in Seattle
104 minutes

16 minutes
Sam tells his sad story to a radio phone-in show and thousands of women want his address.

Some Like it Hot
121 minutes

23 minutes
Having witnessed the St Valentine's Day Massacre, Jerry and Joe decide their only chance of escaping Spats the mobster is to dress as women.

Butch Cassidy and the Sundance Kid
112 minutes

31 minutes
The superposse begin their pursuit of Butch and Sundance.

Jaws
124 minutes

13 minutes
The second victim, a young boy, is killed by the shark and the beaches are closed.

Second Act
At some point in the middle of the long Second Act, something major will happen that changes the nature and tone of everything that comes after. This event re-energises the narrative. This is often referred to as the Mid-point Climax.

Third Act
At the end of the Second Act, a powerful event signals the beginning of the end, drawing together the various story strands. It throws the audience headlong into the Third Act and is, for obvious reasons, called the Second Act Climax.

70 minutes
Luke convinces Han Solo to help him save Princess Leia, while Obi-Wan disables the tractor beam.

98 minutes
The Rebellion prepare to attack the Death Star, in an all-or-nothing battle.

88 minutes
Michael Corleone kills Sollozzo and Captain McCluskey, and thus commits himself to the family.

152 minutes
Michael discovers that Tessio is the family traitor, and all family scores can now be settled.

62 minutes
Amie flies to Seattle to find Sam.

83 minutes
Sam discovers Jonah has gone to New York; he races after him and the stage is set for the finale.

49 minutes
Jerry and Joe arrive in Florida but must maintain their disguise.

97 minutes
Spats arrives on the scene and Jerry and Joe must escape or be killed.

65 minutes
Butch, Sundance and Etta decide to reform and start again in Bolivia.

93 minutes
Butch and Sundance realise they are destined to remain criminals. Etta leaves them to their fate.

76 minutes
The Orca sets sail to find and kill the shark.

105 minutes
The engine fails and the three men are stranded at sea. The final battle begins.

So... you've bought popcorn and found a good seat – not too close to the screen. You've glared at the couple behind you to stop chattering. The film is well under way and it looks promising. Maybe the brilliant but flawed computer genius has finally cracked the code and realised he's the only one who can save the world, or perhaps the beautiful, grieving widow has resolved to embrace the life-affirming values of a Hebridian fishing village. Whichever it is, you're asking the right question – I wonder what's going to happen next? And something odd happens then. Your attention wanders. You become fascinated by the eerie green glow of the little stick man on the emergency exit sign. Nothing seems to be happening on screen. The story has stalled. Why? Because the screenwriter has either forgotten or maybe never fully understood that screenplays rely on structure and that a rewarding audience experience is built on a hidden, time-based grid.

Most films, mainstream and otherwise, have three acts. The First Act tells you whose story this is and what they want; the Second Act works through the conflicts, reversals and surprises that result from efforts to overcome the forces trying to stop them getting it; the Third Act details the events that will decide whether or not they do get it. It's unlikely that you'll get bored with a film in the first 30-minute act. Beginnings are easy. At some point within the First Act something will happen to kick the hero's story into action (see diagram). In the textbooks it's often called the 'Inciting Incident'. Any novice who comes up with a 'great idea for a film' usually has in mind a character and an Inciting Incident: a war hero goes into a bank and then a bunch of robbers arrive with guns... But if you ask what happens after that, the answer is usually, 'well, I haven't worked out the rest, but I think it's a great beginning'. Maybe, but beginnings are easy. The problems come later.

The most troubling section of a story is the Second Act. In a two-hour film, the Second Act will occupy probably 60 minutes. This is a long stretch of storytelling unless the Second Act is given its own structure – usually by splitting it in two and treating it as two 30-minute pieces. In a well-structured film, at some point in the middle of that long Second Act something major will happen that changes the nature and tone of everything that comes after it (see diagram). This event re-energises the narrative by shifting location, raising the stakes or cutting down the options for the hero.

Problems often surface 10 or 20 minutes into the Second Act if the screenplay is built without an awareness of structure. The narrative becomes rather muddy and rudderless. The story stalls and the mind wanders. And this is where the glowing green stick man comes in. It's not about the short attention span of modern Western culture, it's about the healthy hunger for narrative. Every storyteller, whether the story is a two-minute joke, the Bible or a Shakespearean tragedy, owes it to the audience to keep the story moving forward.

Another powerful event at the end of the Second Act signals the beginning of the end – the drawing together of the various story strands. It's usually called the 'Second Act Climax', and it usually happens around 90 minutes in. The Second Act Climax throws us headlong into the Third Act, where we will find out whether the hero gets what he/she/it wants (see diagram).

In addition to these main stepping stones, there are other, smaller footholds that help the screenwriter, and subsequently the audience, through the journey. Each act is made up of scenes – defined as pieces of action that take place in more or less the same place over more or less continuous time and change the status quo, thus moving the story along. In turn each scene is made up of 'beats' – units of action that shift the balance of power in some small way – scenes in a Laurel and Hardy film, for example, are often structured by beats of escalating slapstick violence.

A question that throws many a would-be screenwriter into a spin is: What's your story about? To answer that, the screenwriter must be clear what his story specifically is about, but also what stories are generally about. All mainstream movies, and many art-house ones, are about what happens to the 'hero' – although the hero may be a stumbling neurotic (Manhattan, Annie Hall, etc), a nation (The Battle of Britain, Dr Strangelove), a toy (Pinocchio, Toy Story), or a square-jawed hunk (Alien, Raiders of the Lost Ark).

If you want to work out who the hero is in a movie, you only need to ask who in the film has the most to win or lose? Movie stories are about what the hero wants – ET wants to get home, Norman Bates wants to stop his 'mother' doing bad things, James Bond wants to save the world and get the girl. But if the hero wants his girl back (Annie Hall) and he asks her and she says okay, that's not going to make anyone cry. Powerful screenplays feature powerful forces that prevent the hero getting what he/she/it wants. What the hero will or will not do to get what they want defines their character and propels the narrative.

The typographic grids of this book have a different function from the time-based grid of the screenplay, but they share some governing principles. For the typographer, the choice of a three, five or seven column grid depends on whether the job is a poster or a magazine, a book cover or a leaflet. For the screenwriter, the kind of story to be told will dictate whether the screenplay has a three-act or a five- or six-act structure. A love story like Annie Hall will probably have three acts – boy meets girl, boy loses girl, boy gets girl back (or not). An action adventure like Raiders of the Lost Ark will probably have seven or eight acts – boy recovers precious artifact and escapes with his life, boy sets out on his next adventure, boy meets girl and rescues her from Nazi villains, etc, etc. A story like Four Weddings and a Funeral will have – well, work it out for yourself.

The notion of creative constraints espoused by many modernist typographers is also essential to a good screenplay. A screenwriter has to take events that happened over a day, a week, a year or a lifetime and relate them in 100 minutes. To do that, one must isolate key moments and use them to tell the tale. The story must be told principally in pictures and with no extraneous action or dialogue. The narrative must stay one step ahead of the audience – but not two. The story must be plausible, but astonishing, familiar yet surprising. All of these constraints must be seen as positive and not limiting.

But remember also that, just as typographic grids don't design a layout for you, time-based grids won't write a script for you. To paraphrase screenplay guru Robert McKee, 'screenplay structure is about principles not rules. A rule says "you must do it this way". A principle says "this works, understand why and use it".'

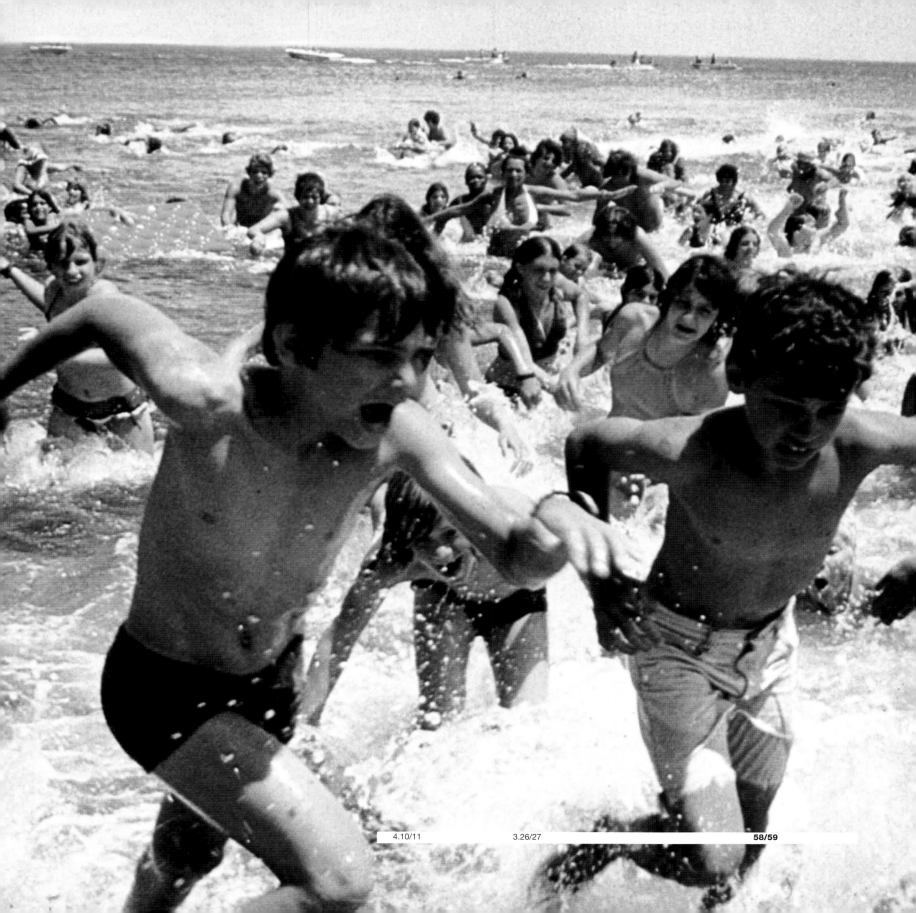

grids in Digital design

case study All digital design is fundamentally about a grid. The unit is the pixel and, as designer **Neil Churcher** describes, the process is more about definitions of structure than ever before.

Client Reuters Kalends wanted to structure their internet-based business calendar for use on the new telephone technology called Smartphone. These are some of the interface components for application in the Smartphone Operating System. Neil Churcher's company Edwards Churcher also designed this operating system for client Symbian. Brand and calendar functions needed to be consistent and seamless.

The AOL mobile portal
was developed to allow
AOL members access
to all AOL content on
WAP enabled phones.
For limited screen displays,
content selection has to
be heavily compressed as
click-through dramatically
affects session hits and
download times. Clever
menu architecture and
personalised content
reduce the number of
click-throughs the user
will take to access content.

Architecture diagram showing the registration sequence for the AOL mobile phone portal. The architecture is designed by taskflow with particular attention to reducing click rates for every task. This demonstrates that time can be another element to consider in devising an information structure.

At an event to mark the publication of Robin Kinross' book, Anthony Froshaug: Typography & Texts/Documents of a Life, the author told an illuminating anecdote. He had employed a typist to transcribe some of Froshaug's previous writings, and she commented that she had never had to type the word 'constraint' so often. Print-based graphic designers working now, particularly those who revel in grids and modular systems, might misunderstand this notion as they are often preoccupied with a set of self-selected parameters. But for Froshaug, working with metal type, the constraints were both conceptual and practical.

Neil Churcher, partner in the digital media company Edwards Churcher, spoke of the parallels between new technology and that of letterpress. For him the pixel, a term derived from abbreviating 'picture' and 'element', makes 'the grid an absolute... there's no way that you can break it, you can't go off the digital lines, it's impossible, it's a fixed point of reference... letterpress is very similar, you are playing within that limitation.' A paper page is not intrinsically a grid – the grid is imposed upon it, whereas a web page, by token of its construction, is always broken down into prescribed elements or units and is therefore always a form of grid.

Using book- or print-based metaphors is not, however, wholly adequate within digital areas of design. Websites, for example, can function as much like television as a book – the structure is multi-dimensional with a variety of access points that include time as part of the structure. 'You can always tell a great site,' says Churcher, 'because even when something is downloading it keeps your attention.' Churcher, however, refers to his role as that of an 'information architect' and considers structure primarily in relation to the organisation of complex information.

Graphic designers who work in print often consider the design of digital data to be fundamentally uncontrollable. This reveals an understanding of the term 'design' to mean appearance alone. For Churcher, design is far more fundamental. It also means the underlying system used to organise data in all its different applications. Churcher feels that the technology is a tool that needs to be in the hands of designers to produce the best overall results. For him, this is a totally integrated process. He wonders if designers fear control over the technology, mistakenly thinking that it is not their domain and thereby denying themselves input into the design process.

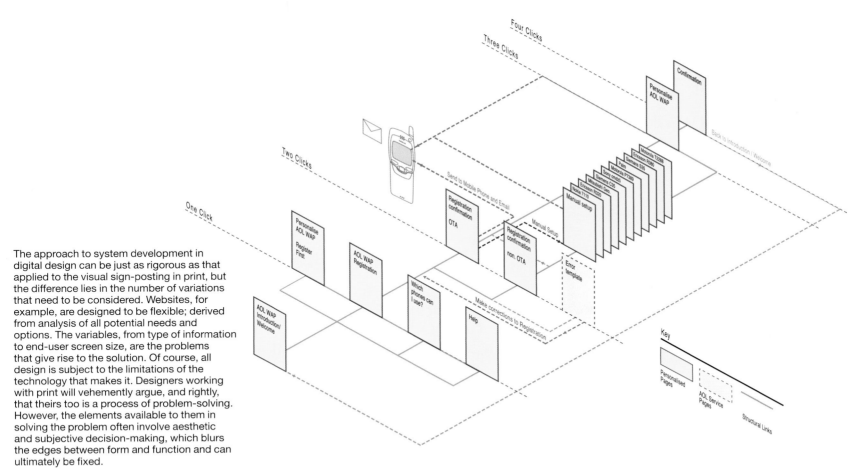

The approach to system development in digital design can be just as rigorous as that applied to the visual sign-posting in print, but the difference lies in the number of variations that need to be considered. Websites, for example, are designed to be flexible; derived from analysis of all potential needs and options. The variables, from type of information to end-user screen size, are the problems that give rise to the solution. Of course, all design is subject to the limitations of the technology that makes it. Designers working with print will vehemently argue, and rightly, that theirs too is a process of problem-solving. However, the elements available to them in solving the problem often involve aesthetic and subjective decision-making, which blurs the edges between form and function and can ultimately be fixed.

Software developed over the last two years has given even greater flexibility in the delivery of data. The structure that will determine the ultimate look and hierarchy of the information is often not only invisible – like a conventional grid – but also abstract, existing separately from its contents. It is a notional set of rules activated only when a user looks at the data. The skill lies in controlling what appear to be infinite and uncontrollable variables. 'There's always control,' comments Churcher, 'it's not frightening, it's the work.'

Because Kalends content is device-independent, its structure is enhanced for specific devices through the design of style sheets. Presentation and navigation of the portal can be tailored to the capabilities of the device, such as screen resolution, image quality and text formatting. Seen here on WAP, PDA and Pocket PC.

Templates for cross-platform technologies are designed in a similar way to style sheets in QuarkXPress but include elaborate rules, which will override each other as determined by the designer in response to different situations. The rules may be something more like this example. On a news-based website, if a news heading has 60 characters and a picture, the heading is displayed large and bold. If the heading has 180 characters, then the character size is reduced to fit the space and the image is only displayed as a thumbnail. The rules are driven by content, but consideration also has to be given to the way the data is being viewed. If the same news feed is displayed on a mobile phone, the style sheet would automatically abbreviate any header to 20 characters and would not display any picture at all. In this way, designers control all aspects of the data and its delivery. They design the initial rules, they specify the requirements of the content and they design the way text and image are displayed. Churcher refers to this process as 'dynamic content management'.

The degree of control over the visual structure is of course a core consideration. Websites, for example, can be designed so that columns expand in any direction to fill a screen, expand only in one or two directions or are fixed in proportion rather more like the layout of a conventional page. Rules can also be applied that overrule the end-user's preferences. The world of computing and the internet is still viewed by many users as strange and chaotic, which for the digital designer will amplify issues about control. The point of data delivery should give 'the perception of stability' – in order to place trust in the information given, the delivery must appear to be controlled. Ironically, this may mean resorting to graphic conventions established by print; scrolling endlessly from left to right, for example, becomes disturbing, while moving from top to bottom does not.

Reassuringly, Churcher is still preoccupied with the consistency of design minutiae as applied to his field. For him, there is satisfaction if he can look at the same site in Netscape on a PC and then see it on a Mac and the alignments of, for example, heading to picture are exactly the same – 'then that's a good job, that represents hours of hard work... after all we can get obsessed down to the last pixel.'

The relationship between streets often seems random. However, **Professor Bill Hillier**, founder of Space Syntax, reveals that there are structures that underpin even the most chaotic-looking towns and cities of the world.

right
Shown here are 12 grids that are made up of the same number of cells. Red indicates lowest trip length to all other cells, blue highest. The surprise is that the average trip length for each grid depends on its configuration. The most trip-efficient grid is top right, with small blocks in the centre and larger blocks towards the edges, as found in most traditional towns.

following pages
Space Syntax analyse the patterns of streets by applying mathematical formulas to the plans of different cities. These will determine, for example, which streets will be busiest – shown here in progressively warmer colours. Hillier points out that in London, shown overleaf, Oxford Street is bound to be the main thoroughfare simply because of its position on the grid.

Space Syntax has analysed a variety of cities over the world. Different cultures produce different street formations, as shown on the next spreads. Hamadan (Iran) is on the left and Atlanta (US) on the right. When analysed 'syntactically', however, the strongest lines tend to form a wheel-like pattern in all cultures.

'I like grids because grids are, conceptually, what cities are about,' says Professor Bill Hillier, founder of Space Syntax. The Space Syntax Laboratory is a research unit in the Bartlett School of Graduate Studies at UCL in London, with a 'spin-off' company attached. Space Syntax Limited handles commercial projects through its director, Tim Stonor, and has offices in Sydney, Brussels, Stockholm, Athens, Paris and Seoul. The two work closely together carrying out studies for public- and private-sector clients – architects, planners and property developers – including Sir Norman Foster, Sir Terry Farrell and Sir Stuart Lipton, to help them predict how people will use the places they design. By applying the space syntax methodology, it is possible to predict which parts of a complex place, such as a city or district, will be busy, and which will be less used.

Hillier argues that all cities, whether developed organically or built to a grid-like plan, are fundamentally based on grid structures. Even cities whose streets appear to be randomly distributed are, when analysed mathematically, found to be much closer to perfect grids than they are to random formations.

For Hillier, a grid is defined as: 'Groups of outward-facing contiguous buildings defining all the space around them, which then accumulate and form linear spaces.'

'All settlements evolve towards grids,' he says, 'but not necessarily regular grids.' Although it seems unlikely that cities such as London are (when analysed mathematically) quite close to being regular grids, looking at Hillier's diagrams of city streets his argument is persuasive. 'The difference between a "naturally grown" settlement and a planned grid is quite marginal,' he says. 'In a grid, all the lines (ie streets) continue to the end of the settlement. In London you find that they nearly all do. Certain lines are almost continuous all the way through.'

Because grids are structures that link different places, the structure of the grid determines, to a large extent, which parts of the grid will be busy and which will not. As Hillier puts it: 'Every grid has a major influence on how people move around.'

'Space syntax is a theory of space and a method of analysing and designing space,' he explains. 'It is based on two ideas. One is the idea that it is the pattern of space that counts; so we have to develop methods that quantify patterns, and measure patterns, and understand patterns. A great deal of what we do, particularly predicting movement, is that kind of thing. The second idea is that space isn't a background to what human beings do, it is an aspect of what they do. Space is intrinsic to what we do. So we try to put these two things together and understand the patterns formed by the things we do. If you do that, it turns out you can analyse somewhere like London and understand how it functions, and you can predict things.'

Often, the places that are likely to be busy simply because of the structure of the grid turn out to be the places where the shops are. An analysis of London shows, for instance, that Oxford Street will be busy simply because of its position within the structure of the layout of London's streets. Whereas the casual observer might assume that a certain street, such as Oxford Street, is busy because it is full of shops, Hillier argues the opposite: shops have thrived in that street because it was busy due to its position on the grid.

Many planners believe that if you put shops in a relatively quiet area, they will act as 'magnets' attracting life to the area. Controversially, Hillier argues that they won't. 'So many designers still try and put the shops where people aren't naturally going to be moving because they think that the shops will attract people – and they don't,' he says. 'If you don't get it right you eventually have to close down the shops.'

'You have to go with the flow, you have to work with the grid structure,' he says. 'That is the secret of making towns work.'

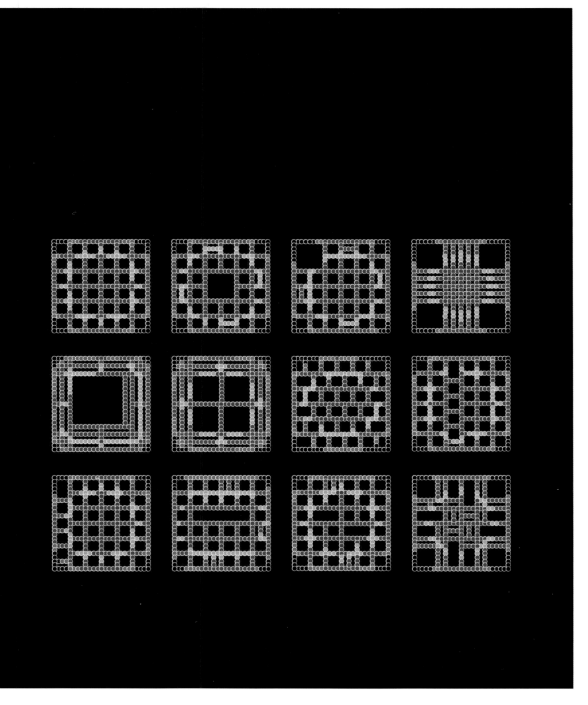

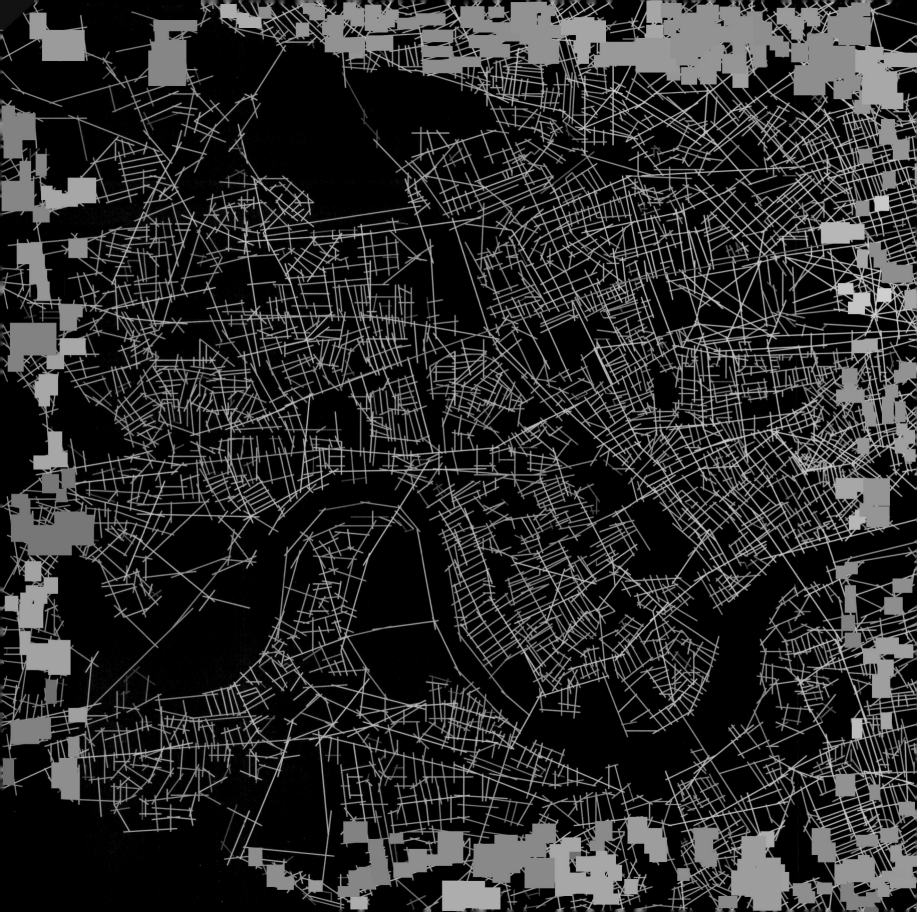

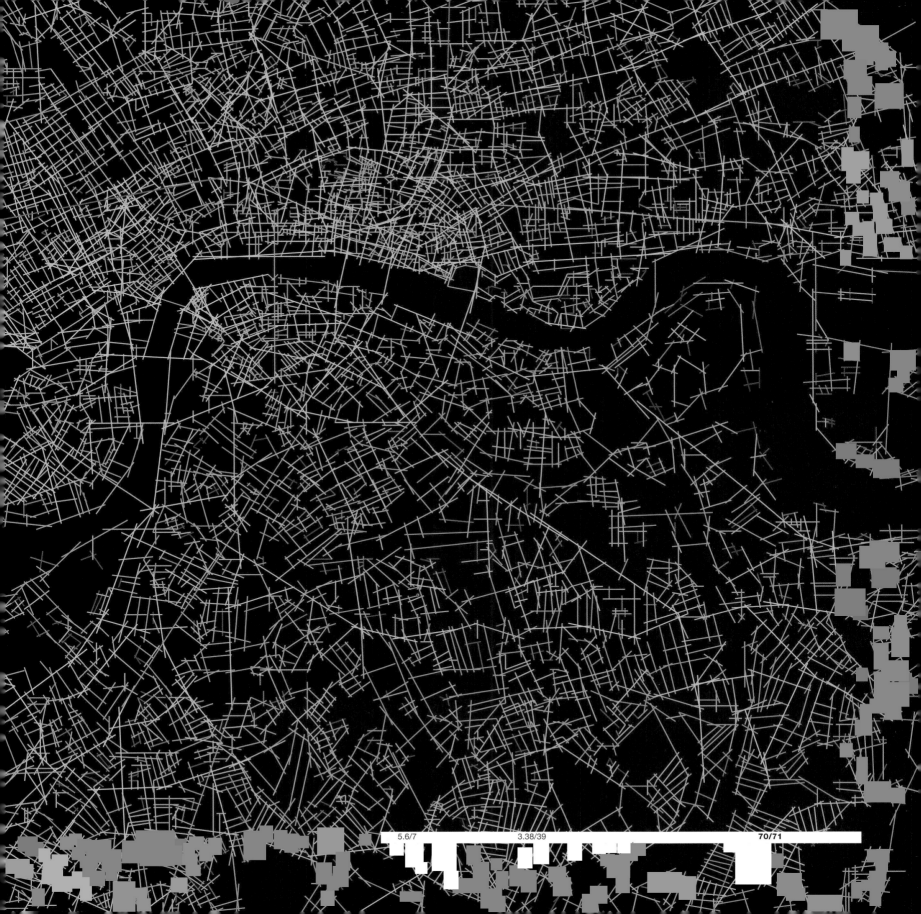

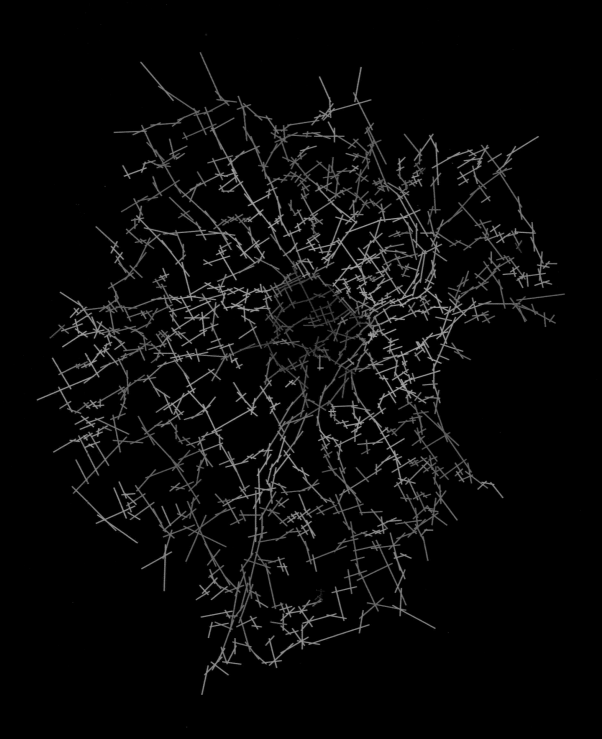

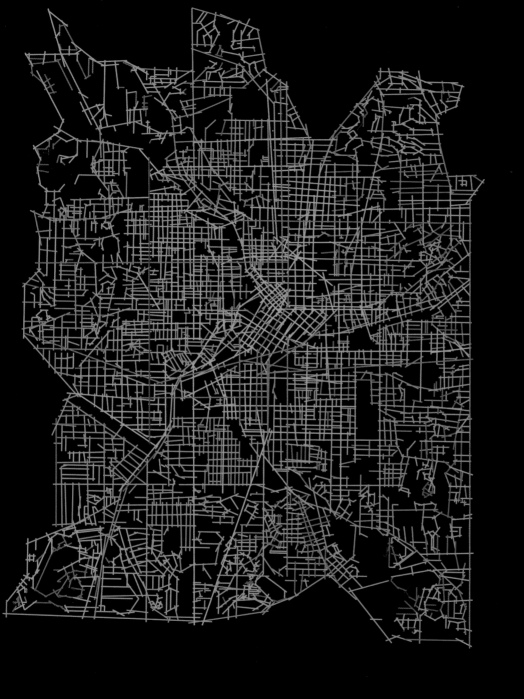

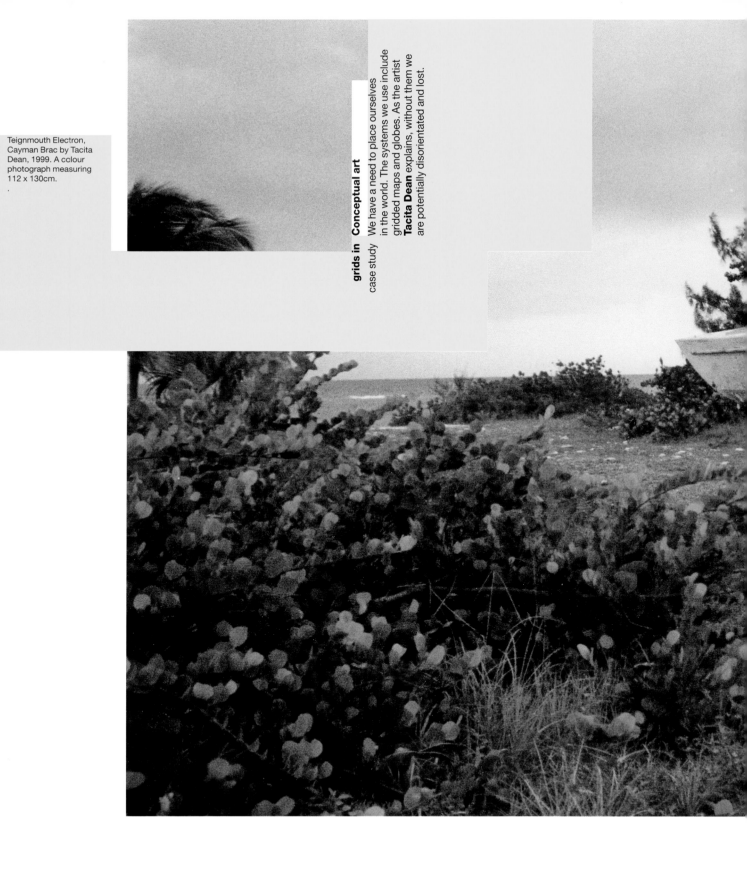

Teignmouth Electron,
Cayman Brac by Tacita
Dean, 1999. A cclour
photograph measuring
112 x 130cm.
.

grids in Conceptual art

case study We have a need to place ourselves in the world. The systems we use include gridded maps and globes. As the artist **Tacita Dean** explains, without them we are potentially disorientated and lost.

'The whole surface of the sea is gridded, invisibly,' points out Tacita Dean, an artist whose work often focuses on the sea, and our relationship to it.

Dean uses a wide variety of media – chalk drawings on blackboards, film, sound, and even a hugely complex and specially made jukebox. 'I find the content, and then the form comes from it,' she says. 'And most of the time it's film, but it can be anything – a CD, a photograph, a drawing or whatever.'

Much of Dean's work explores the relationship between formal, manmade structures that measure time or mark space, and the unpredictable natural elements that surround them – the sea, the weather. Several of her films have focused on lighthouses. 'They are the manmade element to the sea, the cipher that helps us locate ourselves in our human world,' she says. 'Each lighthouse has its own rotation, they are beautifully ciphered right the way up the coast. They are all marked on maps so that you know that such-and-such a lighthouse has two flashes a minute.'

Just as the temporal regularity of the sun rising and setting provides one way for sailors to locate themselves in an otherwise unchanging environment, so does the regularity of a lighthouse's rotating beam. Often, the films that Dean makes of these phenomena are shown as continuous-loop films, which are shown with their own temporal regularity, adding to the complex conceptual structure behind the work. 'It's like concentric circles, in a way,' she says, 'like circular grids.'

The other, more obvious grid to consider in the context of the sea is that of latitude and longitude – again, a conceptual grid, but one that has overriding importance for navigation, and therefore safety. Sailors who could not calculate their position with any exactitude were said to be prone to time-madness, losing all sense of their spatial and temporal bearings.

grids in Conceptual art

Dean recently became interested in the story of Donald Crowhurst, a British sailor who competed in the first single-handed non-stop round-the-world yacht race in 1968. After 243 days at sea, Crowhurst disappeared at the point when he seemed to be winning the race. His vessel, Teignmouth Electron, was later found abandoned. When his log books were found, it became clear that from an early stage he had faked his journey and instead of going around the world, had stayed in the southern Atlantic, hiding from the shipping lanes and losing all sense of himself. Obsessed by his deceit, and the financial ruin he faced having put all his money into the project, he appears to have taken his life.

'All this was pre-satellite navigation,' explains Dean. 'In those days you had to work out where you were through site readings. You worked it out at noon, when the sun was at its highest point. It's complicated, but you could work out your longitude using local time and Greenwich Mean Time. And latitude is easy to know. But if you lost Greenwich Mean Time, if you didn't keep your chronometer wound up, you could no longer locate yourself on the surface of the earth.'

Although no-one knows precisely what happened to him, Dean has her own theory. 'I believe that Crowhurst suffered from time-madness,' she says. 'He just couldn't temporally locate himself, and, therefore, spatially as well. We know he started to read Einstein's Theory of Relativity. In the end, I believe – and it's always only going to be a hypothesis – he started to count down chronometer time, "I will end my life at…" And at that time, I think, he jumped overboard with his chronometer.'

The grid	Principle	Everywhere	Cultural	Psychology	Making	Breaking
	When		Architecture	Wim Crouwel	Control	
	What		Music	Simon Esterson	Precision	
	Why		Furniture design	Linda van Deursen	Measurement	
	How		Fine art	David Carson	Micro/macro	
			Interior design	Peter Gill	Components	
			Screenplays	Krieger I Sztatecsny		
			Digital design	Cartlidge Levene		
			Town planning	Wendelin Hess		
			Conceptual art	Hamish Muir		
				Ellen Lupton		
				John Maeda		

The designer and the grid
Introduction
The principle of the grid
Grids are everywhere
The grid in cultural context
The psychology of the grid
Making the grid
Breaking the grid
Bibliography/Contacts/Credits/Index

Jason Wright MAIP MCTP
Analytical psychotherapist
(UKCP Registered)
Director of The CORE Trust,
a charity working with addicted people.
Jason Wright has a private practice
in North London.

This section takes the form of a series of interviews with 13 graphic designers. It reveals a tension between modernist and postmodernist thinking; on the one hand a search for truth and purity, and on the other an attempt to contain a more chaotic plurality. The distinctions do not appear to be factors of age, experience or cultural background, so, as the analytical psychotherapist Jason Wright asks in this introduction, is it possible that people who favour the grid could conform to some psychological type, or exhibit some common trait?

A grid provides a framework within which a designer or typographer can order the potential chaos of letters and images on a page; a device to find a quantitative measure for aesthetic values. Many of us focus on finding containment in some way; these are attempts to resolve fundamental questions regarding chaos and order.

Much psychological and psychotherapeutic thinking is focused on how experiences are contained when the developmental process is disrupted. For example, when we describe someone who is slightly obsessive as being 'anal', we are actually referring to the Freudian notion that there has been some disturbance during the anal phase of development, which generates these obsessive behaviours. So does this mean that those who obsessively use the grid to contain type and images on the page are actually 'acting out' issues that are connected to this stage of development? Possibly, but this is not the most creative way of understanding what psychological relevance the use of the grid has.

The tension between chaos and order and its concomitant anxieties are present in all human activity, not just graphic design. We rely on assumptions to simplify this complexity. But in what social and psychological factors are these assumptions grounded? They can be deconstructed as cultural stereotypes, or investigated using in-depth analysis of personal history and how it has motivated one as an individual. It is the process of challenging or questioning these assumptions that is important, because in doing so we are re-evaluating our perception of our environment and our role within it.

With this re-evaluation we come to understand the complex forms that order can take. For instance, order can be discovered in environments that previously were considered chaotic, such as climate. The questions raised by these attempts to understand our environment and ourselves are relevant to any structure we use as a defining tool, of which, of course, the grid is one.

Any attempt at communication, however subliminal, must have some psychological context and intention. This leads to questions about how the grid, as a tool, might both fetter and facilitate the communication of the ideas and feelings behind the designer's choices.

Designers need to order their thoughts and actions visually. How, given the innate psychodynamic structures that any one designer will have, and the time in which they live, has their interaction with the grid enabled them to contain the unconscious processes that influenced their work? Answering this truly enters the tensions between clear modernity and the muddy postmodern. Hopefully, the following interviews will provide some insight into how the designers, by using the grid (or not), created actual physical and psychological spaces that allowed their work to happen.

Wim Crouwel

biography
born 1928
nationality Dutch

1946–49
Art Academy Minerva
Groningen
1952–53
Amsterdam Art Academy
1954–63
Freelance designer
and partner in design studio
Amsterdam
1963–80
Founding partner of Total Design
Amsterdam
1980–85
Consultant to Total Design
Amsterdam
1985–93
Director of Museum
Boymans-van Beuningen
Rotterdam
1994 to the present
Freelance designer and consultant
Amsterdam
1954–85
Professor and lecturer at a variety
of international colleges including
Amsterdam Art Academy,
Royal College of Art in London
and Technical University in Delft

'I was called "gridnik" because all the time I was talking about grids and giving lectures about them.'

Catalogue cover and spread for the Museum Fodor, Amsterdam, 1976. The grid for this series of catalogues, derived from the monospacing of a typewriter, is shown as a series of dots over the whole cover.

fodor 34

Ria Rettich

19 maart - 9 mei 1976

Museum Fodor
Keizersgracht 609
Amsterdam
telefoon (020) 24 99 19
open dagelijks van 9.30 - 17 uur.
zondags van 13 - 17 uur.

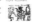

Wim Crouwel is an original. He was influenced enormously by the work and teachings of the post-war designers in Switzerland and in the 1950s and '60s pioneered the application of systematic design thinking in Holland.

While he describes the preceding generation of Swiss designers – Armin Hofmann and Josef Müller-Brockmann for example – as his heroes, the strongest influence was that of his contemporary and colleague Karl Gerstner.

In 1963 Gerstner's book, Designing Programmes, was published. This selection of previously published essays became a cult volume. Its subtitle – Instead of Solutions for Problems, Programmes for Solutions – makes clear the methodical approach that it espoused. Gerstner advocated 'integral typography', by which he meant an appropriate relationship between content and form. This relied upon an analysis of text, images and hierarchy, and a structured approach to layout that inevitably led to the use of a grid.

Both Gerstner and Crouwel were to take this concept to new levels of detail and intricacy. In 1963 Wim Crouwel, Friso Kramer, Benno Wissing, Dick Schwartz and Paul Schwartz set up the renowned design company Total Design. At this time, Crouwel and his colleagues embraced the concept of the grid with great fervour and took experimentation with these structures to a high level of refinement. The studio was adorned with pre-printed grid sheets; some were straightforward while others showed the variety of possible configurations achieved by placing different combinations of columns on top of each other. 'We made a real art out of it,' explains Crouwel.

By the 1970s, corporate culture had embraced modernist typography wholeheartedly, but at the time of its inception it was radical. Crouwel explains that the grid was a natural outcome of the rise of 'no-nonsense typography' with its assimilation of the principles of abstract painting, notions of purity and minimalism and a political idealism. The 'traditional' symmetrical layout was considered to be illogical, and embroidered by unnecessary typographic devices that intruded between reader and author. Modernist typographers advocated simplicity and clarity in all areas of design, which suited new methods of production and the growth of mass communication. Naturally, asymmetry was adopted. Sans-serif fonts, unencumbered with the excrescences derived from calligraphic or stone-cut letterforms, were used and changes in type size or weight kept to a minimum. The relative positioning of elements on the page became the primary method of guiding the reader; hence, the unprecedented use of the grid.

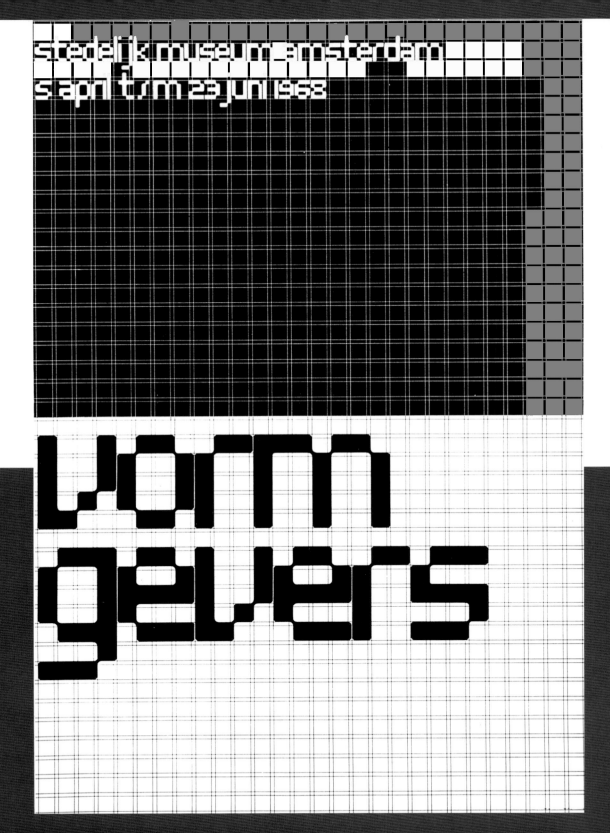

right
The poster and catalogue
covers for the design
exhibition Vormgevers
at the Stedelijk Museum,
Amsterdam, in 1968.
Crouwel decided to make
the contemporary design
tool, the grid, visible.
All the museum's publicity
used the same system
of repeating units both
horizontally and vertically,
with a poster using more
units than a catalogue.

bottom right
A spread from the Claes
Oldenburg catalogue,
Stedelijk Museum, 1970.
The standard grid was used
for all catalogue pages.

top right
Crouwel experiments
with the grid for his
own show at the
Stedelijk Museum in
1979. Pictures and text
appear to be offset.

This methodology still makes sense to Crouwel. 'I could never work all by eye, like a painter,' he comments, 'I was always calculating things. I have to have my basic lines before I bring even a letter onto the page.' This does not mean that Crouwel is unaware of the visual potential of his work, 'My interest in structure is also an aesthetic one. Grids combine the practical with a minimal beauty. Even if you don't want to stand between the reader and the author it should not be grey work,' he comments, 'it should have some tension and some expression in itself. I like to compare it with the lines on a football field. It is a strict grid. In this grid you play a game and these can be nice games or very boring games.'

Crouwel's most rigorous and refined application of a grid was in his 20 years of work, from 1964 to 1985, for the Stedelijk Museum in Amsterdam. At the outset he was keen to develop a system that gave all the museum's publications a unity, and was flexible enough to be used for all their graphic design output.

The grid that he developed used the same configuration of margin to column and intercolumn space both horizontally and vertically across and down the page. The outer margins and intercolumn spaces were the same size. All columns were then four times as big so the repetitive divisions followed a 1/4/1/4/1 etc formation. Catalogues were always the same size. Posters used the same system, with margins, intercolumn spaces and columns the same size as the catalogues, but with an increased number of fields across and down the sheet. A number was attributed to each vertical and horizontal line. Rather like the coordinates of a map, these numbers were used to make instructing typesetters and printers particularly easy, as corrections could be made and specified precisely over the phone. Crouwel admits that a dilemma can arise in applying an uncompromising theory. 'When I worked for the Stedelijk Museum I was very rigorous but now perhaps I am less so, although today I continue to work with grids. Then, I sometimes went for a less interesting page which was still on the grid. There is a fight between the theory and the practice all the time.'

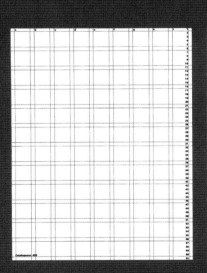

Crouwel is slightly sceptical of purely self-expressive design, but he does believe in the validity of experimentation with form, particularly in response to new technologies. In 1967 he designed the 'new alphabet', a series of letters that took their display on a monitor as a starting point. Crouwel argued that font design did not reflect the means of production or display. The advent of the pixel made curves and diagonals an anathema. The new alphabet adhered tightly to a horizontal and vertical grid. Although Crouwel acknowledges there were legibility problems, this was not the point. The intention was to start a debate about form in relation to means of production. The new alphabet has endured. In 1997 it was fully digitised, missing characters were added by Crouwel and it was issued as
a commercially obtainable font.

In keeping with other designers of his generation, there is a humility that underpins Crouwel's work. His formative years were spent during the optimistic post-war period. Designers were fortunate in having a feeling of enormous self-worth derived from the application of their skills within a large social context, and as a result placed less emphasis on individual self-expression.

Seen in this context, grids were symptomatic of a thoroughness in design methods and a belief in increased access rather than a method of control and limitation. 'It's a way of life,' Crouwel comments. 'It has to do with your inner self and how you consider freedom. Now designers have a very different idea of structure. I'm jealous sometimes! There's a lot of freedom, which is a relief, but the decisions are made on the basis of what one sees on the screen. It's superficial but that is also its strength.' Crouwel is very even-handed in his assessment of the new and carefully considers the motivation of designers working now. 'I'm very curious about contemporary design,' he comments, 'but the big difference, in this postmodernist period, is that in our period we thought design could help society. We wanted to make things more usable. We all did our job to better society but we didn't succeed.'

Spreads and cover from a booklet promoting Crouwel's 'new alphabet', 1967. The letters adhered tightly to a horizontal and vertical grid derived from the pixel.

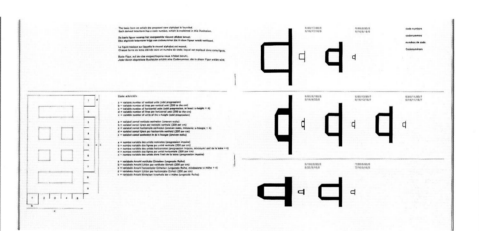

neu
alphabet

a
possibility
for
the
new
development

een
mogelijkheid
voor
de
nieuwe
ontwikkeling

une
possibilité
pour
le
développement
nouveau

eine
möglichkeit
für
die
neue
entwicklung

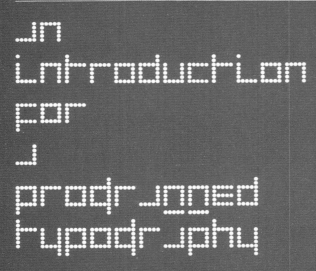

an
introduction
for
a
programmed
typography

Simon Esterson

biography
born **1958**
nationality British

1982
Co-founder of Blueprint magazine
London
1990
Partner of Esterson Lackersteen
London

'I'm not a free-form designer – I can't even design a business card without a grid. That's how I work.'

The front page of an issue of The Guardian showing the standard eight-column grid used for British 'broadsheet' newspapers. Advertising space is sold on the basis of this grid.

101 travel tips The ultimate guide to a hassle-free holiday. Plus Home hot spots in Jobs&Money

The **Guardian**

WIN Tickets to Homelands Guide offers

Ulster close to devolution breakthrough

My Man City hell – by Simon Hattenstone In Sport

Vanessa Regrave – a life in parts In Saturday Review

The secret of life In Weekend

It's good to think

Livingstone

75p
May 6 2000
Published in London and Manchester
guardian.co.uk

Ken shows grace in victory – for 3 hours

Matthew Engel

Ken Livingstone finally ascended the podium in the QEII Conference Centre in Westminster yesterday at 12.20pm. With a brief, businesslike and gracious speech of acceptance, he became mayor of London, concluding a process that was long, disordered and sometimes thoroughly malign.

He stretched out the hand of friendship to his defeated opponents and the government. Since it was so freshly dipped in the magic waters of the democratic will, no one actually spat on it. Not even from a distance: Tony Blair sought refuge in Belfast, which had suddenly become a politically congenial city compared with London.

This time for real, Steve Norris smiled; Susan Kramer looked as though she was thinking it over; Frank Dobson grimaced — perhaps thinking it was the best offer he had had. They were all equally stylish in

response, helped by weeks of knowing how it would all turn out.

This inaugurated an era of good feeling and reconciliation, and it lasted a full three hours. Mr Livingstone then began lecturing the government on the over-valuation of the pound and the threat to Ford jobs in Dagenham.

The Livingstone approach to mayor-making remained eccentric to the last. He arrived early, by tube (which broke down), then went for a swim. He could not keep

the "told you so, Tony" out of his voice, but his behaviour was engagingly antiumphalist.

Meanwhile, the election itself was ending in a manner in keeping with the main parties' handling of it: shambolic.

It was predictable that the new machines used for counting the votes would cause trouble.

Some politicians had speculated that the supposedly slow Brent and Harrow constituency would never get finished in time for the supposed 5am announcement.

It didn't. Its result came nearly two hours after that. But it beat every other section in the capital. With a 30% poll, the first results were supposed to be available at 2.30am. Instead, there was dust in the hard drive at Enfield; a malfunction at Bromley; a breakdown at Kensington. It sounded like the morning travel round-up.

Too late, it was realised that this election had introduced too many novelties at once. Londoners — asked to make a first and second choice for mayor, pick an assembly candidate and then a party as well — were confused enough to make a contender for a top-up seat in the assembly.

The effort to make local democracy accessible and popular had spectacularly failed.

Party officials also admitted that the numbers of votes involved meant that they could give the ballot papers only cursory scrutiny, and that they had only the haziest idea whether the figures that emerged were accurate. Since they were broadly in line with exit polls and expectations, they were assumed to be all right.

It all seemed an alarmingly untransparent form of democracy. "In the end, you have to trust **▶ Page 2**"

The results

Mayoral election

Ken Livingstone	776,427
Steven Norris	564,137

(After counting of second preference)

First vote totals

Livingstone	667,877
Norris	464,434
Dobson	223,884
Kramer	203,452

Greater London assembly
(seats won)

Conservative	9
Labour	9
Liberal Democrats	4
Green party	3

Local elections
(net change in seats)

Labour	−573
Conservative	+593
Liberal Democrats	−18
Green party	+4
Others	+3

Quick Index

Weather 29
Quick Crossword 29
Main Xword Review, 12
Today's TV The Guide

Ken Livingstone yesterday after his victory in the race to become London's mayor. He pledged to 'unite all of the capital' Photograph: Stefan Rousseau

An exhausted and emotional Ken Livingstone yesterday celebrated his remarkable election as independent mayor of London by offering the hand of renewed friendship to his humiliated Labour opponents — and immediately placing them on the horns of a near-impossible dilemma.

As final details of Thursday's council elections confirmed that William Hague's Tories had gained 600 seats, mainly at Labour's expense, Labour and the Liberal Democrats shared one comfort. Tactical anti-Tory voting in the Romsey byelection produced a convincing Liberal Democrat majority of 3,311 in south Hampshire.

Such a defeat on a 60% turnout, double the disappointing rate elsewhere, is certain to dent Mr Hague's new populist tactics on immigration and asylum as the general election looms, especially when contrasted with the leftwing populism successfully promoted by the former GLA leader.

Hours after the long-delayed confirmation that he had won enough second-preference votes to beat off Steven Norris's late surge, mayor-elect Livingstone staged a chaotically informal first press conference in his temporary HQ at Westminster.

He used it to announce his title — he wants to be addressed as "Ken" — and that he will be offering key posts in his administration to rival mayoral candidates, including the post of London's "poverty tsar" to Frank Dobson. They had all fought for "the city we love", he explained.

The new mayor also revealed urgent plans to meet two senior ministers, John Prescott and Stephen Byers, next week to discuss Ford's threatened factory closure at Dagenham — an early pointer to the interventionist style he will deploy to radicalise New Labour's economic policies.

"I am overwhelmed that London has given me a mandate against the three most powerful party machines in Britain," Mr Livingstone told reporters before walking

through the streets of London cheered by supporters.

Cheekily quoting Sir Winston Churchill's maxim — "in victory, magnanimity" — he explained: "The job of the mayor is to unite all of the capital so I will immediately be taking measures to involve all parties in the government of the city. This process of consultation has already begun."

Speaking from Hillsborough, where he was engaged in Irish peace talks, Tony Blair was equally diplomatic. "Whatever my personal views about Ken Livingstone, they haven't changed, that's not the point. The people of London have made their verdict clear and it's my responsibility to make sure it works for London," he said.

Mr Livingstone is stressing that he wants to "heal this wound, not deepen it". But pressures to readmit him to Labour's ranks will be strongly resisted. Despite his praise of Mr Dobson — his "old friend and colleague has borne a terrible brunt of opprobrium which was not his" — the former health secretary is not for wooing.

Mr Dobson managed a gracious concession speech when his third-place defeat was confirmed, but its certain to say no to his tormentor's job offer. "In a democracy we have to tell the truth whether it turns out to be popular or not," he said. That was a coded attack.

Also set to decline are Mr Norris and the Liberal Democrat candidate, Susan Kramer, whose 28% of the second-preference top-up votes — by far the highest share — was a tribute to her campaign.

But the real dilemma is to be resolved in the days ahead is what Labour's nine members on the 25-strong Greater London assembly will do when Mr Livingstone invites them to join his cabinet or take other senior posts in his gift.

Pending a direct approach to his nominees he named no names. But the Haringey council veterans Lord Toby Harris and Nicky Gavron are in the frame along with the broadcaster Trevor Phillips, who would have been Mr Dobson's deputy.

Darren Johnson, the Green GLA member, is also likely to get something, although Mr Livingstone withdrew an ear-

lier promise of the deputy's spot because the Greens are, as yet, too inexperienced.

Much to Labour's fury, the Greens benefited from Mr Livingstone's tactical support and picked up three assembly seats. Labour's nine, the same as the Tories, are fewer than predicted. Mr Livingstone called it a drubbing, Labour's "worst election defeat in London", but insisted it was not his fault, because Mr Blair had refused his own offers of a deal.

Such talk will make it harder for the Labour GLA trio to accept the mayor's olive branch — thus risking accusations that it is Labour that is blocking the chance for a new consensual politics.

"They're damned if they say yes, and damned if they don't," admitted one Labour official. Downing Street has learned its lesson from excess control in the past and will leave the group to resolve its own dilemma.

Mr Livingstone refused to say yesterday if he will take the government to the high court over its public-private partnership scheme to modernise the tube.

Inside

● The PM's office made it clear it did not want blood on the carpet. **Michael White** and **Kevin Maguire**, page 3

● "Ever since his 1997 triumph, friends have talked of Tony Blair walking on water. On Thursday night he sank." **David McKie**, page 9

● Election special reports and analysis, pages 2–9

● People have asked whether they intend to collaborate with the government. The simple answer is yes." **Ken Livingstone**, page 26

● The political rulebook was burned yesterday, leaving politicians and citizens alike to pore over its remains." **Leader comment**, page 27

● Local election results at **www.guardianunlimited.co.uk/elect2000**
Breakdown of the mayoral vote at **www.guardian unlimited.co.uk/mayor**

Martin Amis – the facts

"I've been namedropping ever since I first said Dad." In Experience, his brilliant new memoir serialised exclusively in the Guardian next week, Martin Amis reflects on life with Kingsley and describes his own journey from feckless adolescence to midlife crisis and fatherhood.
Starting Monday in G2

They unveiled the surprise proposal to re-form the power-sharing executive at Stormont on May 22, as long as the IRA plays its part with a positive statement spelling out its willingness to put its weapons beyond use.

In a joint statement, the British and Irish governments revealed vital changes to the Good Friday agreement, now two years old, which appear to have been the price to be paid to pull the IRA on board. The switches echo republican demands. The deadline for decommissioning is to be extended to June next year. It was meant to be May 22 this year.

The definition of decommissioning is set to be widened. No longer will destruction of weapons be required. Putting them beyond use, an implicit definition less offensive to the IRA, will be sufficient.

The government also made it clear it would never again act unilaterally in suspending the institutions, as Peter Mandelson, the Northern Ireland secretary, did on February 11. That can now happen only after a review of the agreement, involving both governments.

Other key details of the government's blueprint were being kept under wraps early today. Although the parties know the broad outlines, they will only receive the full details this morning, and will be asked to consult their memberships.

There was a growing sense of optimism as the day wore on at Hillsborough yesterday. Mr Blair, on a day when devolution turned on him in London, may yet have rescued his plans for self-government in Northern Ireland in sensational fashion.

(continuing left column)

...have set out the mechanisms and steps necessary for achieving the full implementation of the many outstanding aspects of the Good Friday agreement."

He said: "For weeks now we have been calling upon the republican movement to tell us what they are going to do. We now hope they will tell us what they are going to do."

Mr Trimble, who two months ago survived a challenge to his leadership, will face difficulties in selling to his sceptical Ulster Unionist Council proposals that fall short of a start to IRA decommissioning before he is asked to rejoin government with Sinn Féin. His assembly party is understood to be divided on the plan.

The main elements encompass a positive IRA statement, committing to an arms gesture within two months; government plans to cut troop numbers; and perhaps a respite for the RUC's name. That might be the carrot to tempt Mr Trimble to push his party to accept the deal. The next few days will be crucial.

Ulster talks, page 11

...to restore devolution to Northern Ireland in 16 days' time after a second night of intensive negotiations at Hillsborough Castle in Co Down.

Simon Esterson

The Guardian's master grid has 24 columns. Different combinations of these units make it possible to have a variety of text measures.

Ten more years: 64-year-old veteran draws parallel with Mandela in proposing post as honorary NUM president

News

Ageing King Arthur clings on to his shrinking court

Long decline of a once mighty union

Martin Wainwright

Arthur Scargill, leader of a tiny army of miners but a huge financial empire, signalled his hopes yesterday of continuing to play a major role in their affairs for at least the next decade.

To furious attacks from his critics, the 64-year-old persuaded a meeting of National Union of Mineworkers' officials to take the first steps towards creating a new position of honorary president to keep him involved after his planned retirement in July.

The suggested post would be unpaid but part of a restructuring of senior NUM positions which opponents of the veteran tactician say would keep the Scargill stamp on the union which he has led for 20 years.

It would not need endorsement by individual members, now shrinking towards an expected 2,600 next year, compared with the mighty army of 180,000 between the victorious strikes of 1972 and 1974 and the disastrous one of 1984-85.

Although humiliated by the stark decline of the NUM, to minnow numbers which risk takeover by a larger union if and when the Arthur era ends, Mr Scargill has shown formidable skill in fighting to protect and enhance the union's outsize assets, pensions and convalescent homes. Friends and allies say that he would find it impossible to break completely with the union which has been his life since he started at Woolley colliery, near Wakefield, aged 15.

"It's an outrageous attempt to keep a hold on power for as long as possible," said Kevin Barron, Labour MP for Rother Valley in South Yorkshire, who was expelled from the NUM 10 years ago after earlier attacks on Scargill. "Where is the Arthur Scargill who believed that all MPs should be deselected on a vote of individual party members? That union leaders should be elected by all their members? That mineworkers should take retirement at 50?

"Members of the NUM wouldn't support this if they each had a vote on it. Feelings have changed. People who were strong critics of mine when I was expelled, like Dave Douglass [NUM secretary of Hatfield colliery, Doncaster, who has called for a members' vote on the issue] have turned against Arthur Scargill."

The Hatfield branch saw a number of angry protests when the plan was raised at a meeting on Saturday, including an allegation of "unbelievable cheek". Mr Scargill also had a bumpy ride at the last NUM national executive meeting of 2001 in December.

Terse views

Minutes leaked to the Yorkshire Post record objections from three executive members and allegations from the fourth of a "stitch-up". "The president vehemently stated there was no stitch-up," the minute book adds. Delegates leaving yesterday's meeting of Yorkshire area NUM secretaries at the union's Barnsley HQ gave divided - and terse - views on the issue. One said that the idea had "just got through" while another said: "He's great. I wish he could stop in there for another hundred year."

Mr Scargill, who will draw the last pay cheque of his £70,000 salary in July, dismissed the notion that this honorary ambition meant that he was unable or unwilling to surrender his grip on union power until he reaches 74. He said that the planned new post would allow him to concentrate on politics, where his Socialist Labour party has been left without a president following the death from cancer last week of the position's holder, and Mr Scargill's deputy at the NUM, Frank Cave.

"I'll be retiring early', said Mr Scargill, who turned 64 only last Friday. "And it's an honorary presidency, no different from Nelson Mandela in South Africa, who was a miner and who is honorary president of the NUM in South Africa. I doubt whether Nelson Mandela's ever been to a meeting of the NUM but it doesn't stop him being honorary president.

"Honorary means what it says - honorary, unpaid president of the NUM." Scoffing at the idea that he might try gardening his Barnsley home is opposite Britain's greatest rhododendron collection at Wentworth Castle), he said: "My job will be to pursue the aim I've always had, and that is to build in Britain a socialist society."

An example of his tenacity, long after the NUM had lost its national clout, came in 1998 when he and Mr Cave were removed by the charity commissioners as trustees of the Yorkshire Miners' Welfare Trust and the Yorkshire Miners' Welfare Convalescent Homes. The high court decided "regretfully" that the two men had switched £800,000 to the convalescent homes to keep the money out of reach of a new welfare system involving the private sector, which they opposed.

Mr Justice Neuberger found that the transfer had been done without proper authority and constituted "misconduct". But as well as ruling out any suggestion of personal gain, he emphasised the two officials' motives of concern for the convalescent homes and genuine belief that they were acting on an overriding principle - the welfare of miners.

The leaked executive committee minutes say that if the proposal goes ahead, Mr Scargill would continue paid work after his retirement for the International Miners' Organisation, which is affiliated to the NUM and has already appointed him president for life.

As for the horror, for a headlines veteran, of has-been status: he has far outlasted his political arch enemy Margaret Thatcher as an effective force.

● The National Union of Mineworkers was the mightiest industrial force in the country for much of the 20th century and the only trade union credited with a government's scalp, when Edward Heath was voted out of power in 1974. Along with its industry, the union has shrunk to inconsequence today. But it retains vast assets and is involved in multi-million pound pensions for its army of former members.

● At the time of the 1984-85 strike, there were some 180,000 members. Two years ago there were fewer than 6,000 and predictions for the end of the coming year are below 3,000. During the same period the number of pits has shrunk from 170 run by the National Coal Board to 13, all private.

● Until the strike, the NUM enjoyed a monopoly over rank and file miners. The strike created the breakaway Union of Democratic Mineworkers which took much of the NUM's Nottinghamshire strength.

● In 1945 the NUM sponsored 37 MPs, compared with 17 paid or part-paid by the TGWU. Today 12 MPs are still NUM-sponsored.

● At the height of Scargill's power in 1982, the NUM moved from London to build its own £2m headquarters in Sheffield, shaped like the head of a miner's pick. It was abandoned before it was finally completed, and the castellated Yorkshire office in Barnsley, known as Arthur's Castle, with red roses planted outside round a statue of a miner with his family by Graham Ibbeson, better-known for his sculpture of Eric Morecambe.

● Most poignant is the decline of the Durham Miners' Gala, once a huge rallying point for the labour movement, which leading Labour politicians felt obliged to attend and speak at. Last year's 117th gala was attended by only 1,000, and most Labour politicians no longer bother to go.

Martin Wainwright and Richard Nelsson

Scargill today, a lonely figure at a mining history lecture; below, at the centre of NUM strikers at Orgreave, when his union boasted 180,000 members Photographs: Jeff Morgan and Don McPhee

Goodlee byelode to Professor Stanley Unwin, 90

Maev Kennedy Arts and heritage correspondent

"Professor" Stanley Unwin, purveyor of the highest quality nonsense to the masses, and icon of generations of comedians and pop stars, has died aged 90.

The former BBC engineer invented Unwinese, a language which bore a tormentingly glimpsable relationship to English and sense, while telling bedtime stories to his children. His glory days were on BBC radio and television in the 1940s and 50s, but generations of artists and advertising copy writers kept discovering him anew. As he once remarked of his favourite jazz artists, it was "a stait of a historical impagers indeedy-ho!"

Among his many admirers were Spike Milligan, Freddy Starr, the late Tommy Cooper - who, audaciously calling the kettle black, described him as "bleeding barmy" - and John Lennon. Lennon acknowledged that his first book, A Spaniard in the Works, was thoroughly Unwinised.

He died peacefully on Saturday in hospital in Daventry, Northamptonshire, according to his former agent, after 30 years of attempts to retire. He appeared in films, memorably as the landlord in Carry On Regardless, and as the chancellor in Chitty Chitty Bang Bang, and in innumerable commercials, but his voice and manner were also clearly composed in Unwinese.

His voice can currently be heard on the Wubble U track Petal, a hippyish blend of Hammond organ and drum and bass, lamenting that "It's difficult these days to get good grass", and he also made a guest appearance on the video. However his career as a pop star was launched in 1967, the original Summer of Love, when the Small Faces released Ogden's Nut Gone Flake, a title clearly composed in Unwinese.

The record is revered as the first UK concept album, with one side featuring Professor Unwin narrating the story of Happiness Stan, and his daunted search for the other side of the moon.

Although endlessly imitated himself, Professor Unwin admitted that his language became as an imitation of his mother. He was born and brought up in Pretoria, South Africa, where his mother tripped and fell heavily one day, explaining to the little boy that she had "falloloped over and grazed her kneeclapper".

Her influence was still clearly visible half a century later in the opening lines of his version of Goldilocks: "Once apolytito and Goldiloppers set out in the deep dark of the forry. She was carry a basket with butteresflabe and cheesy flavour".

He was already famous for his inventive wit among his BBC colleagues, when he was offered his first spot, on regional radio in 1949, delivering a spoof sports commentary. He was still recording jingles for Kiss FM radio, and an ad for Pirelli tyres in his late 80s.

Obituary, page 18

Stanley Unwin: inventive wit

Simon Esterson, a partner in the London-based graphic design studio Esterson Lackersteen, is renowned for his editorial design, having been responsible for the look of numerous magazines and newspapers, including The Guardian in the UK, and Domus, the international journal of architecture and interiors. He also has extensive experience of book and catalogue design for a variety of galleries and museums including the Royal Academy of Arts and the British Museum in London.

Despite admitting that he can't work without a grid, he treats them very pragmatically, as a useful tool rather than an end in themselves. The intellectual buzz that some designers derive from working with extraordinarily complex structures is not something that motivates him.

'For me, it's a pragmatic tool, it's about how you land something on the page,' he says. 'My grids aren't really sophisticated. The sophisticated grids are about horizontals and verticals. But in newspapers, using horizontals can come to mean that there is a lot of white space. So a lot of my newspaper grids might have horizontal positions, but often they aren't used in a very sophisticated way.'

There are good reasons for this beyond the problem of excess white space: editorial design is unusual in that the designer usually does not have full control over the results. Having set up the basic parameters – the grid, the masthead, the choice of typefaces, rules about the way that captions should work and pictures should be used – the designer usually has to leave the layout of individual pages to the magazine or newspaper's sub-editors. The sub-editors, working to very tight deadlines, then have to fit the stories and images into the page and write the headlines and captions. By training, sub-editors are more concerned with words than design – a designer who expected them to work with an overly complex grid system would not last long.

Another constraint on newspaper design is advertising. In the UK, the serious 'broadsheet' newspapers all have eight-column grids. This uniformity means that advertising agencies can design their print ads to fit into any newspaper. In addition, there is the need to distinguish visually between different sorts of articles – news, features and comment. A long, descriptive feature about a film star, for instance, is a very different sort of thing to a short, factual news story about inflation. They need to look different to each other so that the reader senses what sort of thing each one is. With 'comment' pieces it is important that the reader understands that they are reading someone's personal point of view, and not a more objective account of an issue. A different column width or other such visual cue can help communicate the difference.

'The Guardian had to be an eight-column grid because of the ads, but the interesting thing for us was to see if we could do another grid to work with it,' says Esterson, who devised the design with Mark Porter, who is now The Guardian's Creative Director. 'And the problem with The Guardian is that they have these longer pieces of writing that aren't exactly news or features,' he adds. These longer, descriptive pieces give readers more background information about a news issue. Esterson wanted to create a format for them that allowed them to be run next to news stories, but in such a way as to distinguish them.

He dealt with this by devising a system that allows either an eight-column grid or a six-column grid – or a mixture of the two – on each news page. In order to facilitate this the master grid has 24 columns. Three units of this master grid are combined to form the eight-column structure; four units are joined to form the six-column grid and two units are combined to take the captions. This combination leads to immense flexibility. The eight- and six-column grids can even be used side by side: for instance, there might be four wide columns (from the six-column grid), two narrow columns (from the eight-column grid), and the remaining gap used for a picture caption.

This sort of flexibility is increasingly important as editors try to make even the most serious stories look interesting and accessible on the page by using more pictures, diagrams and captions. 'You don't want people to flick through and think, "Oh no, I've got a long read coming up here",' says Esterson.

Comment pieces, grouped together in the middle of the paper, are distinguished by having type that is ranged left, ragged right, giving a more informal look. Vertically, The Guardian's grid is flexible, yet well defined. Horizontally, however, it is much less precise. 'Underlying the page is a horizontal grid,' says Esterson. 'It's not complex, but there are zones where things start.'

The most consistent horizontal is the thick rule running across the top of each page. Underneath is a word or phrase identifying the stories on that page, for instance, 'national news'. For major news events, which result in a large collection of related news stories run on one or more pages, there is a grey band beneath the rule, identifying the issue, such as 'rail crisis'.

A good newspaper or magazine design is one that is robust enough to work well when used by people whose first concern is words, and who are often under immense time pressure. If the design doesn't work, it will gradually be adapted (or abused, depending on your perspective) by the sub-editors whose job it is to make sure that the paper goes to press on time. The person who created the design has little or no control over its day-to-day use. Even when designing books and art catalogues – another of Esterson's specialities – it is often the case that, with hundreds of pages, a team of people will be working on the project. For Esterson, grids work when they can be explained. 'You make the rules. You control the system – but you can instruct someone else in how it works,' he says. 'It's like a map.'

There is, of course, no reason why a book, magazine or newspaper design has to have a grid. Each page could be designed individually. The drawback to this is that it would be time-consuming, it would rely on whoever did the layouts having a very good eye for composition, and it would be difficult to share the work – the chances are that each designer working on the project would have a very different style and the coherence of the whole could be lost.

'Some designers think repetition is boring,' he says. 'I think it is a system. I've seen magazines that don't have a grid that look fantastic. And sometimes you pick up things and think this is all grid and no content. Grids can be very boring or fantastically interesting.'

left
The comment section of the paper uses all combinations of the 24-column master grid. Type is ranged left to clearly identify the different nature of the text.

Linda van Deursen

biography
born 1961
nationality Dutch

1982–86
Graphic Design Department
Gerrit Rietveld Academy
Amsterdam
1987
Co-founder of Mevis & van Deursen
with Armand Mevis
Amsterdam
1992 to the present
Teaching at Gerrit Rietveld Academy
Amsterdam

'As long as it looks right, I don't care at all. The computer makes so many of these considerations about maths and precision irrelevant when you can change things so easily. You don't work with a ruler anymore.'

Front and back covers with flaps and a variety of pages from the journal If/Then, published in 1999. Each page looks organised and structured although the grid is applied loosely.

After an initial period of exploration and experimentation, the grid has became assimilated into graphic design consciousness. The structure of a page was of course given cognisance prior to the term 'grid', but it was not considered in isolation until the post-war period. Grids were originally a response to new graphic design problems and an increase in information graphics of all kinds – posters, leaflets, catalogues, reports, timetables – and so became synonymous with a re-evaluation of the role of design in socio-political terms.

The Dutch designer Linda van Deursen is representative of the generation of designers working now, for whom grids are primarily practical tools rather than symptomatic of an overall design philosophy. 'I'm interested in structure but not so much in grids,' comments van Deursen.

Embodied within a focus on grids is an awareness of the potential of design systems, and it is this distinction that many contemporary designers are keen to make. The repetitive nature of the pages of a book, for example, lend themselves to structural exploration. Over the past five years, van Deursen and her partner Armand Mevis have produced more and more books and now work on between five and eight a year. 'We try to develop new structures within those that a book already provides,' explains van Deursen.

The books are generally collaborative ventures with artists, photographers or architects. Van Deursen talks enthusiastically of the editing process that is central to her role as designer; from the format of a book, to the number of pages, its flatplan and the pacing of image with text. 'Grids do not exist in a vacuum. They exist in relation to the content,' she explains. 'We never start with a grid. We start with an idea which is then translated into a form, a structure.'

Once these broader issues are resolved, Mevis and van Deursen will of course employ grids. 'You can't make a book without a grid. Why would you want to design each page separately?' she asks. 'I wish I could make a book without one but it's very rare to find content that will allow for that.' These grids can be simple or highly complex structures, according to the requirements of the job. A recent project, Metatag, for Amsterdam's Waag Society, had text in both English and Dutch that required a complex grid to accommodate and draw a visual distinction between both languages. Mevis and van Deursen decided to take this a stage further, working with 'clashing grids' that have no relation and produce two entirely different layouts in one book.

Dealing imaginatively with the issue of repetition is not only a consideration within the pages of a book. Mevis and van Deursen have also worked on magazines and are aware of the role that a grid plays in its easy recognition and production. The simple grid for Metropolis M, a Dutch magazine on contemporary art, allows for other designers to produce it while still retaining its overall visual style.

At the heart of van Deursen's approach is a passionate belief in the visual over and above the theoretical. 'Grids are invisible. They only become apparent if you specifically examine the design, so I don't get anything from them other than a visual experience.' She also questions how relevant it is for contemporary designers to place an emphasis on precision when new technology accommodates intuitive and aesthetically driven decision-making so much more readily than before. While happy to acknowledge the practical use of a grid, and the pleasure derived from its successful application, a rigid dogma that does not allow for organic development seems to miss the point. 'I do think that things can have a great theoretical relationship with each other – mathematically the numbers are beautiful – but when you print it out it looks dull, move it slightly and suddenly it looks ok.'

This approach may be traceable to a fairly loose and experimental education at the Gerrit Rietveld Academy in Amsterdam, in which nothing of grid structures in the practical sense was taught. Once working, she and Mevis have learnt through necessity, which gives an ongoing freshness to their work. 'We had to learn the hard way, which was actually quite nice. We try to figure out what works. We are confronted by a problem and then try to solve it every time.'

Covers and spreads
from Metatag, 2001.
The book is in both
Dutch and English.
Each language reads
from either end of
the book and uses
completely different
grids and typography.
The Dutch text runs
in red and black and
uses a broadly more
traditional-looking
structure. This 'clashes'
with the contemporary-
looking English text.

David Carson

biography
born 1956
nationality American

mid-1970s
BA Sociology, plus teaching qualification
San Diego State University
1992 to the present
Freelance design studio
New York

'I need a blank screen to begin designing – no guidelines, or rules.'

'I can't work with any kind of guidelines on the computer – the first thing I do is eliminate them,' says David Carson. 'I have to get rid of all that before I start work. It probably comes from my lack of training – I never learned what a grid was. By the time I knew, I was a few years in and didn't see a place for them in my work.'

Carson is famous for his controversial, intuitive approach to graphic design, the result of having become a designer almost by accident after his passion for surfing led to work on specialist magazines such as Surfer and Beach Culture (US). Aiming to communicate the excitement of surfing to his readers, and not knowing any of the 'rules' of magazine design, he followed his intuition, mixing images and text with free-form abandon. He continued in this way, designing music magazines such as RayGun, aimed at young, visually aware audiences who were passionate enough about music to want to put effort into reading his unconventional layouts.

Spreads from RayGun magazine

top
Super Chunk
Carson experimented with a variety of column widths for aesthetic effect.

bottom
Independents Day
Each column has its own font.

far right
Screaming Trees
The reader needed to be keen on the subject to persevere with a design that was a little difficult to read. This design is a quiet laugh at optimum line length.
Illustration
Doug Aitken
Background photo
Anne Brit Aase
Group photo
David Hawkes

Designing every element of a page from scratch is a dangerous approach: the potential for simply creating a mess is considerable. Carson, however, has enough visual skill to avoid this and despite alarming collisions between text and image, his magazine pages work – and are particularly appealing to the youthful, iconoclastic audience he usually designs for.

Nowadays Carson works on more mainstream projects – Microsoft has been one of his major clients – but he still works hard to ensure that the message communicated by his design enhances the message communicated by the text. This, he says, is why he doesn't like grids; working within a grid system can lead to blandness. 'Magazines can be the worst,' he says. 'They might have an article about flowers, and one about a murder, and they will both look the same. When I design, I read the article and try to interpret it, so that the design gives it more life, more emotion, more impact. I try, visually, to bring the readers in. And hopefully they will be rewarded by a good story.'

Carson is pragmatic enough to see that in some situations working to a grid system is probably the only way to get the job done: 'I can't really argue about a grid on a daily newspaper, it sort of makes sense,' he says. However, for the most part he believes that grids can lead to laziness, as designers simply accept pre-formatted settings that have been programmed into their computers by technicians. The result, he thinks, is blandness. 'A lot of people can do a reasonable layout because the technology makes it easier, so there are a lot of solid magazines. But very few of them stand out. The problem with a grid is that people use it as a crutch and you end up with a lot of boring design.'

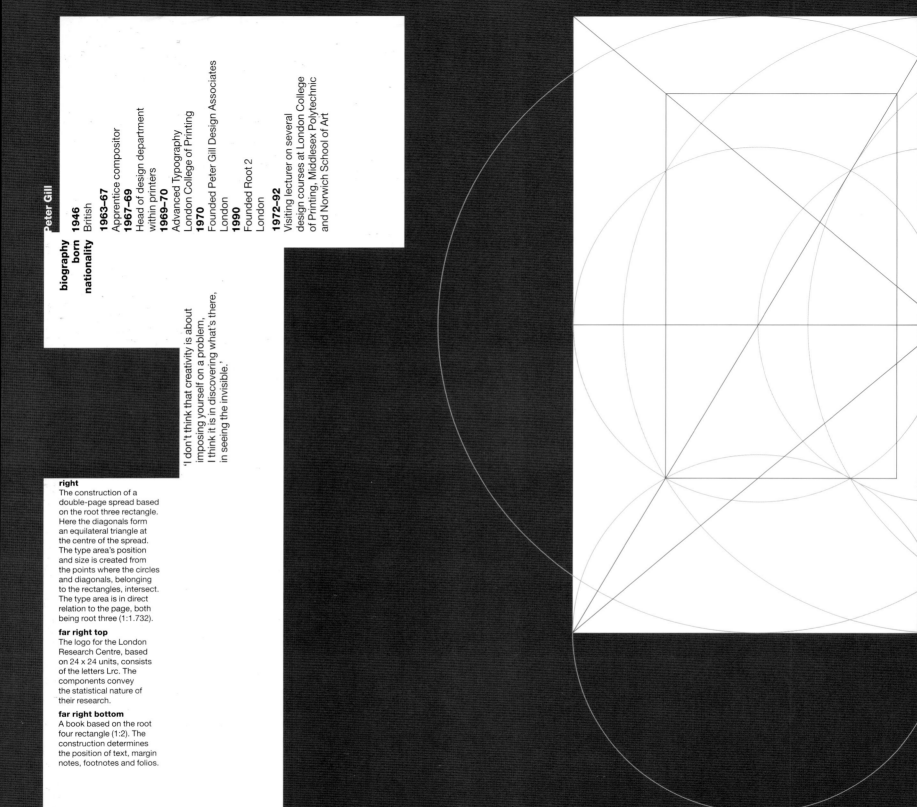

Peter Gill

biography	
born	**1946**
nationality	British

1963–67
Apprentice compositor

1967–69
Head of design department within printers

1969–70
Advanced Typography
London College of Printing

1970
Founded Peter Gill Design Associates
London

1990
Founded Root 2
London

1972–92
Visiting lecturer on several design courses at London College of Printing, Middlesex Polytechnic and Norwich School of Art

'I don't think that creativity is about imposing yourself on a problem, I think it is in discovering what's there, in seeing the invisible.'

right
The construction of a double-page spread based on the root three rectangle. Here the diagonals form an equilateral triangle at the centre of the spread. The type area's position and size is created from the points where the circles and diagonals, belonging to the rectangles, intersect. The type area is in direct relation to the page, both being root three (1:1.732).

far right top
The logo for the London Research Centre, based on 24 x 24 units, consists of the letters Lrc. The components convey the statistical nature of their research.

far right bottom
A book based on the root four rectangle (1:2). The construction determines the position of text, margin notes, footnotes and folios.

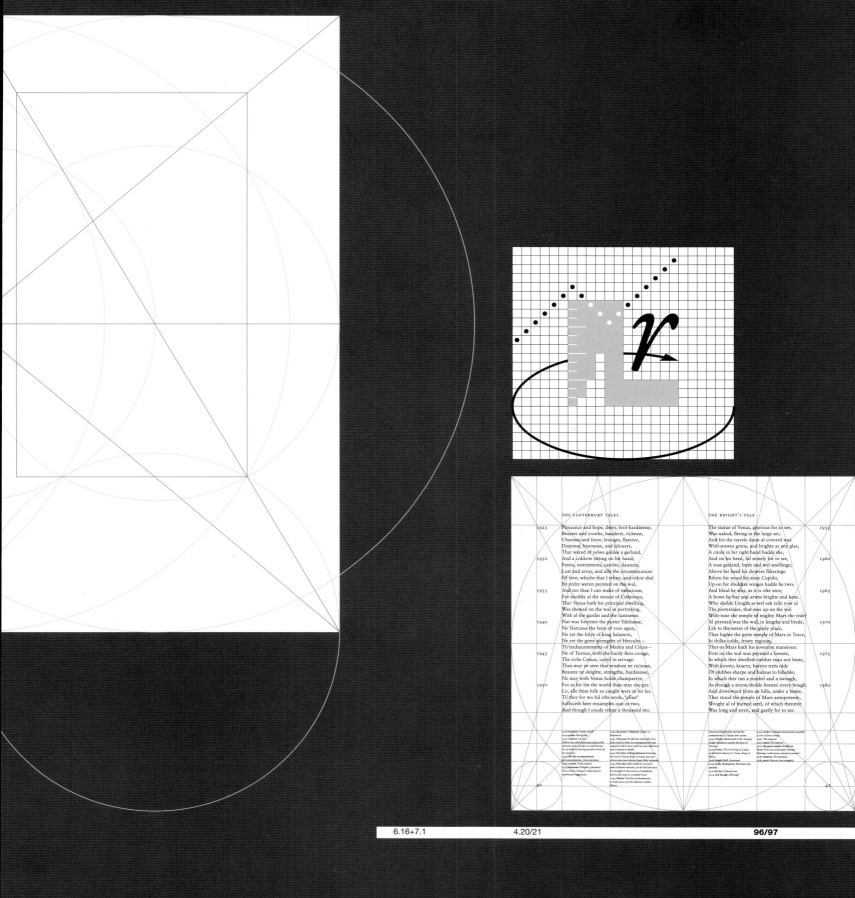

THE CANTERBURY TALES

THE KNIGHT'S TALE

1925	Plesaunce and hope, desyr, fool-hardinesse,
	Beautee and youthe, bauderie, richesse,
	Charmes and force, lesinges, flaterye,
	Dispense, bisynesse, and Ielousye,
	That wered of yelwe goldes a gerland,
1930	And a cokkow sitting on hir hand;
	Festes, instruments, caroles, daunces,
	Lust and array, and alle the circumstaunces
	Of love, whiche that I rekne, and rekne shal
	By ordre weren peynted on the wal,
1935	And mo than I can make of mencioun;
	For soothly al the mount of Citheroun,
	Ther Venus hath hir principal dwelling,
	Was shewed on the wal in portreying,
	With al the gardin and the lustinesse.
1940	Nat was foryeten the porter Ydelnesse,
	Ne Narcisus the faire of yore agon,
	Ne yet the folye of king Salamon,
	Ne yet the grete strengthe of Hercules –
	Th'enchauntementes of Medea and Circes –
1945	Ne of Turnus, with the hardy fiers corage,
	The riche Cresus, caytif in servage.
	Thus may ye seen that wisdom ne richesse,
	Beautee ne sleighte, strengthe, hardinesse,
	Ne may with Venus holde champartye;
1950	For as hir list the world than may she gye.
	Lo, alle thise folk so caught were in hir las,
	Til they for wo ful ofte seyde, 'allas!'
	Suffyceth heer ensamples oon or two,
	And though I coude rekne a thousand mo.

	The statue of Venus, glorious for to see,
	Was naked, fleting in the large see,
	And fro the navele doun al covered was
	With wawes grene, and brighte as any glas,
	A citole in hir right hand hadde she,
1960	And on hir heed, ful semely for to see,
	A rose gerland, fresh and wel smellinge;
	Above hir heed hir dovves flikeringe.
	Biforn hir stood hir sone Cupido,
	Up-on hir shuldres winges hadde he two;
1965	And blind he was, as it is ofte sene;
	A bowe he bar and arwes brighte and kene.
	Why sholde I noght as wel eek telle yow al
	The portreiture, that was up-on the wal
	With-inne the temple of mighty Mars the rede?
1970	Al peynted was the wal, in lengthe and brede,
	Lyk to the estres of the grisly place,
	That highte the grete temple of Mars in Trace,
	In thilke colde, frosty regioun,
	Ther-as Mars hath his sovereyn mansioun.
1975	First on the wal was peynted a foreste,
	In which ther dwelleth neither man nor beste,
	With knotty, knarry, bareyn trees olde
	Of stubbes sharpe and hidous to biholde;
	In which ther ran a rumbel and a swough,
1980	As though a storm sholde bresten every bough:
	And downward from an hille, under a bente,
	Ther stood the temple of Mars armipotente,
	Wroght al of burned steel, of which thentree
	Was long and streit, and gastly for to see.

1926 **bauderie** Gaiety, mirth
1927 **goldes** Marigolds.
1930 **cokkow** Cuckoo. Yellow has often been associated with jealousy, and a cuckoo is well-known for its habit of driving another bird off its nest/eggs and so proved to deserve its reputation.
1932 **alle the circumstaunces** Accompaniments, characteristics.
1940 **soothly** Truly, indeed
1935 **lustinesse** Delights, pleasures. The wordplay Chaucer's time had no unpleasant suggestion.

1941 **the porter Ydelnesse** Vanity or Indolence.
1941 **Narcisus** He did not return the love Echo had for him. In consequence he was caused to fall in love with his own reflection, and so pined to death.
1942 **the folye of king Salamon** Solomon, the son of David, King of Israel, was one whose amorous desires knew little restraint.
1943 **Hercules** After death he received almost divine honours, for he had devoted his strength to the service of mankind, but he also was no constant lover.
1944 **Medea** Used her enchantments to help Jason win the famous Golden Fleece.

Circe's enchantments turned the companions of Ulysses into swine.
1945 **Turnus** Mentioned in the Aeneid, fought Aeneas to secure the love of Lavinia.
1945 **Cresus** The rich King of Lydia, proverbial in slavery to Cyrus, King of Persia.
1948 **sleight** Skill, cleverness
1949 **holde champartye** Maintain any equality.
1950 **hir list** to please her.
1951 **and though** Although.

1959 **citole** A stringed instrument, possibly a sort of lyre or harp.
1967 **The interior.**
1971 **estres** The interior.
1972 **the grete temple of Mars in Trace** Thrace was situated under Mount Haemus, (with snows eternal crowned).
1983 **thentree** The entrance.
1984 **streit** Narrow (not straight).

40

41

Peter Gill's choice of Root 2 for the name of his design practice is a deliberate one that indicates much about his design philosophy and his revelatory approach to structure. On arriving at his Victorian semi in North London, which is home to his studio, one is confronted by custom-made wrought-iron gates, each showing a root two construction within a square. To Gill, a root two rectangle is a symbol of both the exoteric and the esoteric.

The International Standards Organisation (ISO) A, B and C paper sizes are the most common shapes used in printed matter and are all based on the root two rectangle. The proportion was chosen as the industry standard for paper by DIN, the German Institute for Standardisation, because of its unique qualities. It is the only rectangular shape that retains its proportions when divided in half on its long edge – an economic factor frequently used to advantage by designers and printers. It is also a pure proportion, being constructed from a square and a circle. Thus it embodies both the practical and the aesthetic.

Gill lacked any formal design training. He worked in the printing industry for six years prior to embarking on a one-year course at the London College of Printing. Initially he expected this to be a disadvantage, being in a group situation with students who had been through three or four years of design education, but he soon realised the value of his own practical experience. Although he feels that the year in college broadened his outlook, he still perceives himself as primarily self-taught. From the outset, he understood the need for typographic structure and it was at this stage that he developed his interest in grids. 'If you lack a certain design confidence, which given my more technical background I did, the idea of a grid is very attractive. A grid structure is a good support mechanism which can be used to organise and connect the various elements within a design into one system, but it requires both vision and intuition in its application.' Gill's attitude to structure is all-embracing. It underpins his design of symbols, letterforms, stationery, posters, brochures and books.

right
A series of diagrams illustrating how rectangles of pure proportion are constructed from a square and a circle. From left to right: 1:1; 4:5; 3:4; 2:3; 5:8; 3:5; 5:9; 1:2; 1:1.414 (root two); 1:1.618 (golden section or divine proportion); 1:1.732 (root three); 1:2 (root four).

far right top
Root 2 are working on a book about their work. The format is a square, and its grid is directly derived from the symbol that identifies the Root 2 consultancy. A sample layout shows the flexibility of this system.

far right bottom
Gill uses grid systems as a basis in the design of brochures, stationery, logos and lettering. This logo for UK company Tyndale Carpets, designed in the late 1970s, uses a unit structure to determine the line weight and inter-line space that forms the lettering.

As is often the case when studying, reading one article or book can be the start of a lifelong exploration. While at the LCP, Gill came across an article by Jan Tschichold entitled Non-Arbitrary Proportions of Page and Type Area. He was seduced both intellectually and visually and it inspired an interest that over the years has been integrated into his working method. 'Utilising geometry and structure in the design process satisfies a deep need in me for finding order and the right relationship between items.'

Tschichold, and many modernist designers, have sought to discover and define laws of geometry that, when applied to any rectangle, give quantifiable outcomes. Many designers talk of their fascination with the invisible nature of grid structures, but these are often imposed on a format by a designer. Although Gill frequently approaches page layout utilising a variety of unit-based systems, he also adopts a geometric approach in which the format will determine the grid.

This is a new take on the methods discovered by Tschichold used by those fifteenth-century masters, and is a rather more organic process than is often the case. The choice of approach is solely dependent on appropriateness and the complexity and nature of the material.

Gill's governing theory is full of mystery, yet he dismisses it with an air of practicality. He talks with quiet confidence of the different characteristics of each rectangular form as though they are old friends gradually revealing their characters to him. Although Gill works with a variety of formats, the proportions are never arbitrary. The ratio of width to height is always precise, sometimes quantifiable in whole numbers, for example 3:4; and at other times 'irrational', which means based on a geometric construction that cannot be expressed in whole numbers – as is the case with A4, where the ratio is 1:1.414. Gill uses the intersections created by the construction to determine the position of elements on the page, from running heads, footnotes and text to images and lettering. Unlike many mathematically driven designers, he is at ease working with type measurement systems involving two or three decimal places. It is the overall purity of form that is all-important.

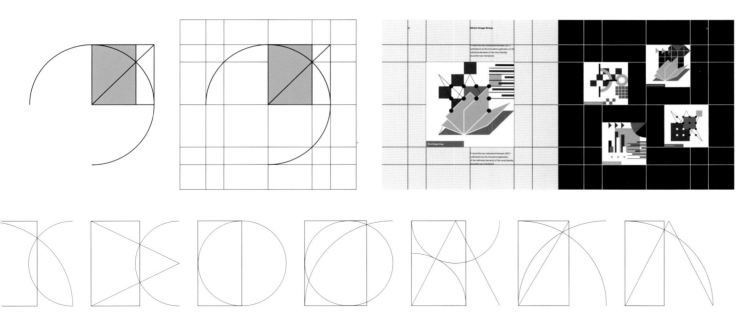

Whether the eventual outcome is symmetric or asymmetric, Gill's work appears less severe than much of the mechanistically derived, unit-based structures and layouts associated particularly with post-war Swiss modernism. His approach allows for flexibility of usage and can result in grids that appear to be fairly free-form. Given the intrinsically different nature of every rectangle, it is the initial choice of format that must be made with issues of appropriateness in mind. Fitness for purpose is key to his approach. The proportion of each rectangle has its own ambience and the ways in which it can be subdivided offer possibilities that serve to satisfy particular typographic requirements.

Gill acknowledges that clients are generally unaware of his process of working, and the time spent perfecting it. 'This is an intellectual game which I see as a necessary piece of entertainment for myself, but one which I must ensure serves the design process rather than hinders it.'

biographies
name **Stephanie Krieger**
born 1967
nationality German

1987–92
Graphic Design Studies
University of Applied Arts
Vienna
1992
Founder of
Büro für visuelle Gestaltung
Vienna

name **Maximilian Sztatecsny**
born 1969
nationality Austrian

1988–93
Graphic Design Studies
University of Applied Arts
Vienna
1992
Founding partner of
Büro für visuelle Gestaltung
Vienna

'I try breaking it but mostly I go back and follow my grid.'

A series of posters for the Architektur Zentrum, Vienna, all using the same field-based grid, as shown, combined with a typographic baseline grid.

Stephanie Krieger and Maximilian Sztatecsny have a new studio. Its double doors, high ceilings and parquet floors seem typically Viennese; opulent and grand. However, its white walls, uncluttered surfaces and well-ordered archives and files are redolent of their approach to work. They are modernists, and traditional modernists at that.

The influence of post-war Swiss typography can be seen in many contemporary designers' work, but Krieger | Sztatecsny applies the principles with a subtlety that is often less evident. Many of the first Swiss practitioners were also abstract painters. The relative positioning of type and image was often governed by issues of access, meaning and function coupled with an exploratory deconstruction of the surface of the page. Very few graphic devices such as rules, boxes or keylines were initially used. The type size, position and, most importantly, the space in which it was placed, were considered to be more than enough elements at the designer's disposal and were regulated by the use of a grid.

Krieger | Sztatecsny takes a similarly determinist and minimalist approach to their work. 'In our work you see the order, our grids are visible in this way,' comments Sztatecsny. The content of each project will dictate the eventual outcome. 'I always read the text first,' remarks Krieger, 'then we work on an idea and the next step is to develop the system – this is a collaborative process. We are respectful of information. It's very interesting for us to talk to people about what they are writing or doing. The main thing for us is content.'

Krieger and Sztatecsny met at the University of Applied Arts in Vienna. Krieger was fortunate on graduation in 1992 to be approached by the then under-financed and relatively low-profile Architektur Zentrum in Vienna, who were in need of an identity. The subject matter was perfect, lending itself to a structured and minimal aesthetic, while the lack of resources meant that Krieger had to be inventive with picture usage and colour. Over a seven-year period, Krieger | Sztatecsny has built up a significant body of work – posters, leaflets, catalogues and invitations – all adhering to a series of simple grid structures.

Both Krieger and Sztatecsny ally themselves to modernist approaches and working methods, using baseline and multi-column grids to structure the page. This is a logical process which they are not preoccupied with reinventing. 'In design you are always making decisions. The grid is a major decision. Once you have it, it helps you make the next set of decisions.'

Sztatecsny considers grids to be implicit in all graphic design, but open to abuse and misunderstanding. 'You cannot really not have a grid – a page is a form of constraint. Lots of pages are another form of grid but if you then divide the page into lots of small columns it's almost like not having a grid. It gives so much structure that there's no structure. I don't see that this approach is that different to appearing to be more free-form. You end up at the same point – it's almost cyclical.'

Even within contemporary minimalist graphics there are a variety of approaches, particularly towards typographic detail. In Britain the design groups North and Cartlidge Levene, for example, also employ the basic principles of modernism, but their work is characterised by tighter than usual linespacing and small margins employed to give a page an edge and dynamism.

Krieger | Sztatecsny quietly explores each of its grid structures by using purely typographic devices such as indents, outdents or vertical type. Krieger turns to a catalogue for the Wiener Festwochen performing arts festival saying, 'this is one of our key works.' In it they employed a grid that works in both directions so that the publication is landscape and portrait in format. This also allowed them to run vertical type on portrait pages that still adhered to the grid. Krieger is convinced that this attention to detail pays off and has a subliminal message. 'Maybe the clients cannot articulate it – they are not trained in graphic design – but they can sense that there is something special.'

Spreads from the catalogue for the Wiener Festwochen, 1998. The fields of the grid are used flexibly so that text can read horizontally or vertically, running to a variety of different measures.

Gesellschaft der Musikfreunde in Wien

BodyCurrency

Theorie-Event

Vorträge, Statements, Diskussion, Performances, Klanginstallationen, Videoinstallationen, Dråg. ...

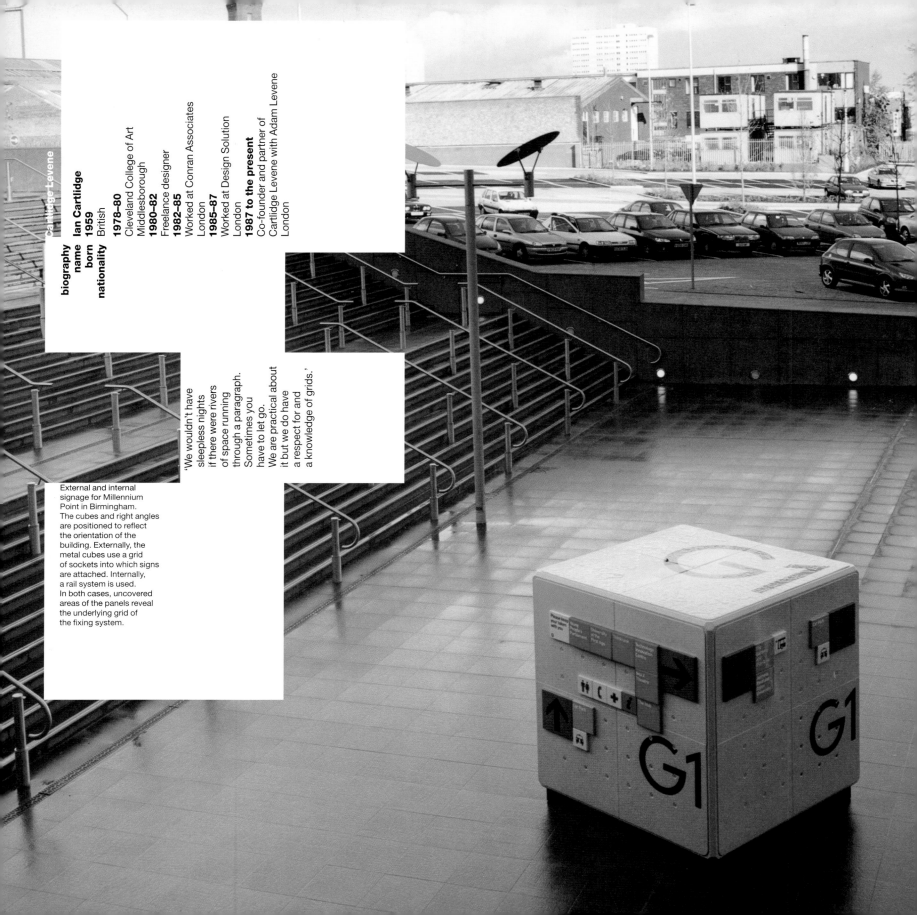

biography
name Ian Cartlidge
born 1959
nationality British

1978–80
Cleveland College of Art
Middlesborough
1980–82
Freelance designer
1982–85
Worked at Conran Associates
London
1985–87
Worked at Design Solution
London
1987 to the present
Co-founder and partner of
Cartlidge Levene with Adam Levene
London

'We wouldn't have
sleepless nights
if there were rivers
of space running
through a paragraph.
Sometimes you
have to let go.
We are practical about
it but we do have
a respect for and
a knowledge of grids.'

External and internal
signage for Millennium
Point in Birmingham.
The cubes and right angles
are positioned to reflect
the orientation of the
building. Externally, the
metal cubes use a grid
of sockets into which signs
are attached. Internally,
a rail system is used.
In both cases, uncovered
areas of the panels reveal
the underlying grid of
the fixing system.

The design company Cartlidge Levene in London has established a reputation for producing clean, functional graphics that appear to be rooted in a modernist tradition. However, the application of the aesthetics of minimalism can sometimes falsely imply an overriding interest in order and control. Having been influenced by Swiss and Dutch modernism, Ian Cartlidge, founding partner, acknowledges that structure is a governing principle in the work, but is keen to point out that for him grids are 'a means to an end and not an end in themselves... they are never at the forefront of my mind'. Grids help a designer 'to piece together a project in a coherent way, often making the production more seamless,' but the ultimate objective of this process is to produce 'a beautiful piece of communication.'

Both Cartlidge and senior designer Paul Winter are pragmatists. Aesthetics and practical considerations drive a project in tandem. Surprisingly, the initial design stages of a project are often more free-form in process than the visual simplicity of the eventual outcome implies. Winter talks of establishing 'the look and feel' of a project prior to working on any underlying structure. Cartlidge concurs; a system is developed not only to give clarity to the design but also to communicate its spirit.

A common misunderstanding of a design that appears to be simple is that it is formulaic and lacks passion. The methodology may become more refined, but each project has a new set of problems to solve. 'I like this roller-coaster ride, it's part of the process,' comments Winter, who appreciates that a real understanding of grids can liberate the designer. 'They give flexibility and structure all at the same time.'

Parallels are often drawn between typography and architecture. In terms of structure, both share fundamental considerations, driven by usage, which often employ a series of vertical and horizontal axes. The collaborative team at Cartlidge Levene has worked increasingly with architects both in developing signage systems and on exhibition projects. 'Perhaps this is because our approach to work has an underlying discipline and we respect grid structures,' comments Cartlidge.

right
Elevations showing the
flexibility and variety of
possible layouts on an
external cube. The signs
are designed to clearly
identify the hierarchy
of the information.

centre
Drawing showing the
1:1.5 ratio used in the
modular signage system.
This proportional
relationship provides
basic sizes of sign
that give hierarchical
distinction.

far right
The system implemented
on an external cube.

The recently completed signage for Nicholas Grimshaw & Partners' Millennium Point in Birmingham demonstrates a multi-layered approach to graphic design structure.

The project houses a number of different enterprises, including Birmingham's equivalent to London's Science Museum, The Thinktank; the Technology Innovation Centre – part of the University of Central England; The Young People's Parliament; an Imax cinema and retail units. Grimshaw exposes much of the structure of his buildings and the overall feel of the signage was intended to complement this approach. The brief was to design an easily updatable system, which was economic to produce and would maximise the sight lines of the building to give easy 'way-finding strategies' both outside and inside the building.

As is often the case at the outset of a project such as the Millennium Point signage, the building was still in the process of being built. The architect's plans were therefore the starting point when considering the signage.

Analysis of these plans made it obvious that the orientation of the building should be used to determine the position of the signs. This axis is not always evident from the inside of the building, since not all internal walls run in parallel or at right angles to it. However, because it gives the building its underlying structure, using it to position the signs gives them all maximum visibility. Viewed in plan form, it is easy to see how the signs are wholly integrated into the building.

Two factors determined the form of the signs themselves: the need for an updatable system, and the different levels of information required. A modular system, made up of a small set of different units, was devised to make production economic and give maximum flexibility. It was decided to use a square as the module. A grid was devised to house combinations of three different-sized square signs. Each size was determined by the initial module. Within the most often used sizes the largest square is one and a half times the size of the middle square, with the relationship between this and the smallest square using the same 1:1.5 ratio. This use of half-sizes immediately makes the overall scheme more visually dynamic.

Each of these three different-sized signs were attached to large free-standing cubes or to 90-degree right-angled surfaces on the walls. A series of exposed sockets make the basic grid visible. Signs can easily be detached or combinations added to. The variety of combinations possible give each cube an individuality while still being part of an overall system.

Last but not least, the square enamel signs themselves, which carry text, arrows and other icons, are also based on an internal grid. 'I think we've got grids under control,' Cartlidge comments with a degree of playfulness. 'At the end of the day,' adds Winter, 'it's just a bit of maths.'

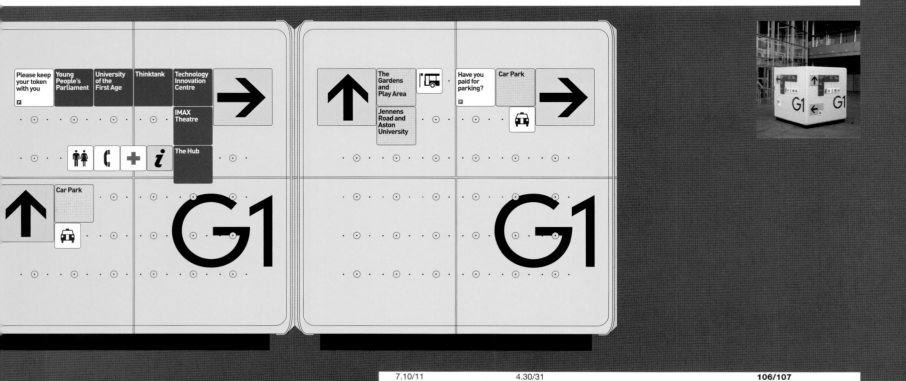

Cover, fold-out first page
and spreads from the
Canal Building brochure.
The grid is directly derived
from the façade of the
building and is then
applied in the layout of
all type and images.

Wendelin Hess

biography

born 1968
nationality Swiss

1986–92
Diploma in Graphic Design
Basel School of Design
1992–97
Co-founder of Müller+Hess with Beat Müller
1997 to the present
Partner of Müller-Hess-Balland (MHB)
with Beat Müller, Ludovic Balland
and Jonas Voegeli
1998–2001
Art Director of Das Magazin
Zürich
1993 to the present
Various teaching positions in Basel,
Lucerne and Zürich

'Having a traditionally Swiss graphic
design education was like getting stuck
in the past, but I wouldn't say that
what we learnt wasn't good, it was
just too narrow.'

MHB's work for the gallery
Kaskadenkondensator,
Basel, is symptomatic
of its approach to
design thinking. During
1997–98, large quantities
of gallery information
cards were produced.
Once used they were then
over-printed to obliterate
old information and add
the new. The resulting cards
are economic to produce
and visually arresting. The
system is simultaneously
controlled and random.

The Selection 228 wenn man genug lang hinsieht hat es Humor Adrian Habkütrel.
..... 63 un vrai travail de photographie
C'est un des travaux les plus difficile à faire. Il a réussi à conserver le climatGérard Petremand

mein Favorit für den Magazin-Preis, gestern, heute, wo kann ich mein Kreuz machen? Nicolas Faure und fast alle

zu Projekt 97 Europäischer Kameraträger schaut hin, Exoten kucken zurück... Lars Müller
zu Projekt 20 reinste Dokumentarfotografie... d.h. der Autor verschwindet, ist in seiner Funktion austauschbar Wer?
zu Projekt 74 hat einfach Witz und basta Irene Schildknecht

zu Schwarzweissreportagen auch wenn sie vom Exotismus leben und sich selbst überlebt haben und es keiner mehr an- schaut, sie müssen ihren Platz in der Fotografie weiterhin haben, sei es nur aus nostalgischen Gründen der Erinnerung an eine grosse Epoche der Fotogeschichte, sie sind die Saurier, begraben wir sie nicht ganz... Urs Stahel

Inhalt, Contenu, Contenuto Katalog
Statements der Jury, du jury, della giuria
Jurymitglieder, Membres du jury, Membri della giuria
Vorwort von, Préface de, Premessa di Dr. David Streiff, Direktor des Bundesamtes für Kultur
Vorwort von, Préface de, Premessa di Lucia Degonda, Projektgruppe 'The Selection vfg›
Jurybericht, Rapport du jury, Rapporto della giuria Thomas Cugini, Jurypräsident
Essay: Im Nahbereich der Ironie von, Ironie en gros plan› de, ‹Nel vicino campo dell'ironia› di Daniele Muscionico

Selektionierte, Lauréats, Selezionati
Redaktionelle Fotografie, photographie redactionnelle, Fotografia redazionale
(Projekt 273, Jobs) Isabel Truniger
(Projekt 204, Lower Eastside) Christian Grund und Noë Flum
(Projekt 289, Klone) Tobias Madörin
(Projekt 123, Saisoncamper) Stefan Jäggi
(Projekt 20, Castasegna) Peter Lüem
(Projekt 74, Babe) Rita Palanikumar
(Projekt 16, Nomaden in Tibet) Ladislav Drezdowicz
(Projekt 229, Netzwerk) Susanna Stauss
Werbung, Publicité, Pubblicità (Projekt 331, Angie Becker) Sven Bänziger
(Projekt 69, Theaterspektakel) Stefan Minder
Freie Fotografie, Photographie libre, Fotografia libera (Projekt 152, Serienkiller) Peter Tillessen (Magazin-Fotopreis)
(Projekt 32, Topiques) Gérard Petremand
(Projekt 291, Ereignisse) Tobias Madörin
(Projekt 286, Small World) Ruth Erdt
(Projekt 278, heute: Normandie) Christian Aeberhard
(Projekt 303, As Time Goes By) Barbara Davatz
(Projekt 333, Ohne Titel) Franziska Wüsten
(Projekt 236, Wechselwirkungen) Hans Schürmann
(Projekt 161, Leben/©/Werk) Andy Luginbühl

Porträt, Portrait, Ritratto vfg. vereinigung fotografischer gestalterInnen
Mitglieder, Membres de l'association, Membri del'Associazione vfg.
Verdankung, Remerciements, Ringraziamento Patronat/ Medienpartner/ Sponsoren
Impressum, Impressum, Sigla editoriale The Selection vfg 1999/ Katalog

Spreads from All Design, a book for the Museum für Gestaltung, in Zürich, 2001. A system was developed to incorporate small images as close to their textual references as possible. An image section later in the book shows them at larger sizes with full captions.

wartete mit umfassenden Ideen und einer totalen Umgestaltung des NASA-Entwurfs auf (ABB.11:). Wenngleich nur

→ 11:S.26

wenige seiner Vorschläge offiziell umgesetzt wurden, übten diese einen wesentlichen Einfluss aus. [*5] Dies kann als die Geburtsstunde der Weltraumarchitektur bezeichnet werden: Man setzte sich intensiv mit dem menschlichen Habitat im All auseinander. Ohne den Druck von Loewy und den Astronauten hätte es wohl in der ersten amerikanischen Raumstation kein Fenster gegeben, da dieses aus Ingenieurssicht ein zu hohes «Sicherheitsrisiko» darstellte. Trotz der Beteiligung eines professionellen Designteams war man natürlich weit von einer integrierten Planung entfernt und hinsichtlich der «Habitability» [*6] machte man mehr negative als positive Erfahrungen. Diese negative Erfahrungen, die nicht nur zu offener Kritik der Astronauten führten, sondern sogar zu einem mehrstündigen «Kommunikationsstreik» – der Kontakt mit der Bodenstation wurde unterbrochen –, sensibilisierte die NASA für diese Thematik. Mit Beginn der Planung der Raumstation «Freedom» Mitte der achtziger Jahre führten von der NASA beauftragte Architekten eine Reihe von Studien über die innere Organisation und Raumaufteilung der Module durch.

Die internationale Raumstation wird nach ihrer geplanten Fertigstellung im Jahre 2005 mit Abmessungen von 108 m x 74 m und einem Gewicht von 415 t die grösste je gebaute Raumstation sein (ABB.12:). Sie wird auf einer Umlaufbahn von etwa

→ 12:S.26

400 km über der Erdoberfläche alle 90 Minuten die Erde einmal umkreisen. Sie ist, völlig unbemerkt von Architekturzeitschriften, das grossartigste Bauwerk der Menschheit, das zur Zeit entsteht. Nachts wird sie von blossem Auge am Sternenhimmel zu sehen sein. Sie ist das Ergebnis einer der umfangreichsten internationalen Zusammenarbeiten, die «auf diesem Planeten» je zustande gekommen ist. Europäer, Japaner, Amerikaner, Kanadier, Brasilianer und Russen tragen zum Bau der Station bei. Nach dem Fall des eisernen Vorhangs und Ronald Reagans «Star Wars»-Projekt [*7] wird sie zum Symbol einer erfolgreichen friedlichen Nutzung der Raum-

fahrt, zum Wohle der Menschheit auf der Erde. Sie wird sechs Astronauten Arbeits- und **Lebensraum** bieten und unzähligen Wissenschaftlern auf der Erde als Plattform für Experimente in der Schwerelosigkeit dienen.

Aufbauend auf vorhandenen Studien begann der Lehrstuhl für Gebäudelehre und Produktentwicklung der Architekturfakultät der TU München im Herbst 1998 in Kooperation mit dem Fachgebiet Raumfahrttechnik und dem Johnson Space Center der NASA in Houston Planungen für das Habitation Modul der ISS. Architekturstudenten arbeiteten mit Ingenieuren, Astronauten und dem Habitability Center der NASA an Konzepten für das Leben und Arbeiten in der Schwerelosigkeit. Das Wohnmodul der ISS besteht wie die anderen Module der Raumstation aus einem Aluminiumzylinder von 4,5 m Durchmesser [*8], darin sind 24 Buchten für sogenannte «Racks», modulare Einheiten, welche in der Raumstation eingesetzt werden (**ABB.13+14:**). Diese → 13/14:S.269

Racks sollen eine Küche mit Tisch am **Fenster**, einen Waschraum mit WC und sechs persönliche «Crew Quarters» (Schlafkabinen) beherbergen. [*9] Aus den Studien für das Wohnmodul entstanden eine Reihe von neuen Entwicklungen für die Schwerelosigkeit (siehe auch den Katalogbeitrag **«Leben in der Schwerelosigkeit»**). Ein → S.854 Hauptanliegen der Planung war, das der Schwerelosigkeit innewohnende Chaos zu vermeiden und eine klare Organisation, definierte und gut zu reinigende Oberflächen, eine angenehme Beleuchtung, definierte Ablagepunkte usw. zu schaffen (**ABB.15:**). → S.270

[*5] → — Rebecca Dalvesco, «Architecture in Motion: The Interior Design of Skylab», in: John Zukowsky (Hg.), 2001: Building for Space Travel, New York 2001, S. 162–167.

[*6] → — Der Begriff «Habitability» ist am ehesten mit «Wohnlichkeit» zu übersetzen und spricht vor allem die längerfristigen Auswirkungen der Lebensumgebung einer Raumstation auf die Crew an. Siehe auch: Ernst Messerschmid, Raumstationen: Systeme und Nutzung, Berlin/Heidelberg 1997, S. 385–409.

[*7] → — Welches unglücklicherweise in veränderter Form von Präsident Bush jr. wieder aufgegriffen wurde, auf Kosten von geplanten zivilen Langfristmissionen in der Raumfahrt. Hier scheint sich die Geschichte selbst einzuholen.

[*8] → — 4,5 m Durchmesser entspricht der Ladebucht des Space Shuttles.

[*9] → — Die ursprünglichen Planungen für die Raumstation Freedom sahen ein doppelt so grosses Wohnmodul vor, zur Zeit ist in Frage gestellt, ob es überhaupt ein Wohnmodul geben wird.

above
Spreads from Art
Basel Catalogue, 2001,
showing the flexible
use of a structure to
place emphasis on
different parts of the
text. The positions of
the text are determined
by their length.

far right
The index is
designed to enliven
the extensive lists.

Wendelin Hess, partner in the design team Müller-Hess-Balland (MHB), is surprisingly well-balanced in his attitude to Swiss typography. Having been born and educated in Switzerland, he inherits one of the most influential design philosophies of recent history: 'Wherever you go people who are interested in grids tend to have Müller-Brockmann's book Grid Systems in Graphic Design at the top of their pile,' he comments. It would be easy to either conform to stereotype or to rebel, but Hess is objective. He is grateful to have been taught thoroughly, with rigour and passion, but is also clear that Swiss typography is part of a continuum that cannot stand still. 'My tutors were from the generation that were taught in the 1960s, by the godfathers of Swiss typography. It was like a religion. You learnt the micro and macro of typographic rules and left college with the capacity to design in this way – beautifully – but it became clear that you then had to break out and mix what you had learnt with more contemporary influences and views.'

A result of Hess' more catholic tastes is his comprehensive knowledge of recent graphic design history. He is comfortable tracing even the most free-form of work back to grid-based structures. He argues that it would not have been possible for grids to have been discarded had they not been focused on in the first place. 'Wolfgang Weingart started to interpret grids and systems more loosely in the late 1970s,' he explains. 'Even so, when he broke the rules his work still looked very structured and organised, but this approach was the inspiration for the more experimental movements of the late 1980s and '90s.'

MHB is keen that its work does not become formulaic, a criticism often levelled against the application of the rules espoused in the 1950s and '60s. 'The results of contemporary designers who work now in a traditionally Swiss way can be very beautiful and successful because they have clarity, and are legible and functional – particularly at a time when so much work is overloaded with visual components. But I always wonder why those working within these narrow historic boundaries do not get bored using these systems over and over again.'

Hess talks of the design philosophy developed by himself and his partners through experience over the last eight years. He acknowledges and accepts that grids are about limitations, defining the 'invisible' grid broadly as all the constraints that apply from the job's conception: What is the content? Who is the audience? What is the budget? What format should be used? 'Our grids are closely associated with economic constraints and the client's needs,' says Hess. He considers the use of grids as graphic elements to be merely decorative. For him, the 'visible' grid is the series of regular vertical and horizontal lines that many designers consider invisible and which are made apparent once used to underpin the position of images and text.

MHB adopts a less mechanistic approach that is responsive to content. 'We are more interested in determining the structure by an analysis of the content. Sympathetic deconstruction of text requires the invention of irregular grids,' comments Hess.

One of the major differences between the modernist practitioners of the post-war period and contemporary designers is that the former were keen to justify aesthetics as functioning within a broad social context. Hess sees a distinction between more obviously populist and commercial work, with its practical constraints, and that which encourages greater experimentation and freedom. In this sense, he and his business partners have become more concerned with being discriminating in their choice of client. 'We are concerned by the question of who you work for and what the quality and nature of their output is.'

MHB is working on the relaunch of the weekly newspaper Die Weltwoche, which is to become a large-format magazine. Hess adopts a necessarily pragmatic approach. 'To get through the workload and to maintain the quality of the layouts it has to be grid-based. This must not be experimental. In this kind of project the standard is set by the quality of the pictures and text.'

Ultimately, this is not enough of a challenge for MHB. It is motivated to develop imaginative systems in response to new design problems. A recent book project for the Museum für Gestaltung in Zürich posed just such a problem. The authors of this selection of essays needed their texts to be accompanied by images, which were often of poor quality and needed to be positioned as close to their textual references as possible. MHB took this dictate literally and all images appeared at small sizes within the text, almost like typographic icons, exactly where they were mentioned. Images were then grouped together at the back, reproduced larger and with full captions. This system produced a more visually dynamic set of essays, which functioned well without drawing attention to the inconsistent image quality. As with many of MHB's projects, the system relied upon randomness to work, a philosophy that would seem the antithesis of that implemented by a grid-based designer for whom control and logic are sacrosanct. 'If you know what the result will look like there's no more surprise and fun in doing it,' argues Hess.

MHB manages to ally a knowledge and understanding of the conventional grid with a mildly anarchic approach that reveals great confidence and tolerance on the part of their clients. 'I think that we are attracted by systems that don't always work,' Hess explains. 'If you have set up a system we like it when it cocks up. We are happy to let things happen the way we didn't intend.'

Hamish Muir

biography
born **1957**
nationality British

1975–76
Foundation
Bournemouth and Poole College of Art
1976–79
BA (hons) Visual Communication
(Graphic Design)
Bath Academy of Art
1980–81
Postgraduate studies
School of Design
Basel
1985–2001
Founding partner and director of 8vo
London
1986–92
Co-editor of Octavo journal

'We're all mad aren't we? All of us –
why should we care about all this stuff?'

Screen data for a single
page from a range
of documents to be
produced for a billing
system designed by 8vo.
It defines the grid in
columns and rows,
then locates information
groups and designates
typographic attributes
for each of these.

When 8vo redesigned
the Thames Water bill
in 1998, they used a similar
system to fulfil all the
requirements.

120 130 140 150 160 170 180 190 200 210

bice date **1**	Customer reference **2**
June 1997	12 34 56789 123

e 1 of 2 **3**

Electricity Bill **4**

10

[51]

ctricity supplied at
OTOWN LIDO
OTOWN ROAD
TOXETER
FFORDSHIRE
2AB **1**

Vat reg. no. 123 45678 90
Sequence number E123456789 **2**

20

30

[51]

al due **1**

,907.06

al Account

For information only
Thank you for paying by Direct
Debit. The amount shown will
be debited from your account
on 11/07/1997 **2**

40

[51]
[155] [47]

Business Services
0123 456 7890
For any enquiries about this
account, please call us and
quote your customer reference
number **12 34 56789 123** **1**

50

78
78 CR

ard £10.00 CR
110 112 142 144

60

8

00
00
63
91
00 CR

54 [115]
52

70

£1,917.06
110 112 142 144

80

e 1997

Multiplying Units

90

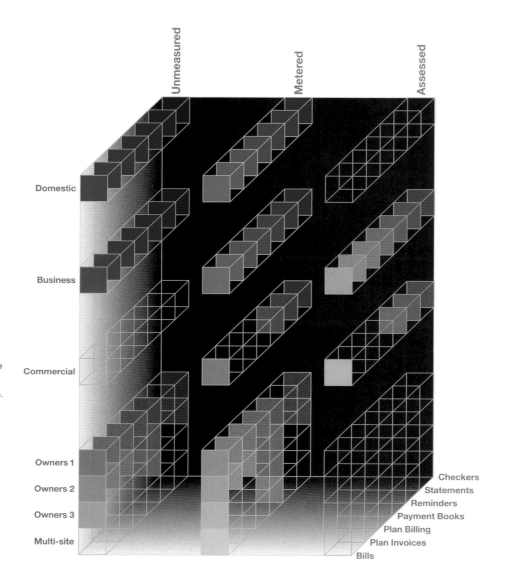

Unmeasured

Metered

Assessed

Domestic

Business

Commercial

Owners 1
Owners 2
Owners 3
Multi-site

Checkers
Statements
Reminders
Payment Books
Plan Billing
Plan Invoices
Bills

right
The 'multi-dimensional' grid produced by 8vo to deconstruct the variables in producing the Thames Water bill.

far right bottom
Business bill for Thames Water.

far right top
A poster for the Flux fringe music festival in Edinburgh. This shows the typographic system of colour-coded bars devised to give structure to the information that was often not available until the very last minute.

If one was to sum up the aesthetic of modernist typography, the terms 'sans-serif', 'ranged left', 'structured' and 'grids' would be in the first sentence. In the mid-1980s, when the design group 8vo first started working in Britain, postmodernist eclecticism mixed with corporate fervour had taken over. The first issue of 8vo's self-published journal Octavo, with its cool typographic minimalism and acres of white space, came as a breath of fresh air; air that of course blew from the continent. It came as no surprise that two of the three founding members of 8vo had been postgraduates in Switzerland. But these are rather lazy assumptions, and now is a good time to revisit some of them, as 8vo have recently decided to go their separate ways.

Hamish Muir, one of the founding members of 8vo, is aware that while much of the work has an aesthetic of order and rationalism, this was sometimes applied excessively, with results that became 'almost baroque in their complexity'. This was partly the outcome of the group's desire to keep pushing forward to try new things, and is also indicative of a broader dilemma. Muir, for example, combines an interest in design systems with a belief in more instinctive visual responses. 'My natural approach to design is an intuitive one. I tend not to think, I do. Then I use grids and bits of postrationalisation to work out why I've done things and how things might work better.' Revealed in Muir's approach to design systems is a dichotomy. 'I'm actually an untidy person. I'm not ordered at all. In some senses I have to use grids to bring some order to the chaos that's whirring around in my head.'

Muir's interest in grids appears to be a practical, rather than a mystical, one. He tells a story of his time studying in Basel, during the early 1980s, when his tutor Wolfgang Weingart was asked by a student, 'would you please explain grids to me?' Weingart picked up a sheet of acetate with ruled lines on it and said 'that's a grid'. No real mystery there, then. It was hardly surprising for the time. After all, did all Swiss designers want to be defined by the legacy of Müller-Brockmann et al? Even now, 40 years after the publication of Müller-Brockmann's highly influential book The Graphic Artist and his Design Problems, 'Swiss typography' is used as shorthand for a visually minimal and conceptually ordered approach to graphic design.

By choice, Muir only ever uses a few fonts and is happy to acknowledge that devices that help to reduce the number of decisions to be made are useful, often providing limitations that can result in greater clarity. Design is a complicated process and grids make it more manageable; as he says, 'if you can bring some order then you can start to evaluate.' For Muir, a grid does not hold interest in isolation but does as part of a system. 'I see the grid as an extension of type systems,' says Muir, 'systems for describing, delineating and making sense of information. I use grids to facilitate that process.'

This doesn't mean that Muir is unaware of the pure pleasure to be derived in developing a system. 'Sometimes there is more satisfaction to be got from considering those abstract things – the process of building can be more interesting than the end result.' Seen in these terms, grids cease to be merely pragmatically useful. They are indicative of an approach to the systematic, even if the system developed has randomness built in.

Superficially, it may be hard to recognise that it is this approach that unites much of 8vo's work, rather than its aesthetic. 'I hate making decisions purely on aesthetics, I like there to be an underlying logic and structure,' says Muir, who demonstrates this by comparing the work undertaken for Thames Water, the British water utilities company, and the Flux music festival in Edinburgh, Scotland. Both projects were united by the erratic nature of the content.

Thames Water approached 8vo to design their water bill, a process that involved analysis and deconstruction, the evaluation of which determined the resulting visual outcome. The water bill is received by several million users, all paying in a variety of ways covering different periods of time. To start the process, 8vo devised a 'multi-dimensional grid' that deconstructed all the potential requirements. The design process then meant devising sets of rules to determine the behaviour of the graphic elements under a variety of differing circumstances.

Obviously, the posters designed for Flux, part of the Edinburgh fringe arts festival, required a completely different visual outcome, but some of the initial typographic problems were the same. In this case, venues, times, dates and performer details were unfixed until the last minute. The project didn't require a grid but rather a typographic system to easily accommodate this diverse information. The system could be tested prior to application, using dummy copy, but the end result would always be determined by the natural flow of the final information. This appears to be a non-interventionist approach, but the system was fixed in the abstract and was designed to accommodate the random nature of the text. Muir sees parallels between this and grid structures. Grids are designed to accommodate particular text and images prior to the page being assembled, but do not wholly determine the visual outcome.

above
A series of spreads from
catalogues produced for
the Museum Boymans-van
Beuningen in Rotterdam,
1989–93, each using
a different grid.

right
A spread and the cover
of the booklet, produced
in 1993, which documented
this process and used
all the catalogue grids
and co-ordinates printed
on top of each other.

Muir has some mistrust of making the grid
overtly visible, an affectation that he feels
is 'a trick' that often implies a false technical
rigour. However, when Wim Crouwel
commissioned 8vo to design the catalogues
for the Museum Boymans-van Beuningen
in Rotterdam, part of his brief to them was
that each publication should have a new grid.
The rationale for this was that the 'container
should be responsive to the content'. When
the work concluded, the museum suggested
to Crouwel and 8vo that they should publish
some kind of documentation of this process.
The result is a publication that celebrates
variety through the grid, with each one over-
printing the next, colour-coded to denote
year of use and revealed structural data.

When asked about maths, Muir says that
he is 'interested in precision', and will
always check coordinates rather than trusting
'snap-to-grid' functions. This is a discussion
with which he is slightly awkward. How
does one ally these concerns with a belief
in intuition? With the distance of time, Muir
is able to consider his work with 8vo more
objectively and question some of those
concerns that had at one time seemed
so pressing and crucial.

He considers the relationship between
analogue and digital. The former allows
for natural erosion and organic change,
for toleration of 'what feels right' and
a roughness that denies the unhealthy
pursuit of perfection. 'Maybe that's
what's wrong with all of us designers,' he
ponders, 'we like to make things precise...
but I like things that are slightly unfinished
and awkward too. What was it that John
Lennon called typographers at art school?
Something like "neat little fuckers" wasn't it?'

Kees van Dongen: vroege jaren
in Rotterdam en Parijs

Kees van Dongen's early years
in Rotterdam and Paris

Museum Boymans-van Beuningen Rotterdam

Design: 8vo, London

Ellen Lupton

biography
born 1963
nationality American

1981–85
BFA
The Cooper Union for the
Advancement of Science and Art
New York

Graduate work in art history
City University of New York
Graduate Center

1985–92
Curator of Herb Lubalin Study Center
The Cooper Union

1992 to the present
Curator of Contemporary Design
Cooper-Hewitt
National Design Museum
Smithsonian Institution

1998 to the present
Chair of Department of Graphic Design
Maryland Institute College of Art
Baltimore

'The power of the grid is to lift the designer outside of the protective capriciousness of the "self" by providing an existing set of possibilities, a set of rules.'

above and right
Two spreads from
Design Writing Research,
published in 1996,
demonstrating the flexibility
of its structure and the
appropriate use of the
grid to reflect content.

far right
Spreads from the book,
The Bauhaus and Design
Theory, 1993. The grid
is used to actively organise
and interpret the content,
sometimes becoming
an overt contribution to
the design.

Body of the Book

head
1. The upper division of the body that contains the brain, mouth, and chief sense organs.
2. A word or series of words, often distinguished typographically, placed at the beginning of a passage or at the top of a page in order to introduce or categorize.

"The hand itself may be altered, redesigned, repaired through, for example, *an asbestos glove* (allowing the hand to act on materials as though it were indifferent to temperatures of 500°), *a baseball mitt* (allowing the hand to receive continual concussion as though immune to concussion), *a scythe* (magnifying the scale and cutting action of the cupped hand many times over), *a pencil* (endowing the hand with a voice), and so on, through hundreds of other objects. *The natural hand* (burnable, breakable, small, and silent) now becomes *the artifact-hand* (unburnable, unbreakable, large, and endlessly vocal)." ELAINE SCARRY

In the 1920s Laszlo Moholy-Nagy saw the camera as an extension of the human body, an instrument that allows the frail biological eye to halt time, cross extreme distances, magnify invisible landscapes, and penetrate opaque structures.[1] All objects manufactured for use are extensions of the body: food, furniture, shelter, and tools do not lie in a region safely "outside" the body, but instead are continuations of the body, turning it inside out. As Elaine Scarry has written, there is no fundamental difference between an object that is external and disposable as a glove and one as internal and permanent as an artificial organ: both become part of the body.[2]

What might be the relationship, then, between writing, typography, and the body? In the West, writing has historically been seen as secondary to speech: while speech appears to give an immediate voice to the interior self, writing is an external device, an intellectual technology employing an artificial code. Speech appears to be naturally birthed by the biological organs of the body, while writing depends on the mediation of external tools: chisel, stylus, pencil, keyboard. Every culture instinctively produces some form of speech; a system of writing, in contrast, must be deliberately designed.

But what if one were to see writing as an extension of the body, no different in essence from an artificial limb or a contact lens? Like a chair supporting the human skeleton, writing supplements the body's capacity to speak: it is permanent rather than ephemeral, it withstands movements in place and time, and it remains readable in the absence of its author.

There is another way in which writing extends the body: it is a physical by-product, a material trace of human activity.[3] Unlike speech, writing leaves behind a visible mark. As the end-product of the so-called "thought process," writing thus resembles excrement. It is also akin to hair, finger nails, and the surface of the skin—each is a part of the body that is continually regenerated yet biologically dead, detachable, disposable. Writing is like blood, sweat, semen, saliva, and other substances that the body periodically produces and eliminates.

[1] Laszlo Moholy-Nagy, *Painting Photography Film* (Cambridge: MIT Press, 1969). First published in 1925.

[2] Elaine Scarry, *The Body in Pain: The Making and Unmaking of the World* (New York: Oxford University Press, 1985).

[3] Jacques Derrida has discussed speech as a physical, material by-product of the mouth rather than a purely phonic, abstract signal: "The text is spit out. It is like a discourse in which the entities model themselves after an excrement, a secretion." Quoted in Gregory Ulmer, *Applied Grammatology: Post(e) Pedagogy from Jacques Derrida to Joseph Beuys* (Baltimore: Johns Hopkins University Press, 1985): 55.

gloss From the Greek *glossa, glotta*, meaning tongue. 1. A brief explanation (as in the margins or between the lines of a text) of a difficult or obscure word or expression. 2. A false and often willfully misleading interpretation. 3. A continuous commentary accompanying a text. A gloss could be an official element of a page or a handwritten remark. Library books are often defiled by the *glosses* of several readers. A book is thus not only read by many, but written by many.

In the language of publishing and typography, we refer to the body of a work as its "main part," its central, substantial core. When we refer to the "body" of a person, we invoke a division between inside and outside: body and soul, body and mind. Similarly, the typographic term "body" suggests a division between inside and outside, between that which properly belongs to a text and the secondary limbs attached to it: glosses, footnotes, heads and subheads, figures, appendices. One of the graphic designer's tasks is to articulate visually the differences between these secondary elements and the "body" of the text. But do such limbs remain safely "outside" the text? Instead we could see these seemingly detachable, external parts as *internal* organs, life-support systems fundamental to the shape of the text, an element such as a gloss, footnote, figure, or appendix is an integral part of the body, opening up the skin of the text, turning it inside out.

body 1. The organized physical substance of an animal or plant, whether living or dead. 2. The dead organism: CORPSE. 3. The trunk of a person or a tree, as distinct from its head, limbs, branches, or roots. 4. The main part of a literary or journalistic work: TEXT.

Whereas the "body" of a text is typically assigned to a single author, notes, glosses, figures, and appendices are organs for importing material from the outside, for exchanging discourse with other documents. Such organs nourish, impregnate, and sometimes deface, infect, the internal body.

The valves of these organs serve not only to absorb, but also to expel, excrete. They generate substances, leaving a mark, a trail of argument in excess of the seemingly self-contained "body" of the work. The organs of the text are sites for elaboration, expansion, overflow, like the body's periodic release of semen or blood. For example, footnotes support the text from below; they represent the foundation of research. They do not constitute a merely passive base or pedestal, however, but rather a vital root system that feeds the work through a subterranean web of other texts. Footnotes can serve as minimal anchors or as loquacious networks that grossly enlarge the reach of the body. By documenting the exchange of fluids between texts, footnotes diagram the paternity of ideas.

figure
1. Bodily shape, especially of a person. 2. A diagram or illustration supporting a text.

foot 1. The terminal part of the vertebrate leg upon which an individual stands. 2. Something resembling a foot in appearance or use.

footnote 1. A note of reference, explanation, or comment, placed below the text on a printed page. 2. Something that is subordinately related to a larger work: COMMENTARY.
appendix 1. A bodily outgrowth or process, specifically the organ VERIFORM APPENDIX, commonly subject to surgical removal. 2. Supplementary material attached to the end of a piece of writing, often consisting of tables, diagrams, glossaries, etc.

50 DESIGN WRITING RESEARCH

Ellen Lupton is a curator, writer and graphic designer. This combination of activities gives her objectivity about her own and others' design practice, which is unusual within the profession today.

In her role as curator and writer, she is highly aware of contemporary approaches to design and sets this knowledge against a broad cultural landscape. Her design work is generally connected to her own writings or exhibitions, and understandably this informs many of her design decisions. 'What's important to me is that people are excited by the content of a given project,' explains Lupton, 'and that they enjoy the way design enhances, emphasises, supports, or elaborates on the content. In my own work, design is never an end in itself. As the author or editor of nearly every project I design, content is extremely important. Designers who deal with other people's content are more free to focus on "aesthetic appeal" at the expense of readers and writers.'

Lupton sees the grid as a tool to help make her work more accessible. She is also keen to demonstrate the grid's potential for flexibility. 'They create the possibility for consistency and repetition as well as discontinuity and breaks,' she comments. 'I like to use the grid to organise the information more actively, something that reflects change across the body of a publication. For example, my book Design Writing Research is very complex, every essay has its own design aesthetic but there is an underlying typographic structure to it too.' As Lupton points out, the chief function of a grid is to give a publication a degree of stability while all the graphic elements are changing.

For Lupton, grids are interesting because they juxtapose the rational and irrational. It is this tension that creates possibilities for invention and discovery. 'The grid is itself arbitrary, like language. It is a system outside the self that follows its own logic. That logic, however, is not necessarily "functional" or "correct". It is grounded in history, politics, ideology. In modern painting the grid is used as a way to look rational but is purely intuitive; ultimately it's mystical and not rational.' Referring to the essay 'Grids' by the academic Rosalind Krauss, Lupton cites the Christian cross as a form of grid. 'What more powerful ideology is there than that!' she remarks.

While acknowledging that grids have, for some, mystical significance, Lupton is not particularly driven by notions of mathematical purity or the desire to experiment with geometrically derived formats and layouts. 'I believe Jeffery Keedy has called this stuff "proportion voodoo". I enjoy systems that relate to culture rather than maths. The lines on notepaper, the sizes of standard stationery, and so on.'

Lupton constantly looks beyond the world of design for her points of reference, mistrusting as she does the profession's introspection and contemporary obsession with self-expression. 'I can't stand designer self-obsession. "It's like this because I thought it." That's how design is polluted.' She is driven ultimately by a desire to communicate effectively and dismisses the notion that tools that help in this process are bound to restrict creativity. 'For me a project is a failure if people don't read and understand it. It must be possible to be inventive and creative and still produce material that people can read.'

The focus on designer intuition 'is one of the great myths and pretensions of modern design', proclaims Lupton passionately. 'People use intuition all the time. When you get dressed in the morning, you make snap judgements but that doesn't make them any more brilliant or mysterious or God-given. A lot of designers fetishise their own intuition as an excuse for not having strong concepts.' Lupton argues that in all decisions one weighs up different factors and that therefore intuition plays a part in the final outcome. The importance placed on this part of the design process reveals a lack of humility or engagement with real design problems. 'Things outside oneself are much more interesting. Things in culture, in use, in function.'

'Intuitive' designers often argue that the notion of the grid is stifling to creativity. Lupton argues that in the right hands the opposite is true. 'The grid is only limiting if it is used that way. To say the grid is limiting is to say that language is limiting, or typography is limiting. It is up to us to use these media critically or passively.'

John Maeda

biography
born 1966
nationality American

1989
BA and MA degrees
in Computer Science and
Electrical Engineering
Massachusetts Institute of Technology (MIT)

1995
Doctoral studies in design
University of Tsukuba Institute
of Art and Design
Japan

1996 to the present
Sony Career Development
Professor of Media Arts and Sciences
and Director of the Aesthetics and
Computation Group
MIT Media Laboratory
Cambridge, MA

1996
Founder Maeda Studio

'If you look at the foundation of our computer visual culture it's Adobe's Postscript, which was invented by a computer scientist, not an illustrator or anyone like that.'

Radial Paint, 1994
Maeda explains this
as an experiment in
painting as restricted to
circular movements.

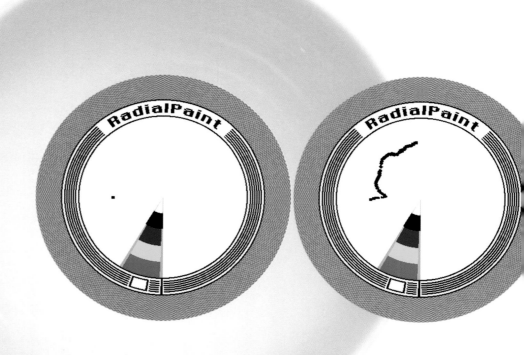

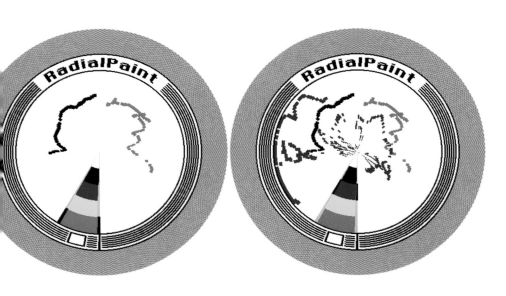

As someone whose career and cultural background have given him a deep understanding of both Japanese and Western design practices, John Maeda is in a unique position to be able to compare the the use of grids in the two cultures. On one level, the two design traditions have a lot in common. As Maeda points out, 'if you look at the history of the Western design tradition, there is a lot that came from Japan. Frank Lloyd Wright, for instance, copied a lot of Japanese things.' And, he says, just as in the West there are some designers who like working with grids and some who don't, the same distinction applies in Japan.

However, on a deeper level, there are subtle yet interesting differences. 'I think that Japan is the country of the grid,' says Maeda. 'But I would say that it is very different to the way it's been applied in America or Europe. There is a lot more of a spiritual feeling that is associated with geometry in Japan.'

'The best example that I can think of is something I was told by a friend who is an acupuncturist. He comes to teach in the US once in a while and thinks it strange that in that country, in order to locate points on the body, they use an alpha-numeric, like "W17" or something. It's a bit like the game of Battleships. He says the problem with this sort of vocabulary is that it is devoid of any sense of the body. In Chinese acupuncture there are what he calls "meridian" lines across the body and they have names, like "dragon" meridian, and have legends associated with them. So there is a kind of rationale to the grid they form. And so maybe there is something fundamentally different about the way that grids are treated in the two cultures.'

In terms of graphic design, Maeda is also conscious of a particular way of structuring visual work that is not found in the West. 'I do believe that there is a very ordered kind of design in Japan that is nothing to do with the grid,' he says. 'It is really something quite different, which I cannot quantify or qualify very well. I just know that I can look at something made by the older Japanese designers, such as Ikko Tanaka, and there's no grid to it. But it had a certain kind of very strict structuring, that's still free at the same time.'

John Maeda

right
Led Array, 2001
This programmable
LED grid is the common
element used in the Light
Box series of objects.

far right
Color Typewriter, 1995
A colour typewriter
in which a grid of colour
tokens, instead of letters,
are created by typing at
the keyboard.

As well as being able to work across the Western/Japanese culture gap, Maeda is able to span the arts/sciences divide, having studied both computer programming and fine art. With advance programming skills he is – more than most designers – able to make the computer do what he wants. Nevertheless, he finds working with the computer an extremely frustrating experience.

'Quark or PageMaker, or whatever, have grid tools but I find myself hating them because I lay things down and then they move around! Some can't move and some can, and then I change something and they all get busted. I used to design on a photo-typesetting machine, so I set grids myself on the camera-ready paper and I'd move things around and I never had a fight like this! I think it's a different relationship.' Maeda adds that he always sketches everything out on paper first because it's so much more intuitive.

It is, perhaps, because he can see beyond the current capabilities of the computer to what it might one day be capable of that makes Maeda so frustrated. Part of what's holding us back, he believes, is our limited conception of what a computer is. 'We think of the computer as a machine with a television screen and a typewriter thing,' he says. 'But in the end, the computer is most interesting when we think of it not having a particular form.'

Dots, 1996.
One in a series of four
prints experimenting
with a variation of the
dot size. Here the dots
appear to chase toward
the centre.

The designer and the grid
Introduction
The principle of the grid
Grids are everywhere
The grid in cultural context
The psychology of the grid
Making the grid
Breaking the grid
Bibliography/Contacts/Credits/Index

X: 20 mm Y: 10 mm	W: 63.5 mm H: 84.667 mm	⌀ 0° Cols:
X: 20 mm Y: 72 pt	W: 63.5 mm H: 240 pt	⌀ 0° Cols: 1
X: 48 pt Y: 72 pt	W: 180 pt H: 240 pt	⌀ 0° Cols:

This instructional section does not set out to define a prescriptive 'how to', which would be potentially rather dry and unilluminating. It is written from an obsessive's perspective and assumes the reader is equally concerned with the pursuit of perfection. Some knowledge is also assumed – not only of what grids are, but also of why they are so appealing.

Just as it is rare to have the opportunity to find out, honestly, what one's friends earn, it is a treat to investigate thoroughly the processes that designers apply to their working methods and find that you are not alone in your obsessions. Other designers also revel in devising a new system to accommodate a set of typographic problems and eradicate its inconsistencies. 'The search for structure rules my life. I look for grids everywhere,' admits Rupert Bassett, who runs his own studio that specialises in corporate information design.

We are sitting in the newly renovated British Museum café, in London. On arrival, Bassett has pointed out the letterforms carved into the stones that run around the Reading Room. He rightly bemoans their inconsistent positioning within these slabs. A grid was provided by the dimensions and relative positioning of these blocks of stone, but it has not been used; cap-heights move up and down at random, destroying what at first seems a considered piece of design.

Clients are often completely unaware of a designer's preoccupation with structure and systems, assuming that it is the visual alone that drives them. Kelvyn Smith, Area of Study Leader, Typo/Graphic Design at the London College of Printing, worked for four years as assistant to the letterpress typographer Alan Kitching. 'In letterpress one has to work with predefined elements that determine some of the structure,' he comments, 'now the mathematics are more significant because they are so refinable.'

Grids sometimes allow designers to indulge in truly idiosyncratic means of self-expression without in any way impeding the end-user. One of the best things about a grid is that it is actually invisible. 'Lots of things I do are for my own sense of purity... I don't think the design should dominate... I try to be as neutral as possible,' says Dave Shaw, senior graphic designer at a London-based development agency working in the education sector. Shaw is responsible for developing a house style for a variety of books, papers and academic publications. 'I love templates,' he says, 'each one is a new technical, and personal, challenge. Other stakeholders in the design process are often unaware of these challenges but nonetheless I am convinced that technical purity immeasurably improves long-term ease of use, effectiveness and efficiency.'

Controlling a page

The measurement palette can be used to accurately position type and images on the page. There is no consensus, however, about which units of measurement to use. The options are: all millimetres or all points in both horizontal and vertical directions, or millimetres to define margins, column widths and intercolumn spaces with points used for all typographically derived divisions down the page. These three options are shown above.

Here the 'x' and 'y' refer to the position of an object on a page, while the 'w' and 'h' refer to the size of the object itself.

The choice of units of measurement can lead to uncomfortable numbers on the palette, particularly if using millimetres in both directions. Type sizes are still always expressed in the smaller unit of the point. If the depth of a text box corresponds to a baseline unit, which is first specified in points, then QuarkXPress will convert this into millimetres. This is shown by 'h' in the top diagram.

A grid is a series of verticals and horizontals that subdivide a page into units of space, which in turn hold type and images. The purpose is to make the process of designing easier, speedier and more efficient. It should, if considered rigorously enough, lead to a consistent and easily navigated piece of design. A grid's proportions and the flexibility with which it is used should also lead to compositions of beauty.

Both Shaw and Bassett liken their work to that of a builder or engineer. 'I try to engineer templates that produce things quickly and efficiently. The template shouldn't get in the way,' says Shaw.

'I am interested in the creation of effective systems which facilitate the consistent composition of graphic elements within a space,' explains Bassett. 'This method of working usually demands the definition of a universal grid structure, the repetitive use of basic units of measurement and the reduction of graphic elements to their simplest visual forms. Because of this I am relatively uninterested in the formal characteristics of individual typefaces. Typographic decisions are often made by considering the size and location of the body of the type rather than the shapes of the letterforms themselves. I am happiest with my work when all the graphic elements fit together like Lego.'

None of this sounds particularly complex or exciting, and yet it is with extraordinary passion that many designers describe their joy in controlling the page. One starts with blank spaces and ends with spaces that mean something in relation to the type and images around them.

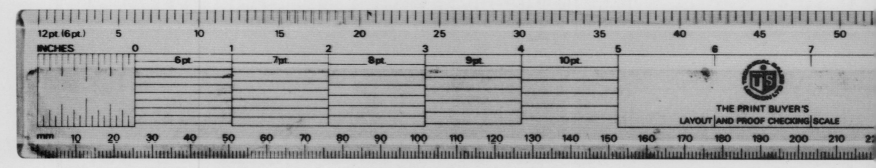

Precision and mathematics

The core concerns in designing a grid have not changed with the arrival of the digital age. 'New technology just helps you get there much quicker,' says Bassett. In many respects, it is the designers who are less interested in structure who have found new visual languages by using technology to blur, layer, distort and filter. For the grid-based designer, the joy of working with computers is that greater accuracy is possible. All programs allow for some mathematical positioning. QuarkXPress, for example, is designed to work for the mathematically driven and motivated; the previously used Cow Gum spreader did not.

Prior to the use of desktop computers, inaccuracy was inevitable in the production of a grid. Rather like King Canute, who attempted to hold back the waves, graphic designers sharpened their pencils, washed set-squares and carefully angled desk lights to avoid distracting shadows falling on their artwork. Type, run out on bromide, was cut and literally pasted onto a base grid of hand-drawn non-reproducible blue lines. The slow-setting glue, Cow Gum, became synonymous with the designer's struggle to control the page. Previous methods of page make-up involved the setting of metal or wood type. Despite the accurate sizing of each letter and space, inevitably this method too was subject to the frailty of human hand.

Smith has experienced the change of technology from letterpress to computer and this has impacted on his work, but not as might be imagined. 'It revolves around structure,' he explains, 'not only structure but mathematics too. The process of refinement is the thing that has changed as the mathematics are much more variable now.' Smith explains that working with the restrictions of letterpress encouraged him to push boundaries and experiment compositionally. The freedom offered by new technology has a reverse effect. Smith is now more interested in finding simple and straightforward solutions.

Shaw, Bassett and Smith all use the on-screen measurement palette constantly. In their hands the numerical keyboard is a design tool as they move around the page keying in co-ordinates to ensure accuracy. 'Positioning by eye shocks me every time,' remarks Bassett.

The process, and much of the language used to describe it, is pseudo-scientific. It reveals a preoccupation with logic that reinforces the idea that designing is quantifiable. Bassett explains to his clients that 'consistency gives authority'; their message will be reinforced not only by a confident design but, more importantly, by one in which every space, every type weight and size means something. Although 'visual mess' can sometimes be an appropriate design response, generally the subliminal meaning derived from a messy design process is that the message is ill-considered also. As Shaw comments, 'I like doing things in steps because it means I can easily control where I need to be to achieve a result. It's fixed and quantitative – this input gives this output.'

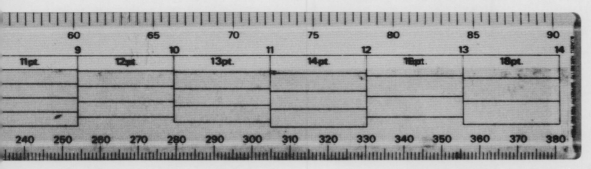

A good old-fashioned ruler showing all the units of measurement a designer might need: points, millimetres and inches. Prior to the use of computers, designers still strove for accuracy.

Units of measurement

One of the most interesting aspects of grid structure is the variety of units of measurement that are possible and that designers feel comfortable with. There are no absolutes as long as the system one chooses allows for flexibility – but is consistent.

Bassett argues that a commitment to one unit of measurement, be it metric or imperial, for both paper and type sizes would be beneficial. The standard paper sizes in Europe are measured in millimetres but, as he points out, working with American paper sizes, which are specified in inches, is more typographically compatible. Type is generally still specified in points, a system that is imperial: 72 points have been standardised to equal one inch.

Although both Shaw and Bassett consider the logical measurement system to be one that can work both horizontally and vertically, they apply this principle very differently.

Shaw uses points, a typographic unit of measurement, to define his overall type area and all the type, images and spaces within it. He sees the requirements of this area as distinct from the outer margins around it and the overall page. All margins are measured in millimetres that 'shut out the point-based system' and bear a closer relationship to the overall page, also measured in millimetres.

Bassett uses millimetres across and down the entire page, which allows for easier integration with standard paper and format sizes. The typographic baseline to baseline measurement is specified in millimetres, as are column widths, margins and intercolumn spaces. Type sizes, however, are specified in points. A point is an incrementally smaller unit than a millimetre and so this allows for greater typographic refinement. The type size could be 14 point, for example, but the baseline to baseline measurement – type size plus 'leading' – would be specified as 5mm.

Smith, however, applies an alternative logic. As type size and leading determine the page structure horizontally, he uses points to specify baseline to baseline units and therefore overall depth of a column or page. Although he is comfortable with the more traditional specification of column width in picas – 12-point units – his preference is to use millimetres for all vertical points of alignment.

Micro/macro considerations

Designing a grid requires a balancing act between considering the minutiae and the bigger picture. The designer is required to consider simultaneously the typographic requirements of the copy and the overall space it should occupy. A grid grows out from the text and other graphic elements, and in from the format.

The text and all graphic elements

One might imagine that there is a formulaic method of designing and working with a grid upon which designers agree. While talking to these three practitioners, each described a different process but all were agreed that the starting point is the text; its meaning and the hierarchical devices it requires. If this analysis is correct, it will design itself. 'I have evolved a process which I comb through again and again,' explains Smith. 'I look at the hierarchy of the information and then start to look at how the form can be broken down in relation to it. I can't work with the mathematics until I've assessed the information.'

Copy analysis is often an overlooked skill. The typographer's job is to signpost correctly, to disentangle often muddled raw copy and help it make sense. The visual language established becomes a code for the reader. 'A grid is a system with which you can show hierarchy and structure,' comments Shaw. Bassett has a similar approach, 'I have to know the relative size, location and specification of everything on the page.'

The components of the grid

Baselines

The relationship of font choice to the grid is a huge subject worthy of another section. Smith takes a minimal and logical position. He always starts with the most neutral of fonts, in one size and weight: Univers 55. He then amends weight and tone, rather than size, to develop a hierarchy. As Smith acknowledges, he 'is not that expressive with the type, it's pretty straightforward. I'm expressive with the composition.'

When considering the grid, the most important number is not the font size but the font size plus the additional space between the lines – the traditionally named 'leading'. It is this measurement from baseline to baseline that is so hugely significant since it determines the ubiquitous baseline grid. This unit of measurement, often subdivided into thirds or quarters, will determine all the horizontal divisions of the grid. The ease with which this degree of precision and control can be achieved is particular to the technology.

Even if the design requires more than one font size, the unit of the baseline grid should be the same throughout to ensure controllable and proportional spacing between paragraphs, above and below headings etc. Even the weights of rules can work within this system.

To fully appreciate the significance of this concept, Bassett and Smith argue that educators must inform students about 'the body of the type'. The computer technology is still responsive to the rules established by metal type and is 'virtual metal typesetting'.

While most designers agree that the baseline of the type is the strongest optical alignment point, the position of the 'x-height' or 'cap-height' is often also considered. Shaw, for example, places his first baseline so that the top of the x-height of the body text aligns with the top of the head margin.

Bassett will subdivide the page horizontally also – by multiples of his baseline space – to achieve a coherent set of positions for hanging points for images. An example of this is the grid system devised as part of the new RAC identity that Bassett worked on while with the design group North (shown on pages 140/141). This system was created to consistently integrate 35mm-proportion photographic images with the basic typographic unit of 10-point type on 4mm linespacing, used universally throughout the RAC literature.

To develop this language, the designer has to understand the requirements of all the elements of the composition. This will include considering:

- Who the audience is
- What sort of text it is and what images illustrate it
- Where it will be read
- The way in which the text is subdivided
- The other typographic devices required (for example, folios, running heads, quotes, captions, lists, tables, contact details, footnotes or any other oddities/variations from straightforward text)

The idea is to design a system that naturally accommodates them all.

Format

As seems appropriate for designers who are preoccupied with systems, Shaw and Bassett both argue that straying from standard formats has to be justified on grounds of logic. This is as much an issue of design principle as expediency. Paper size determines printing-press size and, in turn, finishers accommodate these standards most economically. Standardisation is an essential element in the modernist's design approach and so Bassett considers it to be indulgent, inefficient and expensive to change from standard formats simply for the sake of it. Shaw sees it as an extension of his logical approach that the whole page of any book he designs fits onto one page when it is photocopied.

Smith takes a different approach, although one that is still rooted in notions of non-intervention. In his commercial work, Smith is flexible: 'I have no problem with given, standard formats or with formats that are specifically chosen and appropriate for the job.' In his research work, Smith always starts with a square format. This he considers to be a neutral form, without horizontal or vertical stresses that could determine the overall layout. These act as modules that can later be joined to form a variety of different shapes. From a teaching perspective, Smith also feels it is important that students are not sidetracked. If the format is a given, then they will focus properly on the composition within it and the ideas and decisions necessary for effective communication.

Columns and margins

There is some disagreement about the optimum number of words per line for maximum legibility. However, for continuous text, Müller-Brockmann's guideline of seven is a good starting point for determining a grid. To Smith, these sorts of principles are 'a given'; rules that he has learnt in the letterpress workshop and now applies to the new technology.

For all three designers, pages are usually divided into an odd number of columns. This and the choice of ranged-left typesetting are designed to achieve asymmetric layouts. Basic modernist teaching argued for layouts that work naturally with, not against, the text. Word spaces are equal because each space means the same thing. We read from left to right, so inevitably lines are ranged left and have ragged endings. Straightaway, all text appears to be weighted to one side and has a visual dynamism that can be developed to give emphasis and pace to the overall message.

The narrowest column may be designed to accommodate captions or address details, while multiples of this unit might be used for text. Column widths are easier to work with in whole or half units.

Shaw is primarily interested in the relationship between similar elements; for example, text and headings or margins and the page. He is working on a graph that can specify a hierarchy of type sizes that will work consistently on particular baseline grids. He has chosen points as his preferred unit of measurement, but has decided to consider the outer margins separately from his type area. Although the logo Shaw works with is only used on front covers, the 'logo zone' of 21.5mm determines the outer and top margins of all text pages. The inside and bottom margins will 'take up any slack' after he has fine-tuned the grid. All other decisions are determined by the leading. All column widths are designed as a multiple of the leading; the intercolumn space or gutter is the equivalent of one line space. He believes one line space between columns reflects the correct relationship between columns since they will be further apart than paragraph to paragraph.

Not all systems are designed to result in measurements that are round numbers. Some systems are more proportionally driven. While working with Square Red Studio, Bassett worked on the identity for the newly merged pharmaceutical company GlaxoWellcome. A variety of design agencies around the world would put the identity into practice, and so an easily understood system was essential. This system was applied to all items of communication irrespective of size or proportion. The grid was created for each format by dividing it into ten equal horizontal and ten equal vertical divisions. This resulted in a grid of 100 equal units of the same proportion as the overall format. The grid would then be used to size and position all the graphic elements – typography, photography, etc – required by that item.

For Smith, defining column widths and intercolumn spaces at the outset would be restrictive. Instead, text is placed in text boxes without gutters, with words turned down to the next line as necessary to avoid columns appearing to be too close across the page. This method is responsive to the text but is less systematic than Shaw's or Bassett's.

this spread
The edited highlights of
Shaw's screen captures,
which are shown in full
on the following spread.
The above cover the very
basic considerations
in setting up a grid and
working with style sheets
in QuarkXPress 4.

left to right, top to bottom					
Document set up	**Measurements**	**Baselines**	**Type**	**Paragraphs**	**Multiple master pages**
File> New> Document Use this dialogue box to specify the size of the page, the margins, the number of columns and the intercolumn space (gutter width). It is important to work out the size of your columns prior to this. You are not required to specify this separately, but you cannot calculate accurately all the measurements that you do need to specify without having worked this out.	**Edit> Preferences> Document** Use this box to specify general preferences, for example, which units of measurement are used both horizontally and vertically.	**Edit> Preferences> Document> General> Paragraph** Use this box to specify the increment to use for the baseline grid.	**Edit> Style sheets> New> Character** Use this box to specify any new character-based style sheet. This includes the font, size, colour and overall changes to tracking. It is also possible to give it a quick key equivalent and to specify some of the typographic fine-tuning.	**Edit> Style sheets> New> Paragraph** Use this box to specify any new paragraph style sheet. This can use the character style already identified, or can be based on this and then edited. Click on the format tab at the top of this box to specify the spacing required between paragraphs. QuarkXPress understands headings to also be responsive to paragraph attributes.	**View> Show document layout** It is sometimes necessary to have more than one master page per document. Additional master pages can be created by dragging the page icon and dropping below the A-master A icon in the document layout palette. An alternative grid can then be constructed by selecting the appropriate page and going to Page> Master guides. The master pages can then be used as necessary to form multiple-page documents.

following spread
A series of screen
captures showing Shaw's
methods of working in
QuarkXPress 4. He has
excelled in developing
complex systems to
accommodate all his
typographic needs, from
the basic specification
of document sizes and
grids to the minutiae
of letterspacing.

Dave Shaw
born 1974

1992–95
BA (hons) Graphic Design
Bath College of
Higher Education

1997
Assistant Graphic
Designer working in
the education sector
1998 to the present
Senior Graphic Designer
working in the
education sector

RAC identity programme
RAC literature grid system
2.1
Grid structure

A grid is the structural foundation for any design layout, providing consistent organisation for all graphic elements. Utilising the grid helps to maintain a strong and enduring visual personality.

Each format uses a dedicated grid structure, composed of the following elements:

Format
Format is the overall size of an item. The amount or nature of content determines the choice of format.

Grid area
The grid area defines the working boundary in which graphic elements are contained. Full bleed photography is the only permitted element to extend beyond this area.

Baseline grid
The baseline grid uses 4mm horizontal increments. This measurement is based on the line spacing of body text (10pt type, 4mm line spacing).

Format
The format is the overall size of the working area.

Grid area
The grid area is the area within which graphic elements are placed.

Baseline grid
The baseline grid is the incremental measure upon which type sits. All RAC baseline grids are based on the line spacing for body text (4mm).

Column grid
The column grid is the structure which arranges type into vertical columns.

3 columns

1 column

Cap height of body text (10pt type, 4mm line spacing)

To many, the term 'corporate identity' means simply a company's logotype and colours, but in reality anyone's identity, whether they are a huge global corporation or an individual person, is much, much more than simply how they look or what they wear. Identity is also how we behave, how we think, our approach, the things we think are important, how we talk, what we say, how we treat others, what we believe in and what we do. Identity is what we are.

Column grid

The grid area is divided into a number of vertical columns. The number of columns increases with format size. For example, an A4 portrait format provides a maximum of 12 vertical columns.

Image module grid

Image modules are based on a 35mm photographic format and proportioned in the size 1:1.5. Images can be scaled proportionally to work in conjunction with the baseline grid and column grid. Images are the only permitted element that can extend beyond the grid area.

age modules are based on
45mm photographic format
d proportioned 1:1.5.

age module grid

e image module grid
constructed of individual
odules. Each module
elated to the height of
pitals, the baseline grid
d the column grid;
suring image alignment
h type.

Composite grid

The baseline grid, column grid and image module grid combine to create an organisational structure for the placement of all graphic elements.

Image module

A spread from the RAC corporate identity guide. North devised a system that would consistently integrate 35mm-proportion photographic images with the basic typographic unit of 10-point type on 4mm linespacing, used throughout the RAC literature.

The 4mm baseline grid was overlaid with a series of 28mm image modules to create an overall page grid of six columns. The bottom edges of the image modules were positioned to align with the typographic baselines. Top edges of the modules would then automatically align with the cap height of any accompanying 10-point text.

Bassett also worked with Tim Beard and Mason Wells of North on this part of the RAC corporate identity.

Rupert Bassett
born 1965

1985–88
BA Graphic Design
Ravensbourne College
of Art
1988–90
MA Graphic Design
Royal College of Art

1990 to the present
Teaching at various
colleges including
Ravensbourne College
of Art, Middlesex
University and the London
College of Printing

Work with Square Red
Studio, North, Imagination

Runs own design studio
specialising in corporate
information design

1454 First movable type in Europe

1297 First movable woodblock type

Gutenberg made
everybody a reader.
Xerox made
everybody a publisher.
—Marshall McLuhan

People say that life is the thing,
but I prefer reading.
Logan Pearsall-Smith

Half of the world's
population have never
had a telephone call.

When you laugh
your brain releases
endorphins which
make you feel better.

There is one part
of the human brain
specifically designed
to recognise faces.

You use 72 different
muscles to talk.

talk

talk

talk

talk

The typography designed for the Talk Zone at the Millennium Dome, London, was wholly integrated with the architecture. A 25mm unit was the basis of the system applied by the Talk Zone's architecture team. The graphic design team from Imagination based their typography on this unit, adopting it to determine both image, type sizes and positions.

Bassett and Smith also worked with Andy Lawrence and Eamonn O'Reilly as the Imagination graphic design team for the Talk Zone.

The end results

'It's composition that's of interest to me. I look at grids in the abstract but what I see is the composition. I perceive things linearly, like a journey,' says Smith – whose working methods are the most free-form of the three. He considers his passion for composition to be 'quite painterly': the structure evolves while still being rooted in an 'understanding of mathematics, ratios and proportions'.

All three agree that the use of grids is only one part of the process. 'You have to stop and look at all the elements of the composition together in the end,' admits Bassett. 'Systems will only get you so far: otherwise it could be done by machines.' Having set up style sheets, Shaw looks at a sample page and adjusts as necessary. His interest in the 'craft' of typography gives him an appreciation of the subtlety of typographic detail.

The criticism always levelled against those whose work is heavily grid-based is that it is highly restrictive. Shaw, Bassett and Smith would argue that the opposite is true.

For Bassett and Smith, a perfect example of this was their work, while at the design consultancy Imagination, on the Talk Zone for the Millennium Dome in London. The Talk Zone's architecture team had devised a system of structural components that employed a basic 25mm unit. The Talk Zone's graphic design team decided to adopt this as its basic typographic unit. The typography had to be integrated with the architecture of the Zone as efficiently as possible.

Space within the Millennium Dome was at a premium, and it was essential to devise a system that maintained legibility from a variety of vantage points. A series of type sizes, based on multiples of the 25mm unit, was chosen for application in any medium and were applied according to the specific reading distances available at different points around the Zone. 'It was a faultless system,' comments Bassett, 'it liberated us and allowed us to produce an enormous amount of work quickly and efficiently in all media.' 'It did everything we needed,' adds Smith.

Once a system is established, you no longer have to reinvent the wheel – you can concentrate on riding in the park instead.

Kelvyn Smith
born 1968

1987
BA Graphic Design
Norwich School of Art
1994
MA Sequential and
Narrative Design
Brighton University

1990–94
Assistant to Alan Kitching
The Typography Workshop
London
1994
Founded own design
studio, The Typographic
Studio of Mr Smith

1992–99
Teaching at various
colleges including
Middlesex University,
Kent Institute of Art and
Design, Brighton University
and Colchester Institute
1999–2001
Research Associate
Middlesex University
2001 to the present
Area of Study Leader
Typo/Graphic Design
London College of Printing

The grid

Principle
When
What
Why
How

Everywhere

Cultural
Architecture
Music
Furniture design
Fine art
Interior design
Screenplays
Digital design
Town planning
Conceptual art

Psychology
Wim Crouwel
Simon Esterson
Linda van Deursen
David Carson
Peter Gill
Krieger I Sztatecsny
Cartlidge Levene
Wendelin Hess
Hamish Muir
Ellen Lupton
John Maeda

Making
Control
Precision
Measurement
Micro/macro
Components

Breaking

Are designers growing bored with grids?
Do high-profile projects such as Frank
Gehry's Guggenheim Museum in Bilbao
indicate a move towards more expressive,
free-form design? While some designers
clearly believe that the dominance of the
grid was a twentieth-century phenomenon,
others argue that the grid will remain
a powerful ingredient in everything from
architecture to graphics. Its role, however,
is changing as powerful computer processing
enables designers to use grids in more
complex, subtle, and often less visible, ways.

The designer and the grid
Introduction
The principle of the grid
Grids are everywhere
The grid in cultural context
The psychology of the grid
Making the grid
Breaking the grid
Bibliography/Contacts/Credits/Index

During the early and middle decades of the twentieth century, a wide range of diverse and influential designers were inspired by the structural possibilities and mathematical elegance of grids. In the post-war years especially, when many designers were motivated by a desire to help create a better world, the grid, with its connotations of modernity, rationality and reason, often represented more than just a helpful way to organise space.

From magazine pages to individual typefaces, from building façades to furniture, all sorts of design typologies were reconfigured by modernist designers fascinated by grids. Intrigued, sometimes to the point of obsession, by their mathematical possibilities, and delighting in their conceptual rigour, designers began to focus on grids themselves as significant elements in the intellectual content of their designs.

By the end of the century, however, there was a move away from such grid-focused design. In the 1990s, the emotionally charged print and screen images created by Tomato, and the instinctive graphics of David Carson, were the creation of designers who felt that overt subjectivism and personal expression offered a more interesting, or authentic, way forward than grid-focused design.

Nowadays, while the primacy of the personal, emotional response is still a strong theme in design, it co-exists with a renewed interest in modernism. Many designers – including sans+baum, the designers of this book – continue to be fascinated by the creative potential of the grid. For them, the restrictions imposed by the grid can be a creative liberation. And, for nearly all designers, seen simply as a way of ordering space on a page, or volume in a structure, the grid remains supreme.

Nevertheless, as a source of inspiration, the power of the grid seems to be waning. The motivating force in much of today's design is more likely to spring from experience and emotion than an intellectual delight in rationality and right angles.

In architecture, this desire for subjective expression has to be balanced by the crude practicalities of getting buildings built. Prefabrication and modular systems help bring down costs and make construction time quicker – both have tended to imply grid-based design. However, increasingly powerful computer-aided design programs have allowed designers – architects in particular – to combine the practicalities of modular design with a more free-form expressiveness. Structures that would have been impossible to manufacture or build just a few years ago are now both possible to make and affordable to erect.

The result of this combination of a need for modularity, combined with a desire for free-form expression, can be seen in Frank Gehry's Guggenheim Museum, built in Bilbao in 1997. With its unexpected curves and odd juxtapositions, it surprised and delighted visitors more used to parallel lines and right angles. Despite its unusual shapes and angles, the structure has a grid, still visible in the titanium tiles that clad it. It has been warped and stretched, twisted and distorted – but is recognisable. The design process involved creating a model whose co-ordinates were scanned into a computer using software originally developed for designing fighter jets. The result is a building whose unusual shape has made it instantly recognisable even to those who have never actually visited it – the building is, in effect, its own brand.

Similarly, the designers of Federation Square in Melbourne, Australia, have rejected orthogonal (right-angled) grids for a more complex structure based on triangles, resulting in a highly distinctive lattice. This, too, is likely to become the building's trademark.

The work of architects such as Ushida Findlay, however, with its emphasis on curvaceous organic shapes, seems at first glance to go further in rejecting grid-based design.

In fact, beneath the curvy surfaces of their buildings lie – sometimes quite literally – very conventional grid structures. Take, for instance, Ushida Findlay's Truss-Wall House in Tokyo, which looks like a product of sophisticated computer-aided design yet was built in 1987, before the designers even used computers. Photographs of the building's construction show that underneath its curvy concrete surfaces lies a metal framework of supports configured in a very regular grid. The grid is there, although not visible beneath the irregular walls.

Kathryn Findlay points out that the two forms of geometry – curves and straight lines – can be surprisingly closely related. The nautilus-shell spiral, for instance, can be created by subdividing a golden-triangle rectangle into a square and another rectangle, and so on ad infinitum. 'Most of what we do has some sort of mathematical or geometric logic,' says Findlay. 'It might not be as simple as an orthogonal grid, but it is still always looking for some sort of pattern or order.'

Findlay sees grids as useful tools in the design process, but not something that has to be expressed overtly. For her, what is more important is the way that the building is experienced. 'The materiality, how you feel it and how you experience it, is an important part of architecture,' she says. 'Everybody brings different memories and sensibilities with them. The poetics of what happens is interesting. What it triggers. Like your desire to touch. Basically it should engage all your senses, how you want to touch something, smell something, see something, have a special experience.'

For many designers today, including Findlay, the modernist tenet 'form follows function' still holds. What is new is the idea that an important part of the function of the design can be its ability to trigger emotions or to give us new experiences.

The importance of the subjective experience is something that has increasingly motivated graphic designers too. Like architects, however, few of them reject the grid totally. Vaughan Oliver, a graphic designer who has almost never used a grid, admits that he has survived without them mainly because the work he has chosen to specialise in – music graphics and identities – rarely requires large quantities of text that can be read easily. Many of the books Oliver has designed have been for artists or musicians, books in which images play a far stronger role than text. One example is the book Tokyo Salamander, which was created for Japanese fine artist, Shinro Ohtake, who wanted a book based on a series of dreams. The result is an idiosyncratic volume of multiple layers of over-printed images.

Recently, however, Oliver designed a book about his own work. Keen to ensure that readers could follow the text and therefore learn about his work, he resorted to using a grid. Ironically, sticking to a grid structure made it far less enjoyable for him. 'It wasn't exciting for me,' he says wryly.

Many designers today see grids simply as a useful tool in the design process. Jordi Ramon Pages, a Catalan architecture student whose design, A Skyscraper in New York, won the 2000 RIBA Bronze Medal for Students and SOM Fellowship, shares this view. The project was to design a skyscraper hotel for a specific site in New York. The unusual looped structure of Pages' skyscraper appears to be as far removed from grids as could be possible. Yet the plan of the building was created by a process that began by looking at the grid formed by the New York streets that surround the site, and then adding or subtracting from this grid according to the functional needs of the building. 'I had the grid and put in more and more information, and in the end the grid disappeared. But the design comes from a grid,' says Pages. 'Grids are much more beautiful when they are used for a process and not a result.'

Pages' solution can be used to design a hotel on any site. Information about the site (topography, transport connections etc) is fed into the process, along with information about the type of hotel required (budget, luxury, number of rooms, with or without conference facilities etc). Given these two sets of data, the process will then design the building, ensuring that, for instance, the luxury rooms have the best views. 'The system can be applied anywhere,' says Pages. 'The buildings would look different, but they would have the same logic. The result is not about aesthetics, it is about necessities.' The program will design the individual arches of the building according to the connectivity of the part of the site on which they rest. The arches are then tied together at key points to ensure structural stability. These ties are used, internally, to provide promenades or lobbies. The rooms are suspended from the arches in positions that are optimum for their functions.

Today, even those who use grids frequently are often not fascinated by them in the way that their predecessors used to be. Linda van Deursen for instance, whose work is shown on pages 90–93, usually works with grids for the many books and magazines she designs. 'Grids are really handy to work with,' she says. 'But I'm not really interested in them. I'm interested in structures, and I'm not sure that that's the same thing.'

A few, however, go further. For graphic designer/artist Peter Anderson, the fact that so many designers are dependent on grids is a sign of a deep-seated psychological insecurity. 'The grid as a system is both metaphorically and literally a safety net,' he argues. 'What is it that makes us feel uneasy? Why is it that we create rectangles and squares? It's almost to do with our fear of death. We create these "logical" structures and think we're okay because of it.'

Anderson uses typography in his designs, but rarely works with grids. More often, he warps and twists type, using words more as images than text. With this sort of design, reading the whole text is not the point: scraps of words and phrases will give clues to the meaning, leaving it open to the viewer to interpret the design. While he agrees that for larger projects – books or magazines – a grid is helpful, in general, he avoids them. 'Perhaps naively, I am trying to find another way of using space,' he says.

Anderson firmly believes that the grid has had its day. He puts this change in the context of our relationship with the natural world. 'The more we build, the more we sprawl all over the world, the more we'll feel that somehow we want to get nature back,' he says. 'In the past, nature was dangerous and we had a need to control it. But now it's become like a cute pet. Designers will want to put it back. Design will become more organic. That's going to increase and the grid will become unfashionable.'

Perhaps Anderson is right, and the intense fascination that so many designers have had for grids will come to be seen as a passing phase in the history of design, a strange facet of a certain stage of modernism when rationality ruled and subjectivity was suspect.

Or, perhaps, there are simply two sorts of designers: those who see grids as obsessive, restrictive, and, ultimately, dull, and those who see them as satisfying, flexible and supremely elegant ways of solving complex design problems.

inset
Blood cell image by
Peter Anderson,
commissioned by
a newspaper to illustrate
a feature about the future.
The words that form the
'blood cell' are the names
of every known computer
virus at the time that
the image was created.
Anderson was inspired by
the idea that biology and
technology are becoming
ever closer.

right
Three images from the
connected identity for
Sony, designed by Tomato,
2001. This is the new
identity for all of Sony's
technologies and networks
that are enabled by
connection – one-to-one,
one-to-many, many-to-
many, many-to-one.
This identity is not based
on any orthodox rules
or grids. Its form is
behavioural. It lives on a
server and the behaviour
of the attributes: colour,
the point of view, speed
of change, are the
result of information
converted from different
types of sensors placed
in the world. There is one
sensor per attribute and
every now and then the
existing sensor-attribute
relationship changes.
Neither Sony or Tomato
control this. For a 1.5
second television ident, the
editor of the commercial
downloads the requisite
number of high-resolution
targa frames. For the next
commercial, the operation
is repeated. The identity
might be very similar or
radically different, but it is
never the same. For a print
ad, the designer downloads
one high-resolution frame
per ad. The system is
totally fluid and so cannot
be 'gridded'.

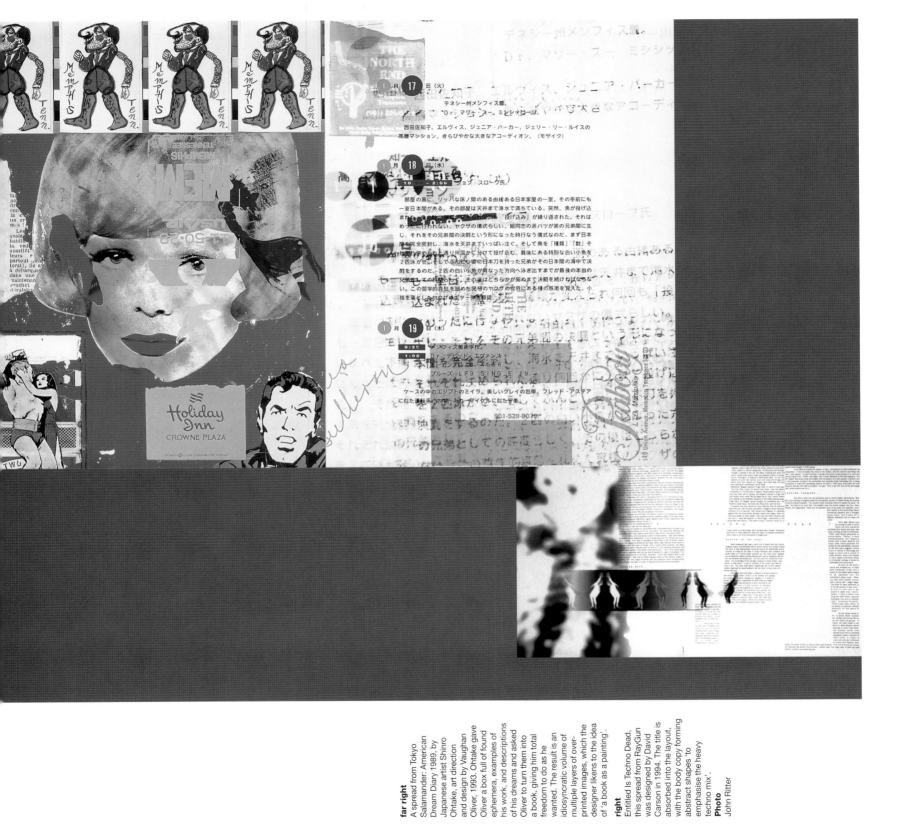

far right
A spread from Tokyo
Salamander: American
Dream Diary 1989, by
Japanese artist Shinro
Ohtake, art direction
and design by Vaughan
Oliver, 1993. Ohtake gave
Oliver a box full of found
ephemera, examples of
his work, and descriptions
of his dreams and asked
Oliver to turn them into
a book, giving him total
freedom to do as he
wanted. The result is an
idiosyncratic volume of
multiple layers of over-
printed images, which the
designer likens to the idea
of 'a book as a painting'.

right
Entitled Is Techno Dead,
this spread from RayGun
was designed by David
Carson in 1994. The title is
absorbed into the layout,
with the body copy forming
abstracte shapes 'to
emphasise the heavy
techno mix'.
Photo
John Ritter

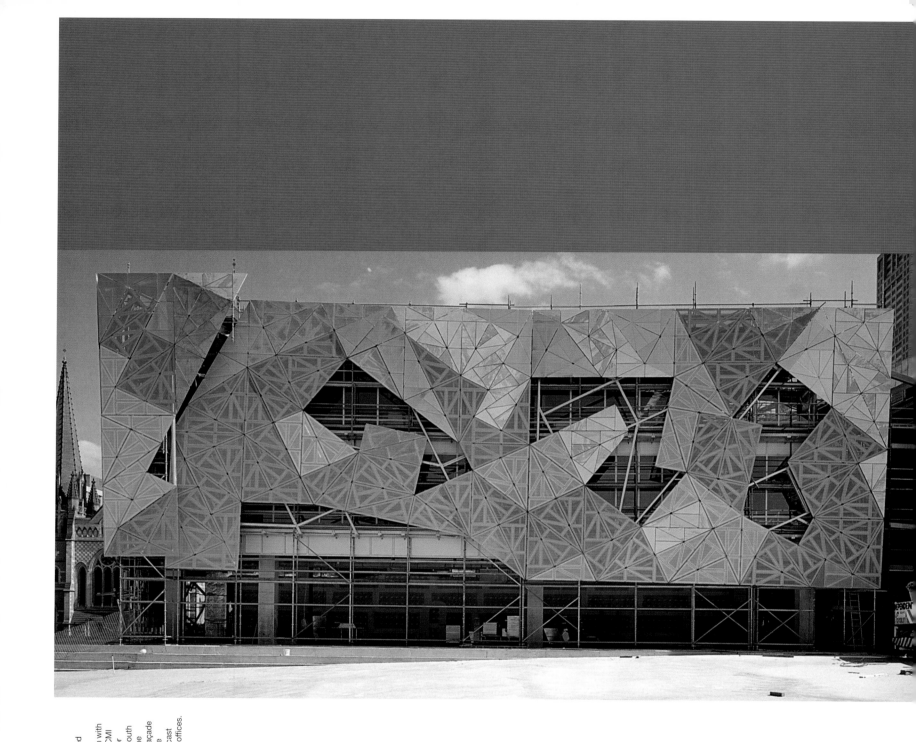

right
Federation Square,
1997–2002, designed
by Lab architecture
studio in association with
Bates Smart. The ACMI
(Australian Centre for
the Moving Image) south
elevation showing the
permeability of the façade
along the edge of the
SBS (Special Broadcast
Services) and ACMI offices.

right
The Guggenheim Museum, designed by Frank Gehry, 1997. On a macro scale this appears to be a building without a grid – the supporting beams are bent and twisted, giving the resulting structure its extraordinary shape. On a smaller scale, however, a grid is visible in the pattern formed by the tiles that clad the surface.

bottom right and following spread
The Truss-Wall House, designed by Ushida Findlay, Japan, 1990–91. As the photographs show, the curvy reinforced concrete walls are supported by a surprisingly regular steel grid structure. The result of this experiment with the innovative 'truss-wall' system of building is a house in which the walls, floors and ceilings merge into one smooth surface. It is a house in which there are almost no right-angles.

insets
A design for a hotel as a skyscraper in New York by Jordi Ramon Pages, student at the Architecture Association. The design won the RIBA Bronze medal for students, and the SOM Fellowship in 2000. The drawings and diagrams show the eventual outcome and the method of working. Information about the site is fed into the process, along with information about the type of hotel required. The program designs the structure to create a hotel that is optimally suited to the site – for instance, the main entrance will be positioned at the point on the site that is best connected to the surrounding area and transport links. The program also ensures that within the hotel, facilities are optimally positioned according to the type of hotel required – luxury, economy, with or without conference facilities and so on.

BLOCK 1　BLOCK 2　BLOCK 3　BLOCK 4　BLOCK 5　BLOCK 6

10.6/7　　　　6.6/7　　　　**150/151**

Catalogues/Periodicals **Books**

**Rietveld Furniture
and the Schroder House**
exhibition catalogue
The South Bank Centre
1990

Ushida Findlay
2G International
Architecture Review
Number 6
1998/II

Hans Rudolf Bosshard
The Typographic Grid
Verlag Niggli
2000

Dennis P Doordan
**Twentieth-Century
Architecture**
Laurence King
2001

Editors Jeannine Fiedler
and Peter Feierabend
Bauhaus
Könemann
2000

Kenneth Frampton
**Modern Architecture:
A Critical History**
Thames & Hudson
1992

Karl Gerstner
**Review of 5 x 10 Years
of Graphic Design etc**
Hatje Cantz Verlag
2001

Armin Hofmann
**Graphic Design Manual:
Principles and Practice**
Van Nostrand Reinhold
1965

Richard Hollis
**Graphic Design:
A Concise History**
Thames & Hudson
2001

Charles Jencks
**Le Corbusier and the
Continual Revolution
in Architecture**
The Monacelli Press
2000

Robin Kinross
**Modern Typography:
An Essay in
Critical History**
Hyphen Press
1994

Robin Kinross
**Anthony Froshaug:
Typography &
Texts/Documents
of a Life**
Hyphen Press
2000

Rosalind E Krauss
**The Originality of the
Avant-Garde and
Other Modernist Myths**
The MIT Press
1999

Editors Ellen Lupton
and J Abbott Miller
**The Bauhaus
and Design Theory**
Thames & Hudson
1993

John Maeda
Maeda @ Media
Thames & Hudson
2000

Ron van der Meer
and Deyan Sudjic
The Architecture Pack
Van der Meer Publishing
1997

Editor Lars Müller
**Josef Müller-Brockmann:
Pioneer of Swiss
Graphic Design**
Lars Müller Publications
2000

Josef Müller-Brockmann
**The Graphic Artist and
his Design Problems**
Arthur Niggli
1961

Josef Müller-Brockmann
Grid Systems
Verlag Niggli
1996

Paul Overy
De Stijl
Thames & Hudson
1991

Emil Ruder
**Typography:
A Manual of Design**
Arthur Niggli
1967

Erik Spiekermann
and EM Ginger
Stop Stealing Sheep
Adobe Press
1993

Herbert Spencer
**Pioneers of Modern
Typography**
Lund Humphries
1982

Jan Tschichold
Asymmetric Typography
(first publication in English)
Faber & Faber
1967

Jan Tschichold
The New Typography
(first publication in English)
University of
California Press
1999

Peter Anderson
pete@interfield.freeserve.co.uk

Rupert Bassett
rupert.bassett@btinternet.com

David Carson
dcarson@earthlink.net
www.davidcarsondesign.com

Cartlidge Levene
ian.cartlidge@cldesign.co.uk

Neil Churcher
mailbox@edwards-churcher.com
www.edwards-churcher.com

Tacita Dean
c/o Frith Street Gallery
59–60 Frith Street
London W1V 5TA
UK
+44 (0)20 7494 1550

Linda van Deursen
mevd@xs4all.nl

Simon Esterson
sesterson@eldesign.co.uk

Kathryn Findlay
www.ushidafindlay.com

Peter Gill
info@root2design.com

Martin Herbert
MartinLHerbert@aol.com

Wendelin Hess
wendelin.hess@muellerhess.ch

Professor Bill Hillier
www.spacesyntax.com

Krieger | Sztatecsny
ks@gestaltung.net

Axel Kufus
werkstudio@kufus.de

Ellen Lupton
elupton@ix.netcom.com

Hamish Muir
hm@noname2.demon.co.uk

Vaughan Oliver
veetwentythree@dial.pipex.com

Jordi Ramon Pages
jpages2@yahoo.es

John Pawson
email@johnpawson.co.uk

Andrew Penketh
andrew_penketh@hotmail.com

David Phillips
david@phillips-yamashita.co.uk

Lucienne Roberts
endash@dircon.co.uk

sans+baum
sans@dircon.co.uk

Dave Shaw
dave_shaw_@btopenworld.com

Kelvyn Smith
k.l.smith@lcp.linst.ac.uk

Julia Thrift
juliathrift@pobox.com

Tomato
mail@tomato.co.uk

John L Walters
john@unknownpublic.com

Damian Wayling
wayling@dircon.co.uk

Bob Wilkinson
sans@dircon.co.uk

Jason Wright
jasonwright@echo.fsbusiness.co.uk

All other contributors can
be contacted via the authors.

Biographies

co-writer
Julia Thrift has been writing about design for more than ten years, contributing to a wide range of publications including Eye, Design, Blueprint, The Guardian and Time Out. She was a contributing editor to Eye magazine for several years. She now works as head of programmes at the Civic Trust, a UK charity that campaigns to improve the quality of the built environment.

co-writer/graphic designer
Lucienne Roberts studied at the Central School of Speech and Drama before realising her true ambitions and training as a graphic designer at the Central School of Art and Design. After a brief period at The Women's Press, Roberts established the design studio sans+baum, aiming to work on projects outside the purely commercial. Roberts has taught at Middlesex University and London College of Printing. She was a judge for the iSTD awards 2001 and is currently writing for Eye magazine.

graphic designer
Bob Wilkinson graduated from Central Saint Martins College of Art and Design in 1993 and started work at Neville Brody's Research Studios. While there, he worked on a range of projects; clients included Zumtobel Lighting and software company Macromedia. After four years he joined Lucienne Roberts at sans+baum where he is involved in a broad range of projects from arts-related to charity-based work. He has taught at various colleges and also works with illustrator Ian Wright for a variety of record labels.

Both Roberts and Wilkinson are signatories of the First Things First 2000 manifesto, a call for greater awareness of design responsibility. sans+baum clients include Breakthrough Breast Cancer, The British Council, Hayward Gallery, Institute of Cancer Research and Crafts Council.

co-writers
Lucienne Roberts
Julia Thrift

graphic design
Lucienne Roberts
Bob Wilkinson
sans+baum

diagrams
pages 8–11, 16–29
Russell Bell

photography
pages 32, 129, 132/133, 140/141, 144
Andrew Penketh

Photography/stills

page 12
courtesy of Universal
The Kobal Collection/
20th Century Fox

page 16
courtesy of
The Kobal Collection

page 34
Seagram Building
RIBA Library
Photographs Collection

page 35
Villa Rotonda
RIBA library
Photographs Collection
Bauhaus, Dessau
Kelly Kellerhoff
Berlin 1995
copyright DACS 2002

page 36
Unité d'Habitation
Emmanuel Thirard
RIBA Library
Photographs Collection

page 39
Nigel Young/
Foster & Partners

page 40
Spiral Extension to
the Victoria & Albert
Museum in London
by Daniel Libeskind
copyright Miller Hare

page 41
Jewish Museum 1999
Herbert Hoeltgen
Ruhrgas AG

pages 48/49
Tomoko Yoneda

page 53
Florian Holzherr

pages 54/55
John Pawson's
London house
Nacasa & Partners

page 59
courtesy of Universal
Pictures/RGA

pages 146 and 150
Federation Square
Lab + Bates Smart

Usage

pages 146 and 151
Guggenheim, Bilbao
Danielle Tinero
RIBA Library
Photographs Collection

pages 150 and 152/153
Truss-Wall House
Katsuhisa Kida

page 24
El Lissitzky
The Art Archive
copyright DACS 2002

page 25
FT Marinetti
The Art Archive/
Dagli Orti (A)
copyright DACS 2002

page 26
Herbert Bayer
Bauhaus, Dessau
copyright DACS 2002

page 27
Jan Tschichold
Grafische Sammlung
Museum für Gestaltung
Zürich

page 37
Villa Stein de Monzie
and Le Modulor
FLC/ADAGP, Paris and
DACS, London 2002

page 42/43
extract from
Cornelius Cardew: Treatise
copyright 1970 assigned
to Hinrichsen Edition
Peters Edition Limited
London, reproduced by
permission of the publishers

page 50
Damien Hirst
courtesy Jay Jopling/
White Cube
London

page 51
Carl Andre
copyright the artist
courtesy Sadie Coles HQ
London

page 51
Sarah Morris
copyright the artist
courtesy Jay Jopling/
White Cube
London

page 52
Piet Mondrian
copyright the artist 2002
Mondrian/Holtzman Trust
c/o Beeldrecht,
Hoofddorp & DACS
London 2002
image copyright Tate
London 2002

page 52
Chuck Close
copyright the artist
photograph by
Ellen Page Wilson
courtesy of
Pace Wildenstein
The Museum of
Modern Art
New York

page 53
Donald Judd
permanent collection
Chinati Foundation
Marfa, Texas
photograph of detail
by Florian Holzer

page 74/75
Tacita Dean
courtesy the artist
Frith Street Gallery
London and
Marian Goodman Gallery
New York/Paris

pages 84–89
reproduced by kind
permission of
The Guardian newspaper

Thanks to

Imagination
North
Square Red Studio
Precise @ Icon
The Set Up

a

advertising material
21, 28, 31, 88
aesthetics
20, 115, 118–19
alphabet
82–3
Amsterdam,
Stedelijk Museum
80–1
Anderson, Peter
147, 148
Andre, Carl
51
AOL mobile phone portal
62–5
architecture
34–41
see also **structure**
mobile phone portals 62–5
Architektur Zentrum,
Vienna
100–1
art
conceptual 74–76
fine 50–3
Pop 51
Art Basel Catalogue
114–15
Arts and Crafts
Movement
23
asymmetry
19, 20–1, 26, 79
AT&T building, New York
40
Atlanta, USA
73

b

Basel
art catalogue 114–15
Kaskadenkondensator 110
baseline grid
26, 101, 134
Bassett, Rupert
130–5, 140–1, 143
Battenberg cake
31, 32
Bauhaus
26, 35, 37
Bayer, Herbert
26
bibliography
154
Bilbao,
Guggenheim Museum
146, 151
bilingual book
91–3
billing system
116–119
Birmingham,
Millennium Point
104–7
books
editorial design 122–3
graphic design 90–1
handwritten 18–19
images in 122–3
Metatag 92–3
printed 20–1
breaking the grid
145–53
bricks
31, 32
British Museum, London
38–9, 40
broadsheet newspapers
84–7, 89
brochures
108–9, 111
BT Talk Zone
142–3

c

Canal Building brochure
108–9
captions
26
Cardew, Cornelius,
Treatise
42–3, 44
carpets
31, 32
Carson, David
94–5, 149
Cartlidge, Ian
104–9
Cartlidge Levene
104–9
catalogues
Art Basel 114–15
Museum Boymans-van
Beuningen 120–1
Stedelijk Museum 80–1
Wiener Festwochen 102–3
chaos
12–13, 76, 77
Churcher, Neil
60–7
cities
68–73
Close, Chuck
52
Color Typewriter
126
colour
18
columns
see also **eight-, seven-,
six-, three-column grids**
book structure 8–11
choice of number 135
early books 18, 19
Swiss typography 27, 29
Wim Crouwel 81
components
134–5
composition
143
computer music
45
computer programs
desk top 132
hotel design 147
QuarkXPress 130–1, 132,
136–9
Radial Paint 124–5
water bill design 116–17
conceptual art
74–7

d

construction of grids
128–44
contacts
154
content
114
corporate identity guide
140–1
credit card
31
Crouwel, Wim
78–83, 120
cubes
104, 106–7
Cubism
24
culture
33

Dadaism
25
De Stijl
25, 50
Dean, Tacita
74–7
Design Writing Research
123
designers
14–15
digital design
60–7
Dots
128
double-page spreads
19, 20, 23, 96–7

e

economy in design
46
Edinburgh,
Flux music festival
119
editorial design
88–9, 123
eight-column grid
84–5, 88–9
Esterson, Simon
84–9
examples
31, 32

f

fabrics
30, 31
Fascist thinking
16, 27
Federation Square,
Melbourne
146, 150
Fibonacci sequence
23
fields
8–11, 18, 27
film structure
56–9
Findlay, Kathryn
146
fine art
50–3
flexibility
114
Flux music festival,
Edinburgh
119
FNP shelving system
47, 49
fonts
21, 27, 82–3, 134
format
135
furniture
46–9
Futurism
25

g

gallery information cards
110
games
30, 31
Gehry, Frank
146, 151
geometry
21
see also **ratios;
rectangles**
Gerstner, Karl
29, 79
Gill, Peter
96–9
golden rectangle
21, 22
golden section
22, 23, 37
graphic design
books 90–1
computer aided 130-143
designer case studies
78–128
Japan 125
principles of grids 18–30
signage system 104–7
Switzerland 110–15
Greek Doric temples
35
gridlock
31, 32
Grimshaw, Nicholas
107
Gropius, Walter
26, 35
The Guardian
84–9
Guggenheim Museum,
Bilbao
146, 151

h

Hamadan, Iran
68, 72
handwritten books
18–20
Herbert, Martin
50–3
Hess, Wendelin
110–15
Hillier, Bill
68–73
Hirst, Damien
50, 52
hotel
147
houses
37

i

images in books
112–13, 115
Inciting Incident
56, 58
information cards
110
interior design
54–5
Internet
see also **Websites**
business calendar 60–1
intuition
123

j

Japan
125, 146, 151–3
Jewish Museum, Berlin
41
Judd, Donald
53

k

Kalends
60–1, 66–7
key-pads
31, 32
kitchen units
48, 54
Krieger, Stephanie
100–3
Kufus, Axel
46–9

l

latitude
76
layout see **structure**
Le Corbusier
36–7
leading
134, 135
Led Array
126
letterpress
130, 132
LeWitt, Sol
52
liberation
28
Libeskind, Daniel
40–1
London
68–71
Millennium Dome 142–3
museums 38–9, 40
Oxford Street 31–2, 68
longitude
76
Lupton, Ellen
122–3

m

Maeda, John
124–8
magazines
88–9, 91, 94–5, 115
Malevich, Kasimir
50
manuscript books
18–20
maps
31, 32
margins
23, 27, 81, 135
mathematics
132, 146
measurement
131, 133
Melbourne,
Federation Square
146, 150
menus, mobile phones
60–3
meridians
125
Metatag
91–3
Mevis, Armand
90–1
MHB see **Müller-
Hess-Balland**
Mid-point Climax
57
Millennium Dome,
London
142–3
Millennium Point,
Birmingham
104–7
minimalism
26
interior design 54–5
typography 100–1, 118–19
mobile phone portals
AOL 62–3
architecture diagram 64–5
Reuters Kalends 60–1
visual structure 66–7
modernism
14–15, 20
opposition to 37, 39–40
renewed interest 146
typography 79, 100–1

n **o** **p** **q** **r** **s**

modular systems
46–7, 49
buildings 146
signage 107
Modulor system
37
Mondrian, Piet
50, 52
Morris, Sarah
50, 51, 52
Morris, William
23
mosaics
30, 31
Muir, Hamish
116–21
Müller-Brockmann, Josef
30, 114, 119
Müller-Hess-Balland (MHB)
110, 114–15
multi-column grid
101
multi-dimensional grid
119
Museum Boymans-van Beuningen, Rotterdam
120–1
Museum für Gestaltung, Zürich
112–13, 115
museums
Amsterdam 80–1
Berlin 41
Bilbao 146, 151
London 38–9, 40
music
42–5

narratives
58
National Grid
31
navigation
44–5
new alphabet
82–3
New York
AT&T building 40
Seagram Building 34, 37
skyscraper 147, 151
news-based Websites
60–1, 66–7
newspapers
21, 84–9

obsession with grids
130
Octavo
118
Ohtake, Shinro
147, 149
Oliver, Vaughan
147, 149
orchestral score
45
order
77
Oxford Street, London
31–2, 69

page control
131, 132
Pages, Jordi Ramon
147, 151
paper sizes
25, 98, 133
paving
31, 32
Pawson, John
54–5
Phillips, David
46–9
pixels
64
points
131, 133, 135
politics
31, 32
Pop Art
51
posters
80–1
postmodernism
14–15, 40
pragmatism
105, 115, 119
precision
15, 120, 132, 134
principles
17–30
printing
18–21, 98
see also **typography**
proportion
15, 22, 24, 25, 55
see also **ratios**
psychology
76–7

QuarkXPress
128–9, 130–1, 132, 136–9

RAC corporate identity guide
140–1
Radial Paint
124–5
ratios
21
squares 106–7
width to height 22, 24, 98
rectangles
21, 22, 24, 97–9
repetition
building design 35
music 44
Reuters Kalends
60–1, 66–7
Roberts, Ray
17–28, 30
Root 2 consultancy
98–9
root four rectangle
24, 97
root three rectangle
24, 96
root two rectangle
24, 98–9
Rotterdam, Museum Boymans-van Beuningen
120–1

sans-serif type
26, 27, 30, 79
Schroder, Truus
37
screenplays
56–9
Seagram Building, New York
34, 37
Second Act Climax
57, 58
self-expression
130
seven-column grid
8–11, 135
shape
25
Shaw, Dave
130–3, 135, 136–9, 143
shelving systems
46, 49
signage systems
104–9
simplicity
18, 23, 105
six-column grid
89, 140–1
skyscraper
147, 151
Smartphone Operating System
60–1
Smith, Kelvyn
130, 132, 133–5, 142–3
Sony identity
148
Space Syntax
68–73
squares
106–7
standardisation
18, 25, 135
starting grids
31, 32
Stedelijk Museum, Amsterdam
80–1
storage
31, 32, 46

structure
19, 20, 81
books 90–3
films 56–9
flexibility 114
graphic design 105
mobile phone portal 62–7
multi-layered approach 107
software 65
typography 98–9, 105
subjectivity
146–7
superstore aisles
31, 32
Switzerland
graphic design 110–15
typography 28–30, 99, 100,
114–15, 118–19
symmetry
19, 23
Sztatecsny, Maximilian
100–1

Talk Zone
142–3
technology
15, 35
templates
130–1
text
134
textiles
31, 32
Thames Water bill
118–19
three-column grid
18, 19
tiles
30, 31
time-based grids
56–9
Tokyo, Truss-Wall House
146, 151–3
Tokyo Salamander
147, 149
Tomato
148
Total Design
79
town planning
33, 68–73
Truss-Wall House, Tokyo
146, 151–3
Tschichold, Jan
27, 98
two-axis grid
44, 45
type size
131, 133
typography
Bauhaus school 26
computer control 136–9
early books 19, 20–1
grid design 131–7
Jan Tschichold 27
measurement 133
modernist 79
specifications 136–9
structure 98–9, 105
Swiss 28–30, 99, 100,
114–15, 118–19
Talk Zone 142–3

undecorated grid
35
**Unité d'Habitation,
Marseille**
36–7
units of measurement
131, 133
Ushida Findlay
146, 151–3

van Deursen, Linda
90–3, 147
**Victoria & Albert
Museum, London**
40
Vienna
Architektur Zentrum 100–1
Wiener Festwochen
catalogue 102–3
Villa Rotonda, Vicenza
35

Walters, John L
42–5
Wayling, Damian
56–9
Websites
60–1, 64–7
Weingart, Wolfgang
114, 119
Die Weltwoche
115
width to height ratios
22, 24, 98
**Wiener Festwochen
catalogue**
102–3
Winter, Paul
105
Wright, Jason
76–7

x-height
134, 138

**Zürich, Museum
für Gestaltung**
112–13, 115

numbers

2-axis grid
44, 45
2-page spreads
19, 20, 23, 96–7
3-column grid
18, 19
6-column grid
89, 140–1
7-column grid
8–11, 135
8-column grid
84–5, 88–9
8vo
116–21
24-column grid
86–7, 89
58 unit grid
29

There is enormous interest in design at the moment, resulting in a very welcome demand for books about the subject. Few of these books, however, would be possible if it were not for the generosity of those who contribute to them – artists, designers, writers, photographers – many of whom give their time or their work for little or no recompense. We are very grateful to all those who contributed so generously to this book.

Thanks also go to Kate Noël-Paton for all her encouragement with this project.

Lucienne Roberts would like to thank Ray and Putzi Roberts, whose love and friendship will be valued always, and Damian Wayling, Diane Magee and Annette Pitura, the most supportive and encouraging of friends. Particular thanks also go to Bob Wilkinson, for his talent and for the hours, willingly spent, of very hard work.

Julia Thrift would like to thank Tim Fletcher for being very patient for a very long time.

Thanks also go to
Shaun Askew
Russell Bell
Jo Gibbons
Richard Hollis
John McGill
Andrew Penketh
David Phillips
Melissa Price
Jason Wright
Tomoko Yoneda
and Rob at Digital